IMAGES
of America

BOLINGBROOK

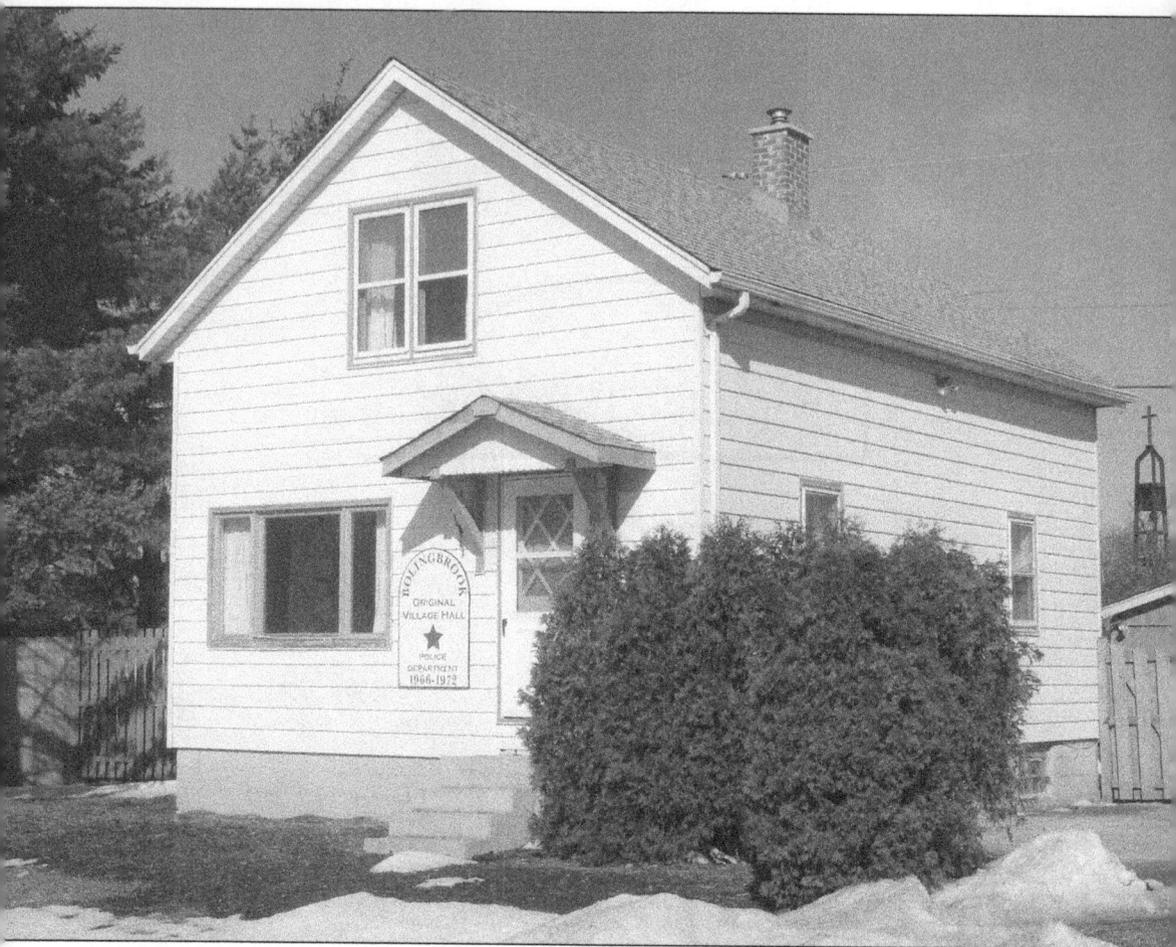

More than just a building, the first village hall was a symbol of the new village of Bolingbrook. Although it was small like the new village, it represented a new beginning of self-reliance and determination to make the community the best place to live. (Courtesy of Bolingbrook Historic Preservation Commission.)

ON THE COVER: Boys play flag football in front of the "White House." While there were few amenities in Bolingbrook in the early 1970s, these children were happy just to be playing ball and did not need a real field. (Courtesy of Bolingbrook Historic Preservation Commission.)

IMAGES
of America

BOLINGBROOK

Village of Bolingbrook Historic Preservation Commission

ARCADIA
PUBLISHING

Published by Arcadia Publishing
Charleston, South Carolina

Library of Congress Control Number: 2014959990

For all general information, please contact Arcadia Publishing:
Telephone 843-853-2070
Fax 843-853-0044
E-mail sales@arcadiapublishing.com
For customer service and orders:
Toll-Free 1-888-313-2665

Visit us on the Internet at www.arcadiapublishing.com

*We dedicate this book to all those people who
made Bolingbrook a place to grow.*

CONTENTS

Acknowledgments 6

Introduction 7

1. Wilderness Trails 9

2. More Cows than People 17

3. Pathways of the Past and Future 25

4. Second Wave 37

5. Off to School 45

6. Readers, Players, and Flyers 57

7. Town Celebrations 75

8. Ghosts 89

9. Leadership Legacy 97

10. A Place to Grow 113

ACKNOWLEDGMENTS

The Bolingbrook Historic Preservation Commission would like to acknowledge and thank Mayor Roger C. Claar, village clerk Carol Penning, and village trustees Leroy Brown, Mike Lawler, Rick Morales, Joe Morelli, Pat Schanks, and Maria Zarate for their continued support throughout this project. Other village staff assisted in this book, including Jim Boan, Reggie Bobikiewicz, Dale McClannahan, James Farrell, Fran Miller, Tom Pawlowicz, and Lucas Rickelman.

We would like to acknowledge Kim Smith, Bolingbrook Park District; Larry Randa, Valley View School District; Melissa Infusino, chamber of commerce; Debra Dudek, Studio 300 and the Fountaindale Library for their help. Thank you to all those individuals who provided information, including Keith Allen, Sandie Calcagno, Lisa Carlstedt, Andy Clow, Joe DePaulo, Peggy and Mike Drey, Nicki Fagust, Felix George, Jerry and Joanne LoPiccalo, Shirley Nona, Kim Peterson, Robert Pinciak, Mary Rennels, Aimee Rupsis, Linda Simpson, Ron Spindel, and Diane Smith. Photograph submissions have received separate acknowledgement. Thank you also to our neighboring historical societies for your help.

We would like to acknowledge the members of the Bolingbrook Historic Preservation Commission who supported the book committee: chair Bill Kohl, Ruth Blumenstein-Costello, Mark Hayes, Jacob McVey, Joseph Picciuca, Dennis Raga, Michael O'Connor, David Overeem, and Diane Zeigler. Finally, a tremendous thank-you to book committee commissioners Judy Bredeweg, Pat Treadway, Ed Russell, Cathy Bouley, and Jerry Wolak, who worked tirelessly to document the history of Bolingbrook.

The information presented in this book is as accurate as possible. We apologize for any errors, inconsistencies, or omissions. Unless otherwise noted, all images appear courtesy of the Village of Bolingbrook and the Historic Preservation Commission.

INTRODUCTION

The story of Bolingbrook's first 50 years is a remarkable one. It epitomizes the American dream, characterized by perseverance and a let's-get-it-done spirit. The first young couples of the early 1960s drove 30 or more miles out on what was old Route 66 looking for a home to raise their families. What they found was full of promise: new model homes, just right for first-time buyers like them, sitting out among the farm fields. So they moved in. There were no neighborhood schools yet. There were not parks yet. Few paved roads. No fire station. No police station. No library. No stores. So they built them. Within five years, they made Bolingbrook an official municipality. They had grown to 5,100 people in 1,200 houses, and they just kept coming and staying for the family-based community, the diverse population, the commercial and industrial tax base, and the great public services, schools, and parks. I could not be prouder.

Regards,
Roger C. Claar, Mayor

Bolingbrook is a village working its way through "Pathways of the Past and Future" to become "A Place to Grow." The community, which is celebrating 50 years, is an energetic, friendly, and affordable place to raise children.

In the 1960s, Dover Development Company eyed the rich, fertile farmland off Route 66 near Barber's Corners. Armed in the beginning with a drawing of five lots around Rocklyn Court and then a subdivision of many homes and streets, Dover convinced Nick Eipers to sell his farm at Briarcliff Road and Route 53. The time was ripe to provide affordable housing for young married couples with children who were looking to leave Chicago. And buy they did. For $100 down and a low monthly payment, Westbury was built out, followed by Colonial Village and King's Park east of Route 53.

However, Dover Development did not count on the hidden traps of business and ended up declaring bankruptcy. Approximately 5,000 people were left with homes in a rural atmosphere of no sidewalks or streetlights, roving wild dogs, a fire department serviced by the nearby village of Lemont, a school district controlled by Lockport, policing by the Will County sheriff, and water and sewer supplied by Citizen's Utilities. Recognizing the problems, the Bolingbrook Homeowner's Association, representing all three subdivisions, spearheaded the notion of incorporation.

What were the consequences of incorporation? It took two tries at referendum to accomplish an affirmative vote. For residents accustomed to Chicago-style politics, the idea of creating their own destiny was new. It began with the name of the village—Bolingbrook. It was a name chosen by Dover Development when they filed their plats with Will County; an English butler was chosen to market the new homes, and English names were chosen for the streets. Did someone in the company trace the history of an English castle in east central Lincolnshire with the name of Bolingbroke? Home to the Earl of Bolingbroke (1580–1646) and the Viscount of Bolingbroke

(1678–1751), it is also mentioned in Shakespeare's King Henry plays. We have someone within the Dover Development Company to thank for the name. The Twelfth Circuit Court of Will County authenticated the incorporation vote on October 6, 1965. The name, Village of Bolingbrook, was then filed with Paul Powell, Illinois secretary of state, on December 16, 1965.

Homebuilders with national headquarters began taking a second look at this community and the inexpensive farmland surrounding it. Offers were made and accepted, and soon the farmers began to disappear. Subdivisions of homes were being built by Kaufman and Broad, Hoffman Builders, Surety Builders, and Winston/Centex, to name a few. Homeowners suddenly became rule makers in the areas of sidewalks, street lights, building codes, and zoning. Arguments occurred regarding village boundaries, commercial developments, and what to do with the 100 children a day moving into an already overburdened school district. Things were moving fast for the new village, and officials and residents did not have a lot of time to discuss direction, lifestyle, or commercial development.

Our school district disconnected from Lockport and became Valley View Unified School District 365. The number 365 was chosen because our children were now on year-round schools—45 days in school, 15 days off. All schools were built with air conditioning, with the idea that the buildings would be used throughout the year. The district maintained a year-round school system for 10 years, but today there is a regular semester schedule with summer vacation.

The Bolingbrook Park and Fountaindale Library Districts were formed by referendum in the early 1970s. Both districts are run by an elected board, and residents of all ages have become accustomed to receiving services that include sports, fitness, and greenways from the park district, and computer services, references, and research support from the library.

With an attitude flush with new and improved opportunities, residents were open to ideas. They supported *Sesame Street* programming on Channel 11 by providing a day of auction services during their public pledge drives. They proved the village has a sense of humor with the annual cornfield regatta sponsored by the Bolingbrook Yacht Club. Under the able direction of Commodore Terry Little, an obstacle course was laid out for homemade yachts. WGN's Bob Collins gave Bolingbrook residents the opportunity to respond to disc jockey Steve Dahl.

The 1970s and 1980s were periods of growth and sometimes a revolving door. Census takers took an annual count to keep the village current with federal and state reimbursements. Old Chicago was opened and closed five years later, but the indoor amusement park with the surrounding shopping mall put Bolingbrook on the destination map. It facilitated the village's first experience receiving sales tax dollars from people outside of town coming and spending their money. Our village officials also suffered from change. Original residents who worked on incorporation were no longer elected, and new residents were transferred to and from other states through their employment. Mayor Roger C. Claar benefitted from all this and was appointed mayor in 1986. He grasped the reins of government, became a voice for Bolingbrook development, and has been reelected every term. Accompanying stability were boundary agreements with all our neighbors. Our footprint was established as 25 square miles and 82,000 residents—a big difference from the first small drawing of five home lots.

In 2015, the village is celebrating its 50th birthday. We were unable to accommodate every event and person involved, as 50 years is a long time. Some stories are left untold, but we feel we are the new face of America. We would like to thank Arcadia Publishing for accepting our proposal and publishing our story. As one reads through this book, a change from the wilderness trails and a rural heritage with rich farmland to a village supporting a diverse group of residents living in the Chicagoland maze of towns and big city living is apparent. We are still looking for affordable housing, a safe place to raise our children, and a village that responds to residents' needs. We have been honored to be listed in *Money* magazine's Best Places to Live, and those of us who live here agree.

One

WILDERNESS TRAILS

DuPage Township, Will County, Illinois, was claimed and settled between 1830 and 1840. In 1804, the federal government acquired land with the signing of the Treaty of St. Louis. The treaty included a 20-mile-wide, 96-mile-long strip of land from Lake Michigan to the Illinois River through northwestern Will County that became known as the Indian Boundary Line. This corridor provided safe passage for early settlers, and present-day Bolingbrook lies within it. Illinois received the land in 1827 and began selling it under a program known as preemption, drawing New England farmers to the area because they could purchase 160 acres for $1.25 an acre. To purchase the land, the farmer had to live on the property. Monies raised from those land sales went toward building the Illinois and Michigan Canal. Opening in 1848, the canal established trade between Chicago, St. Louis, New Orleans, and New York. For those early farmers who settled the Bolingbrook area, a world market became available to ship commodities such as grain and limestone. With increased trade to widespread markets, the Chicago Board of Trade was established in 1848 to regulate the price of goods, a job it still does today.

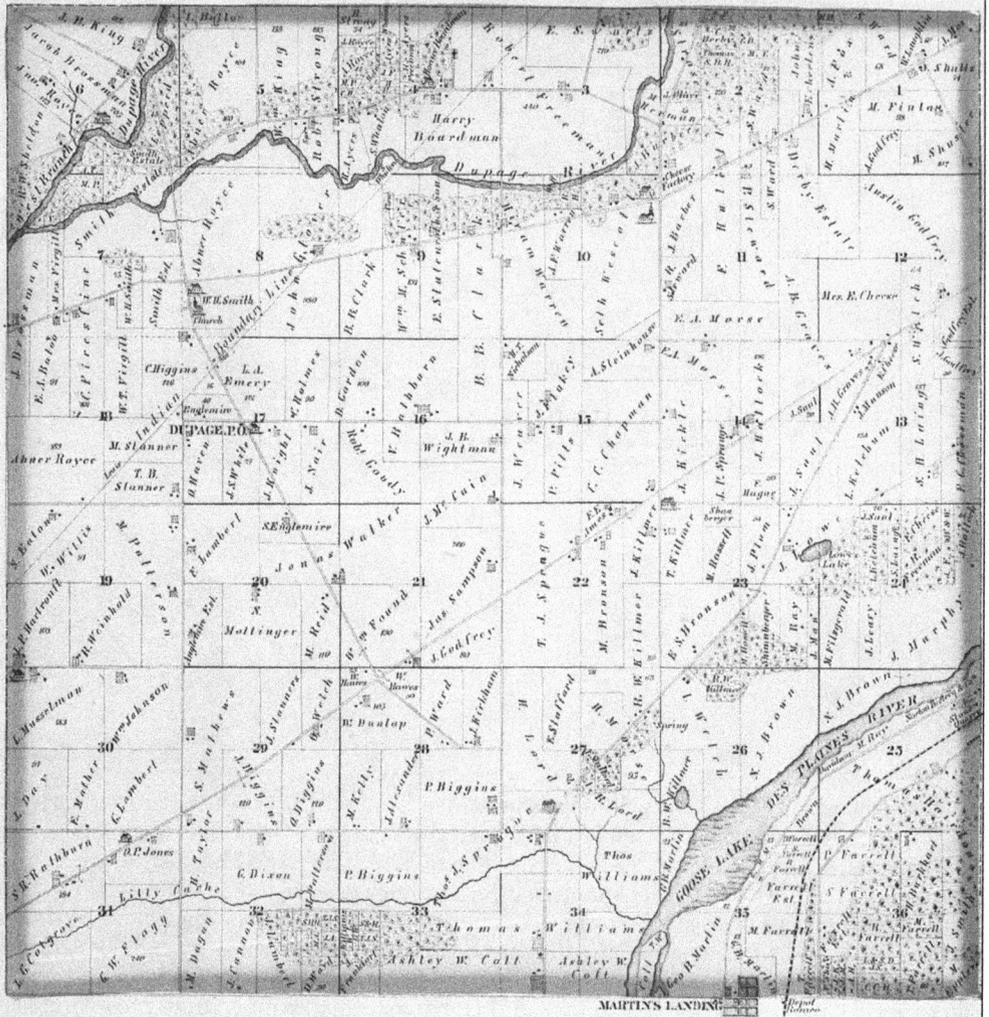

This 1873 map shows the 36 square miles making up DuPage Township and the family-owned farms. The elected township board consisted of a supervisor, clerk, assessor, road commissioner, collector, and six trustees. The township supervisor was also a voting member of the county board. Will County was created from Cook County in 1836, with Joliet as the county seat. In 1838, DuPage County was created with Naperville as the county seat. Residents of what has become Bolingbrook voted on the issue to join DuPage County, but the issue was defeated by one vote.

10

North of the First Presbyterian Church of DuPage Township, located at the north edge of the Hobby Lobby parking lot, stands an old maple tree. The tree predates the early settlement of the Bolingbrook area, and during those pioneer days, settlers hung lanterns from its sweeping branches and held evening social gatherings. Today, this majestic tree has lost some branches, but it remains a testimony to the tenacious spirit of early pioneers and those continuing that pioneering spirit in Bolingbrook.

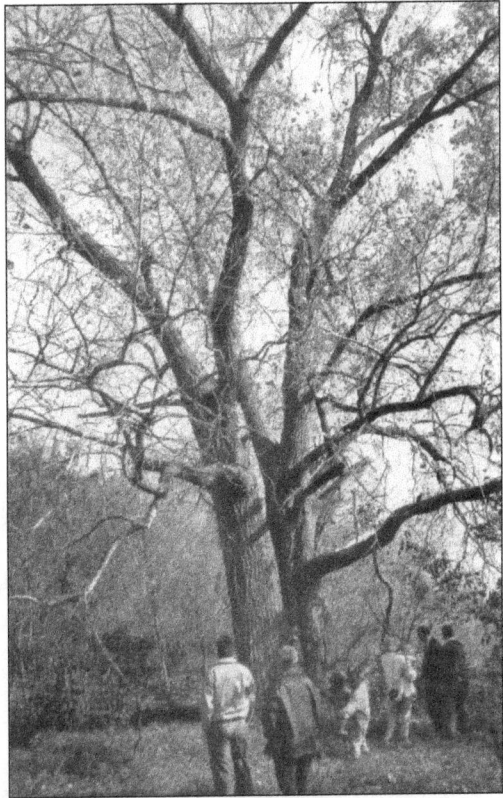

Driving west on Boughton Road near Indian Boundary Road is a sign marking the Indian Boundary Line. The Indian Boundary Line was a corridor providing safe passage for settlers to travel from Lake Michigan to the Illinois River. In 1821–1822, a proposal to build the Illinois and Michigan Canal within the Indian Boundary Line created interest in these lands.

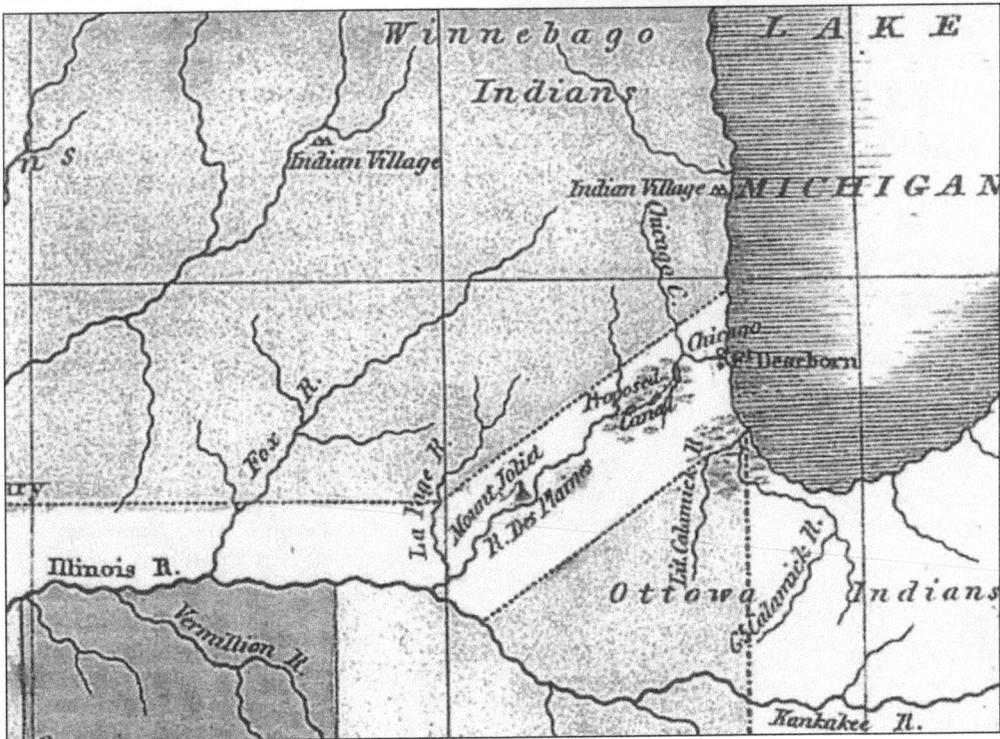

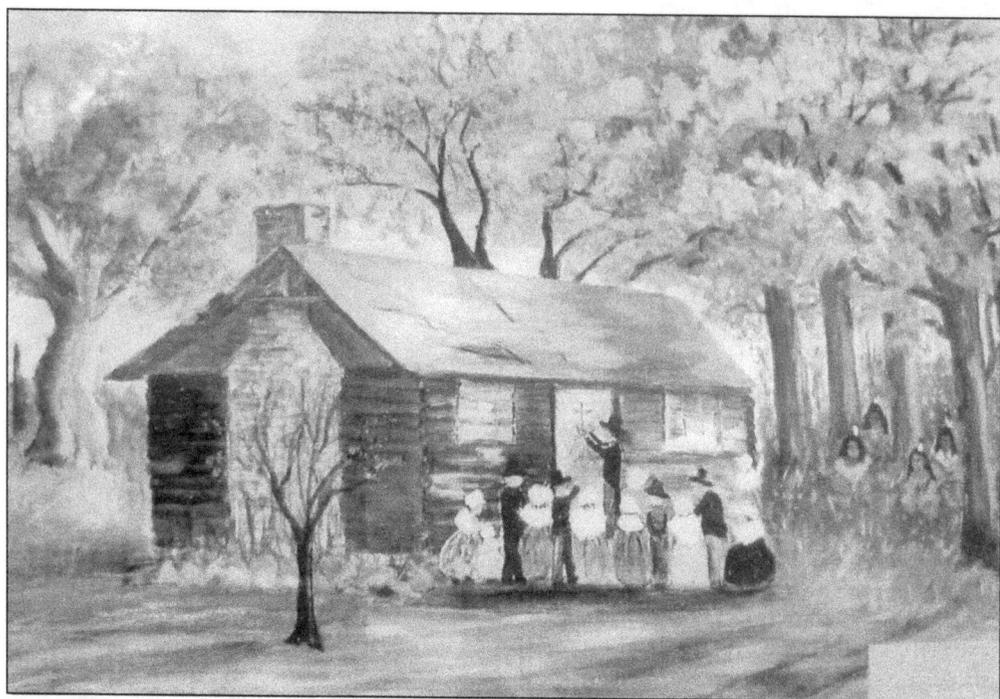

Pastors of the
First Presbyterian Church of DuPage
(DuPage Presbyterian Church)

Jonathan C. Porter T. Rascet J. T. Bird O. P. Lacey E. Patterson

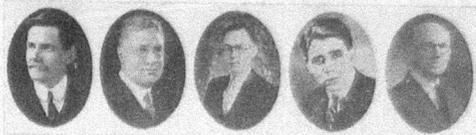

M. B. Mellish A. Stitt W. F. Stein R. L. Northorp M. J. Wiggins

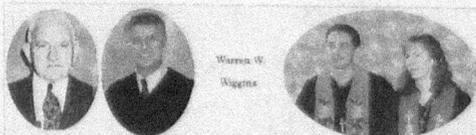

Arnold C. Buol Lawrence R. McCulloch Warren W. Wiggins Timothy and Linda Lane Hartell

Jan Kennedy Mark Hughes

This painting of Old Hickory School hangs in the First Presbyterian Church of DuPage history room. When the church was organized on July 13, 1833, the building served as a school, a house of worship, and meeting hall for local farmers. It was the first one-room school in what was then Cook County. Today, a commemorative stone at Barkdoll and Royce Roads marks the site where Old Hickory once stood, overlooking a bluff. (Courtesy of First Presbyterian Church of DuPage.)

The spiritual leaders pictured here ministered to the First Presbyterian Church of DuPage community for over 181 years. The ministers oversaw the formation and development of church committees such as the DuPage Christian League, Union Dramatic Club, Ladies' Missionary and Aid Societies, Young Ladies Missionary Society, the choir, and boys' and girls' basketball teams. The church provides spiritual and social activities for area residents. (Courtesy of First Presbyterian Church of DuPage.)

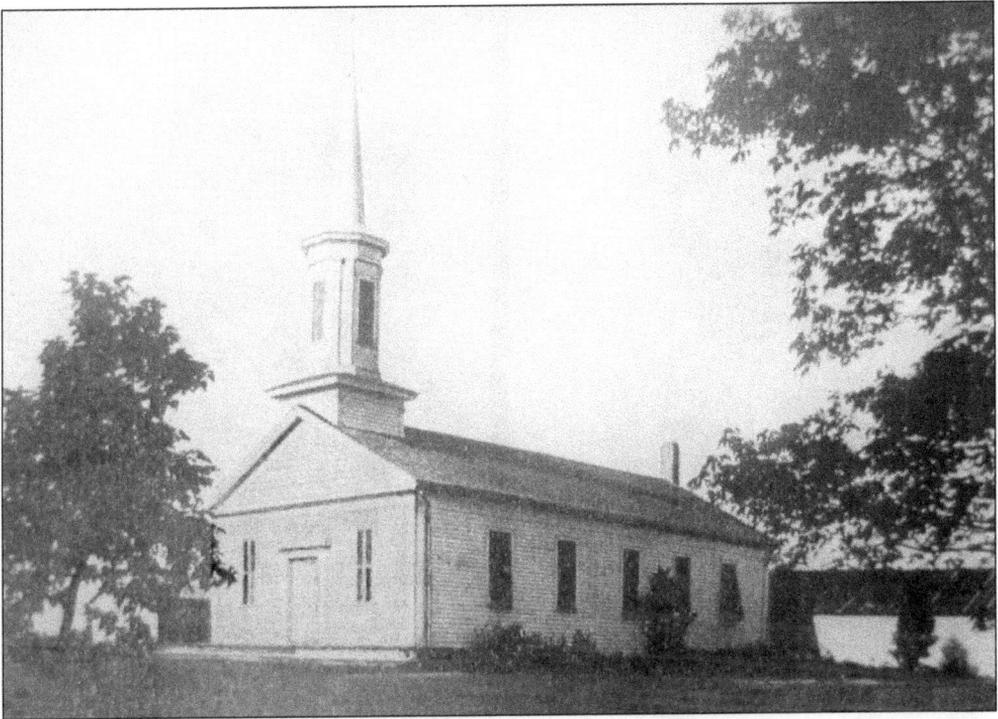

The First Presbyterian Church of DuPage (above), located on Weber Road, was chartered in 1833, one week after the First Presbyterian Church of Chicago. It is the second-oldest Protestant church in northern Illinois. Still located on its original property, the church and parsonage were remodeled in 1908, incorporating the original church as an educational wing. The image below shows the old church on the left. The remodeled church remained in service until 2005, when it was demolished to make way for the present church building. A history room contains many stories of early life in DuPage Township. (Above, courtesy of First Presbyterian Church of DuPage.)

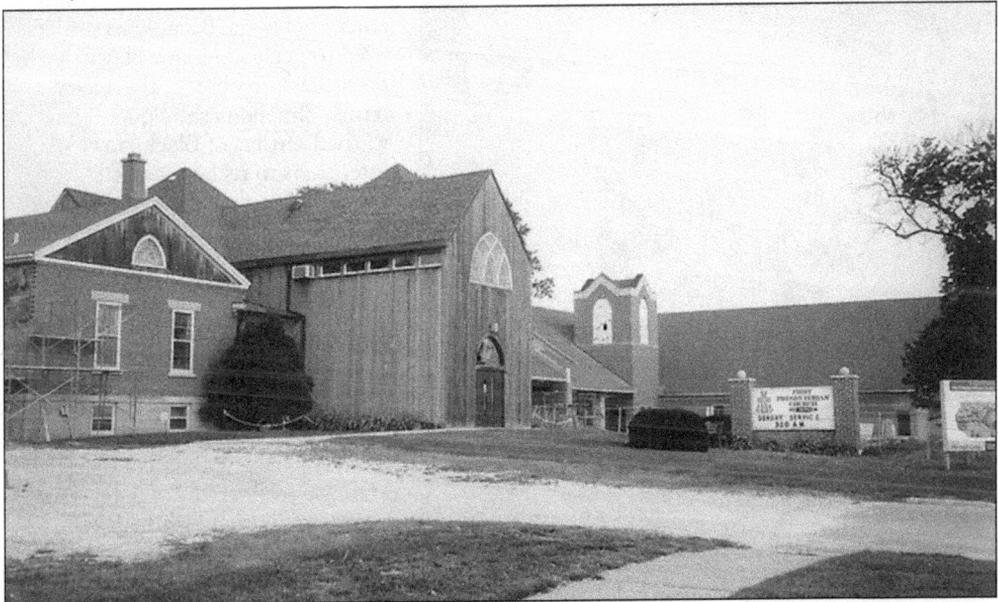

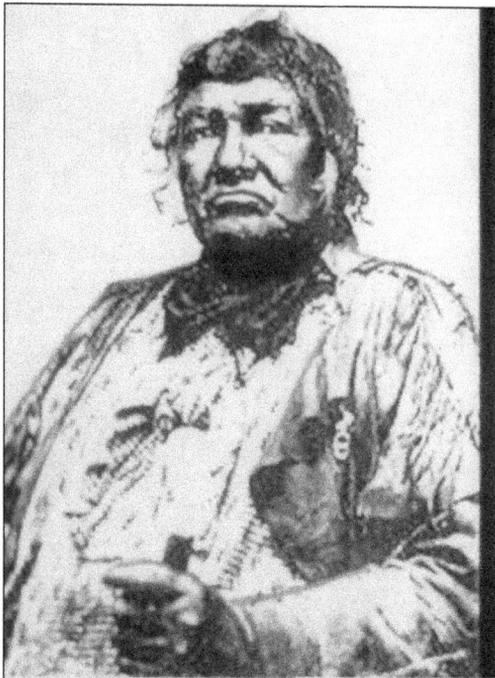

Potowatomi Chief Shabbona **Sauk Chief Black Hawk**

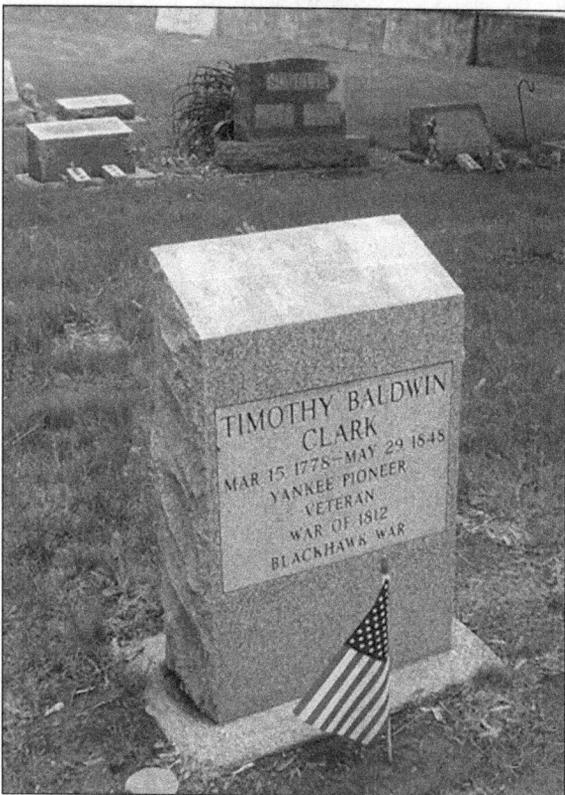

In 1832, Sauk (or Sac) chief Black Hawk crossed the Mississippi River into Illinois to reclaim Sauk lands ceded to the US government by treaty. Black Hawk's action started what is known as the Black Hawk War or Sac War. The Potawatomi chief Shabbona, friendly to settlers, tried to persuade Black Hawk, with no success, to observe the treaty terms. Shabbona subsequently warned settlers of Black Hawk's intentions to reclaim Sauk lands that included what is now Bolingbrook. Militias were sent to stop Chief Black Hawk, and odd battalions were formed for local defense. Two were formed in the Bolingbrook area under Major Buckmaster. Among these battalions were captains Joseph Napier, Harry Boardman, and Holden Seisson and recruits Timothy Baldwin Clark and his son Barrett B. Clark. The Clarks are buried locally in Hillcrest Cemetery on Boughton Road.

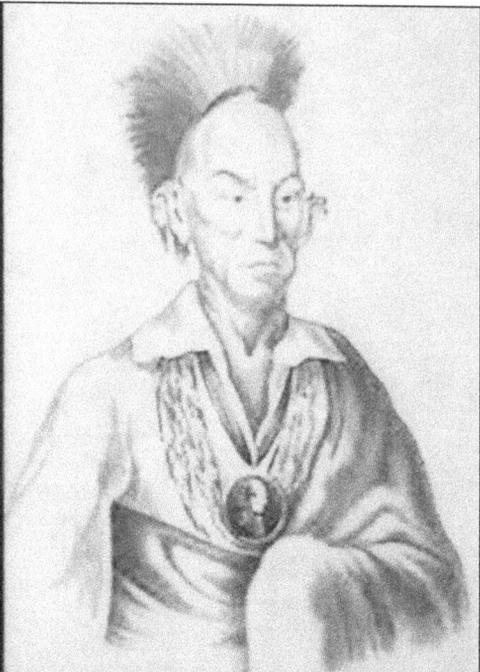

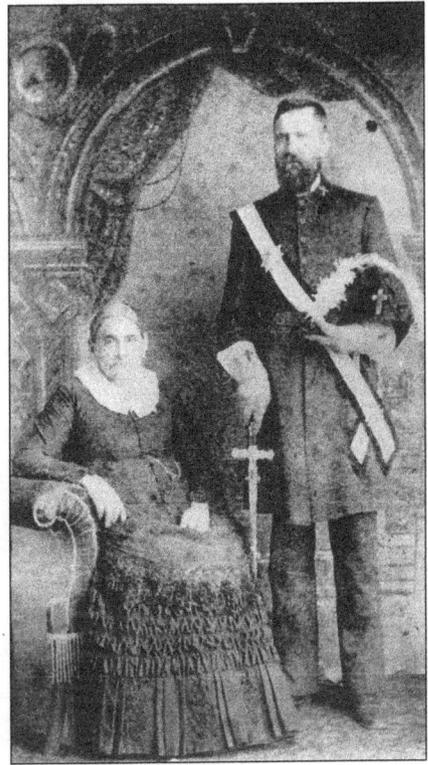

In 1832, early settler Caroline Strong wrote a letter describing some hardships pioneers faced: "We stayed at Chicago nearly four weeks. Women and children fled to Fort Dearborn for protection when danger of Indian attacks threatened the Naper settlement. When thinking we should be safe at home . . . [we returned]. A day or two [later], General Atkinson sent forty of his men, commanded by Captain Payne, to build a fort. . . . The day after they arrived here, one of their men was killed by hostile Indians. The wretches, after scalping him, escaped with a span of horses. They had lurked about the place a number of days. . . . We must have passed within a few rods of them on our return." Caroline, pictured at right with her son Alfred, is buried in Boardman Cemetery with her husband, Robert, and their seven children. (Right, courtesy of Romeoville Area Historical Society.)

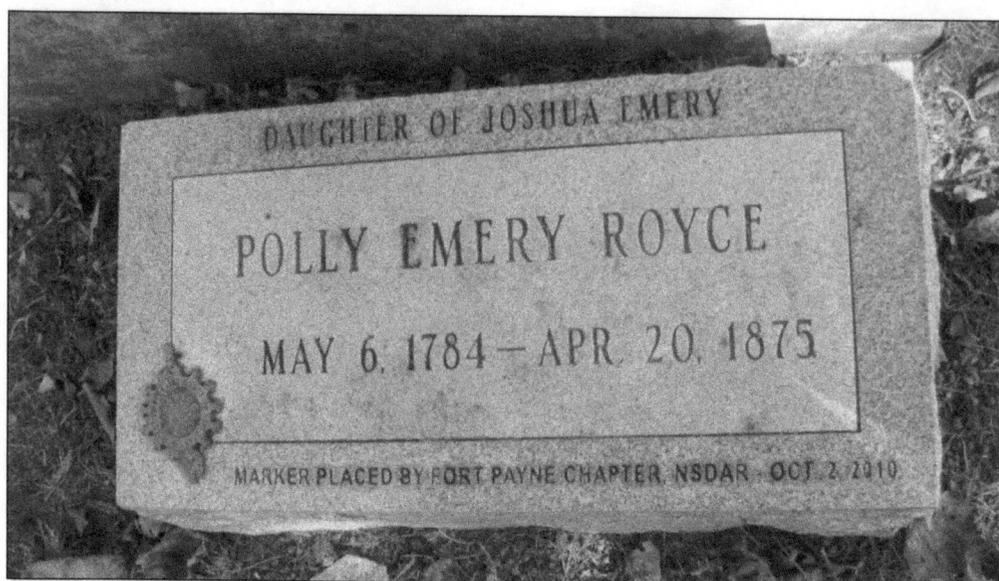

DAUGHTER OF JOSHUA EMERY

POLLY EMERY ROYCE

MAY 6, 1784 — APR. 20, 1875

MARKER PLACED BY FORT PAYNE CHAPTER, NSDAR - OCT. 2, 2010

In 1835, Jonathan and Polly Royce arrived in this area from New York. Jonathan was a successful businessman and cattleman and owned between 3,000 and 4,000 acres of land along Royce Road. Polly was noted for her patriotism. Her father, Joshua Emery, was a soldier in the American Revolution. In 2010, at Boardman Cemetery, she was officially honored with an insignia marker as a Daughter of the American Revolution by the Fort Payne chapter.

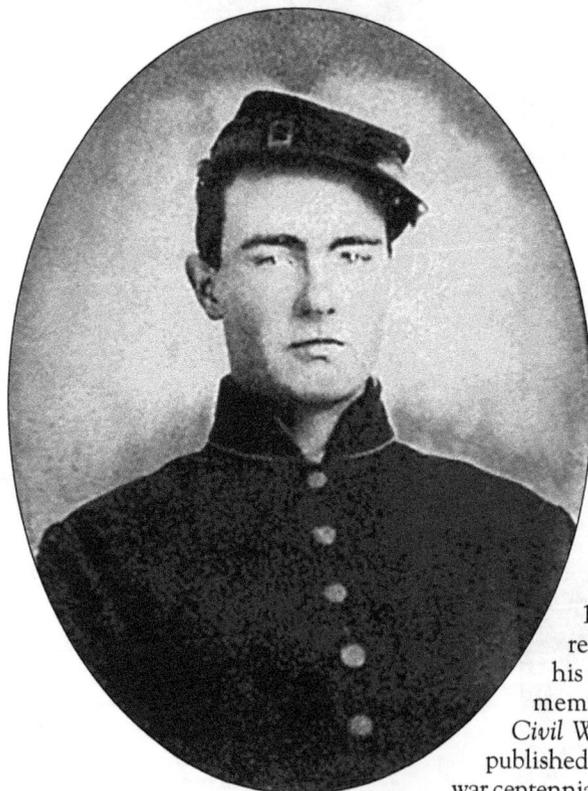

Son of Robert and Caroline Strong, Robert Hale Strong was only 19 years old when he joined the Illinois 105th Infantry Regiment on March 8, 1862. Suffering from severe rheumatism resulting from Civil War injuries and at his mothers' urging, he began to write his memories of that war. *A Yankee Private's Civil War* was the result of his labor. It was published in 1961 by the *Saturday Evening Post's* war centennial series. (Courtesy of Dover Publications.)

Two

MORE COWS THAN PEOPLE

The area known as DuPage Township (later Bolingbrook) had an auspicious beginning. With the opening of the Indian Boundary land and the DuPage River's bountiful water supply, many families moved here in the 1830s. These families came and faced the hardships of frontier life, including the winter of the Big Snow. Within 10 years, prairie was plowed into farms. Log cabins became large farmhouses. The *History of Will County, Illinois*, published in 1878, lists about 170 real estate owners in DuPage Township; 155 are listed as farmers. Some of the early settlers and farmers included Jonathan Royce, John Barber, and Harry Boardman, who are all buried in Boardman Cemetery. Warren, Swift, Sprague, and Clark are some of the farm families buried in Hillcrest Cemetery. While farming was the primary industry, early settlers were able to create a community, establishing a church, cheese factory, sawmill, one-room schools, and cemeteries.

It was not until the improvement of Route 66 and the eventual completion of Interstate 55 that builders began to see the available area farms as a land of opportunity.

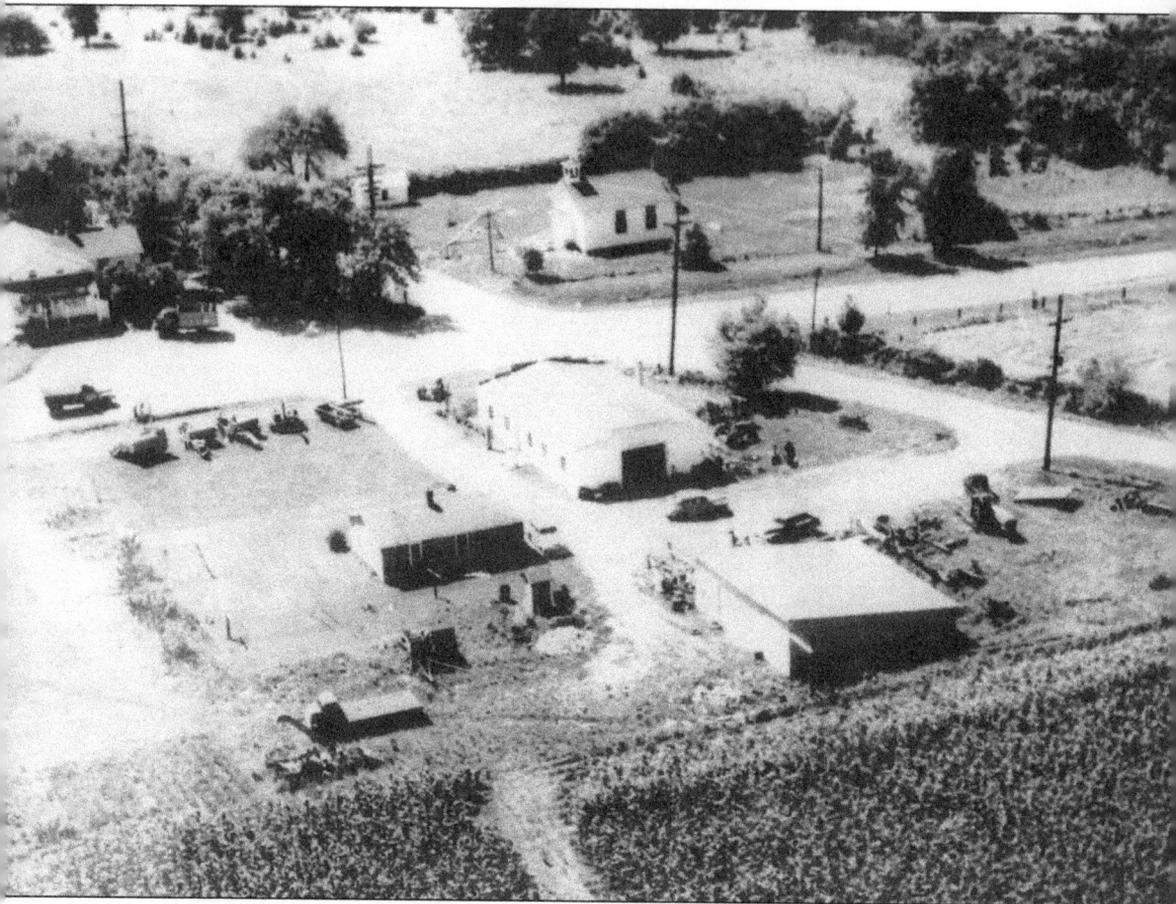

In 1832, John and Emma Barber and their children arrived at Fort Dearborn from Vermont. They established a claim for 211 acres and began a farm at the corners that carried their name for many years. This overview of Barber's Corner, taken in the 1950s, shows the intersection of Oldfield (Boughton) Road and Route 53. On the northwest corner is the Barber's Corner one-room school, and in the foreground is the Breitwieser farm. On the southern end of the farm is a house, an implement store, and the path to their airstrip. Breit's Drive-In was popular when the early subdivisions were built. On the southwest corner is Grace's Clover Farm Store. This was the first general store in the area. It opened in 1952. According to a March 1964 *Village News* advertisement, one could buy two pounds of Clover Farm margarine for 35¢ and two loaves of Rainbow bread for 39¢. Grace Erickson's store closed in 1967.

John and Emma Barber's oldest son, Royal E. Barber (right), studied law and was admitted to the bar in 1847. He moved to Joliet and was elected mayor in 1876. Samantha Warren came with her parents, Hiram and Rachael Warren, from Vermont in 1833. When her mother died, she was left to care for her father and siblings. Her father was to deed the homestead (approximately 176 acres) to her for remaining unmarried and caring for them. Her siblings did not feel Samantha was entitled to the homestead, and a lawsuit ensued. Samantha hired Royal Barber to represent her; the case went to the Illinois Supreme Court, Northern Grand Division, in 1882 for final settlement. She won, and the case stood as a landmark case for women's property rights for some time. Pictured below from left to right are Samantha, Effie, and Rachael Warren. (Right, courtesy of the City of Joliet; below, courtesy of Peggy Salata Roberts.)

To old timers, the stately Greek Revival–style home along Royce road is the Freeman house. Robert Freeman and his first wife, Adaline (Boardman), built the house in the 1840s. During the Civil War, he stored grain in the parlor until the price increased. A staunch Republican, he sent a letter to Abraham Lincoln offering to safely escort him to Washington for his inauguration. After marrying his third wife, Frances Wescott, he moved to Naperville. The house fell into disrepair and was purchased in 1982 by Fred and Bonnie Hackendahl. While adding modern conveniences, they retained the farmhouse character of the home.

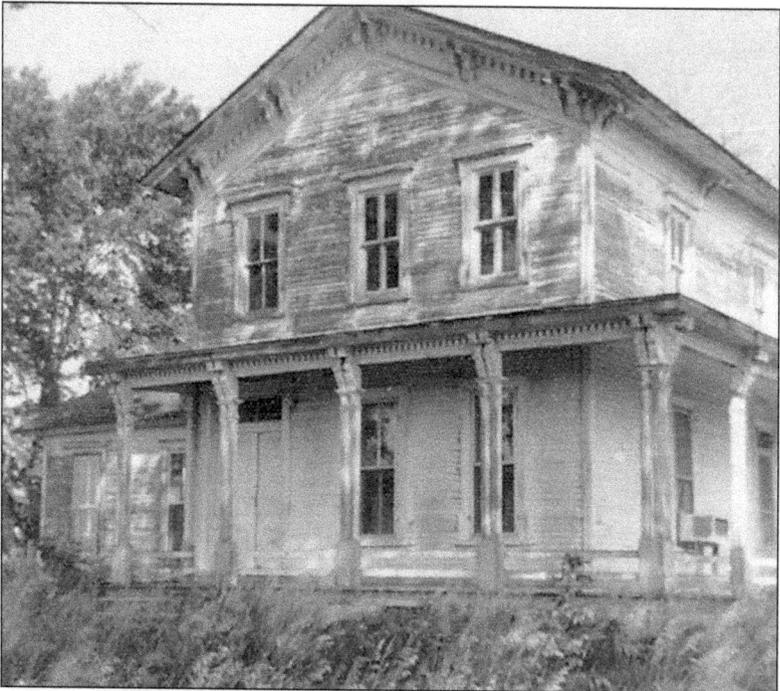

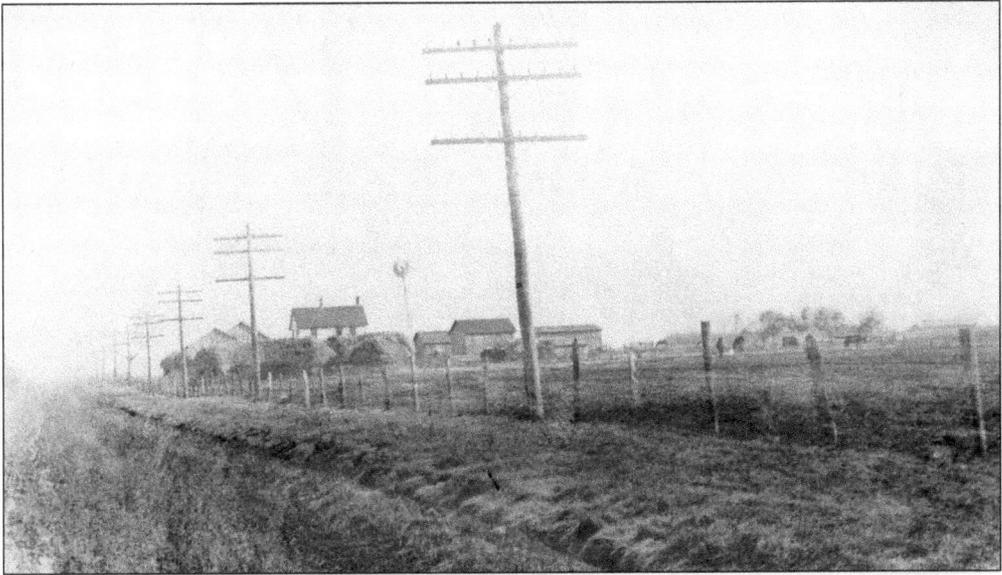

The 1930 federal census finds the farm of Basil Bennett in DuPage Township, Lemont, Rural Route Three. The farm was near what is now South West Frontage Road and Old Chicago Drive. Bennett gained fame at the 1920 Olympics in Antwerp, Belgium, when he won third place in the hammer throw. His bronze medal throw was 48.250 meters, the best of his career. (Courtesy of Romeoville Area Historical Society.)

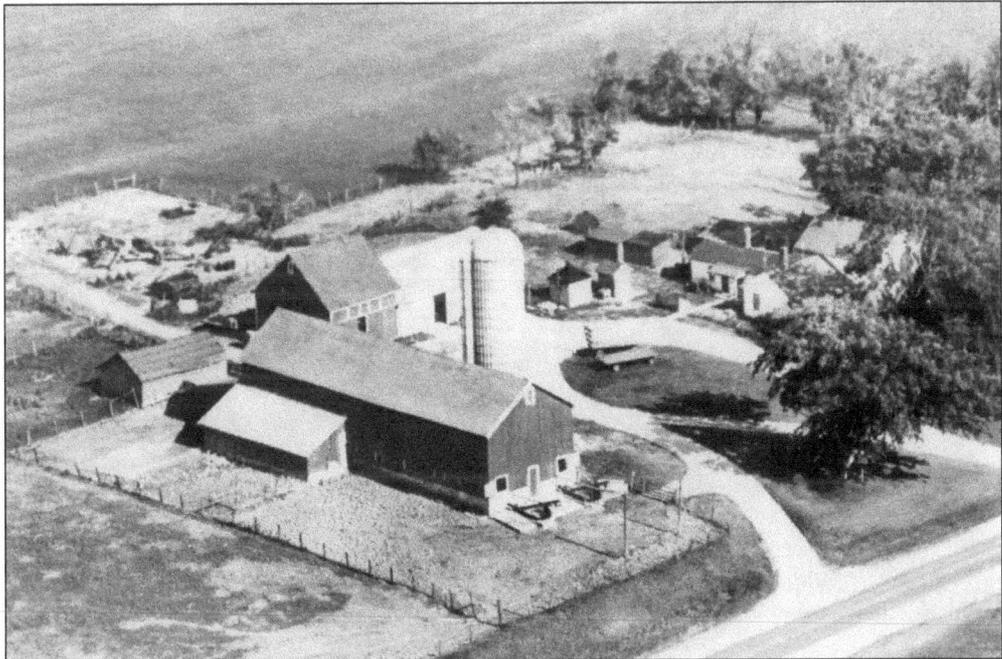

This aerial view of the Breitwieser farm, located on Route 53 north of Boughton Road on the original site of Barber's Corner, shows what Bolingbrook was like before incorporation. West of Route 53 was a pasture for Breitwieser's dairy herd, and an underground tunnel provided a safe cow crossing. The farm was sold to the Winston-Centex Development Company, and is now home to the Winston Village townhomes.

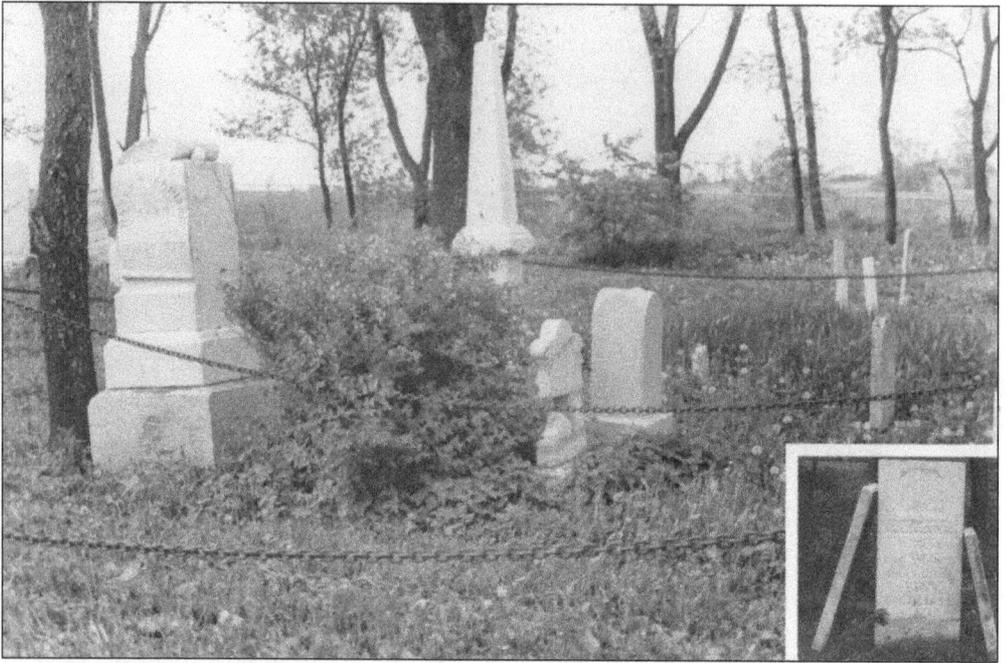

Capt. Harry Boardman came from New York to DuPage Township in 1831, and bought the first McCormick reaper used in Will County in 1846. It was Boardman who set aside one acre of land for a public burying ground; Elizabeth Cleavland, the first recorded death in the area, was buried there in 1832. Original restoration occurred in 1976, when the Bolingbrook Historical Society made it a bicentennial project. Fundraising began for a plan to replace the gate and fence in 1999 with weekly fish fries by DuPage Township. The dedication of the new fence, gate, and plaza took place on October 29, 2002. Pictured below are, from left to right, Peter DeWitt, Felix George, Don Montemayor, Dewey Royce, Lynn Schroth, Bob Schanks, Jim Bingle, Cathy Bouley, Lois Michel, Patricia Stach, Bill Mayer, and Clarence Schrock.

Originally called the Barber's Corner Burying Ground/Cemetery, the graveyard was renamed Hillcrest Cemetery of Barber's Corner in 1929. The oldest known burial is Hattie E. Martin, who died on July 28, 1835, at two months old. Hillcrest Cemetery is the home of more than 40 veterans, including two Black Hawk War and five Civil War veterans. In 2014, three new markers were installed on previously unmarked Civil War veterans' graves with the help of the Sons of Union Veterans of the Civil War (P.H. Sheridan Camp 2). Hillcrest Cemetery has expanded and is still open for burials.

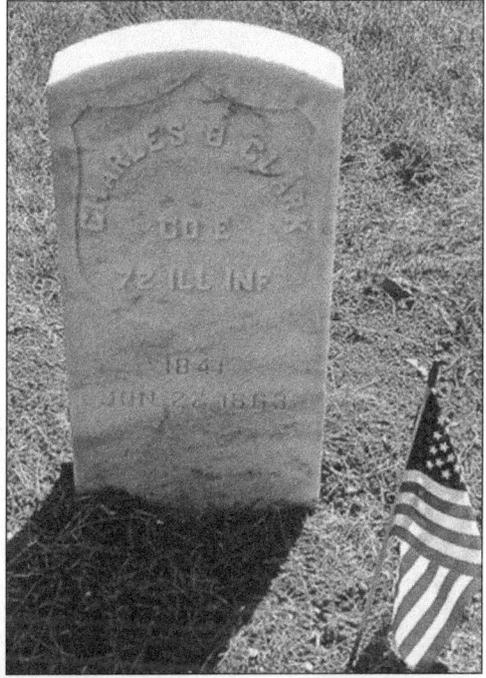

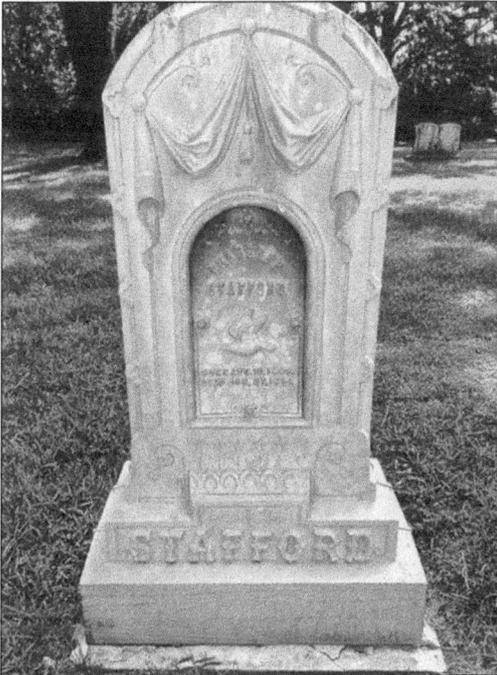

Charles H. Stafford has the only zinc "white bronze" headstone in Hillcrest Cemetery. Zinc headstones were manufactured by only one company, the Monumental Bronze Company in Bridgeport, Connecticut, which made them from 1870 to 1912. They were sold by salesmen who used catalogues to customize the monuments, which featured decorative screws on the name plates. Both Charles and his father were hotelkeepers, so it is fair to assume they knew the salesman. Charles Stafford's monument is over 133 years old.

Education was important to early DuPage Township settlers. Beginning in 1833 with Old Hickory School, the district expanded to five schools by 1846. A petition to the school superintendent in 1851 resulted in the construction of the Higgins School at what is now Lily Cache and Veterans Parkway. In the 1950s, Valley View School District 96 was created, and all one-room schools were closed. The schools were sold for $250 each, and Higgins School became a private residence. (Courtesy of Romeoville Area Historical Society.)

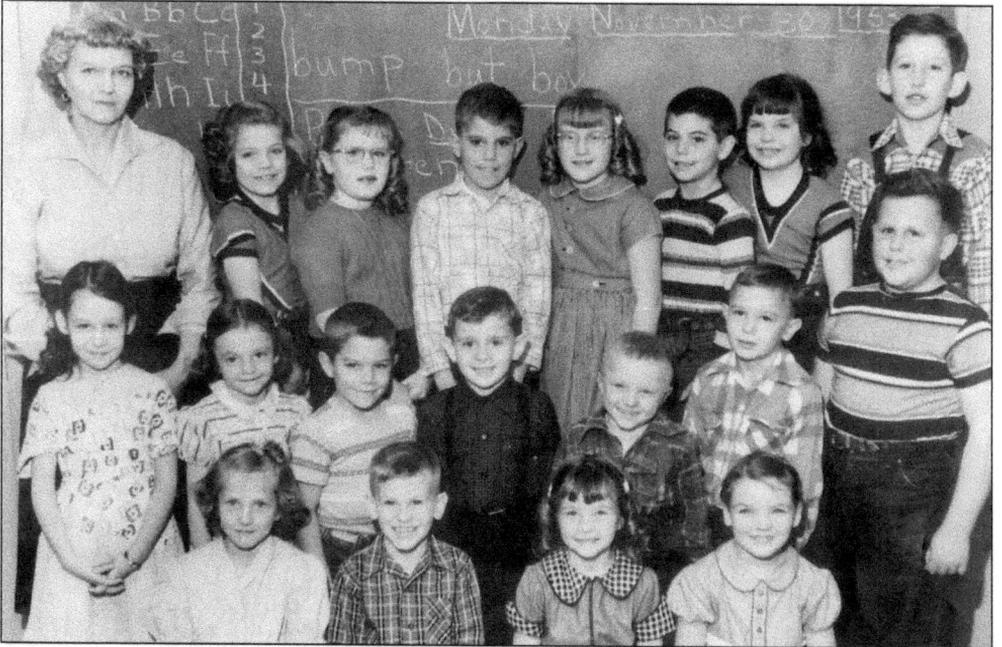

In 1953, Barber's Corners School, located at Boughton Road and Route 53, held its last class. Pictured here on November 30, 1953, are, from left to right, (first row) Nancy Bennet, Leon Totura, Shirley Breitwieser, and Barbara Featherstone; (second row) Sherry Sikish, Phyllis Schultz, Ronny Cleek, Art Eichelberger, Jimmy Schultz, Ralph Chilvers, and Bobby Heisner; (third row) Dorothy Allen (teacher), Darlene Ebel, Betty Jean Edberg, Richard Maas, Janet Breitwieser, Dennis Cleek, Nancy Ebel, and Richard Erickson. In 1954, these students attended Valley View School on Dalhart Avenue in Romeoville.

Three

PATHWAYS OF THE
PAST AND FUTURE

On October 6, 1965, the newly elected mayor and trustees received the village's official incorporation papers in a ceremony presided over by Will County chief judge Michael Orenic. The first Bolingbrook subdivision was Westbury, followed by Colonial Village and King's Park, and living conditions were not as ideal or luxurious as depicted in the developer's advertisements. An early resident, Diane E. Smith, wrote:

> We were the thirty-fifth home to be . . . finished. Since there were no building inspectors, we were allowed to occupy the home. Our electricity was connected to our . . . neighbors, then to a pole, not directly to the home. . . . Home prices ranged from $10,995 to $12,995 depending on the style and model. For $100 down, you could buy a home with 3 or 4 bedrooms, 1-1/2 or 2 bathrooms, a small kitchen with one metal base cabinet with sink and one metal wall cabinet over the sink. A large living room with dining area completed the first floor. The floors were concrete, no tile, wood or carpeting. With no basements, the utility room, furnace and hot water heater had to be housed on the first floor. All houses had sliding windows without storms and no air-conditioning. Any extras had to be put in by the new owner. Our yard was dirt and it was up to you to grade and seed your lawn. The streets in the new subdivision were gravel and mud. Streetlights and sidewalks were after thoughts.

However, conditions did not deter people from coming to Bolingbrook.

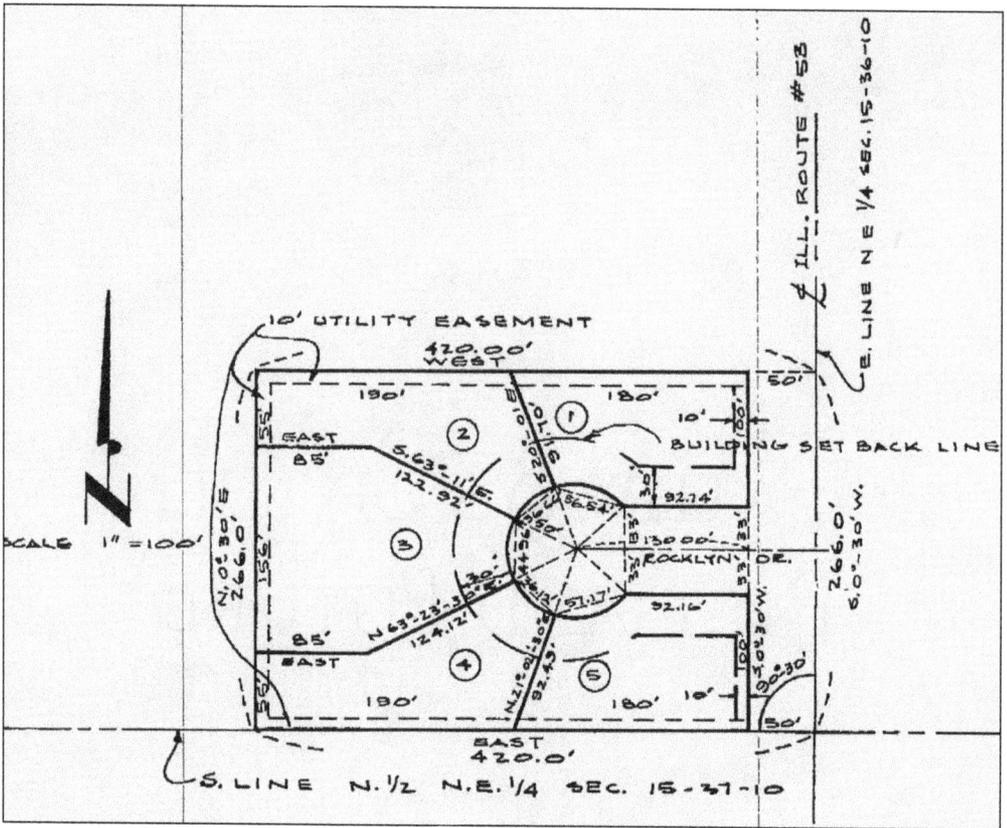

In the early 1960s, Dover Construction Company purchased property for a housing development, and models for Westbury were built on Rocklyn Court, south of Briarcliff Road on Route 53. The plans of the Bolingbrook subdivision, comprising Westbury, Colonial Village, and King's Park, were filed in the Will County Recorder of Deeds. The Colonial Village models pictured below were on Andover Court. Will County was the closest government body with zoning and building laws, and the streets were accepted by the highway commissioner of DuPage Township.

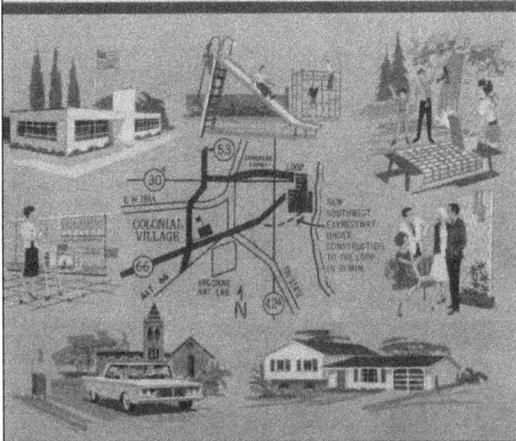
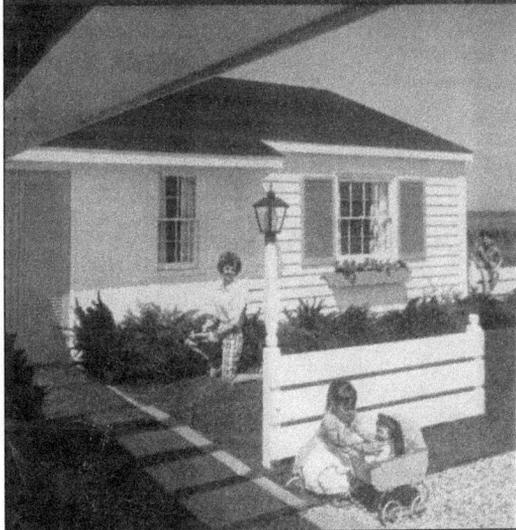

This advertisement from July 28, 1961, shows Mr. Dover inviting people to come out and visit the new homes in Colonial Village and Westbury. Glenhill is now in Glendale Heights, and Colonial Village and Westbury started the growth of what would become Bolingbrook. More than 200 families purchased homes the first weekend after this advertisement appeared in the *Chicago Tribune*. Their dream homes awaited.

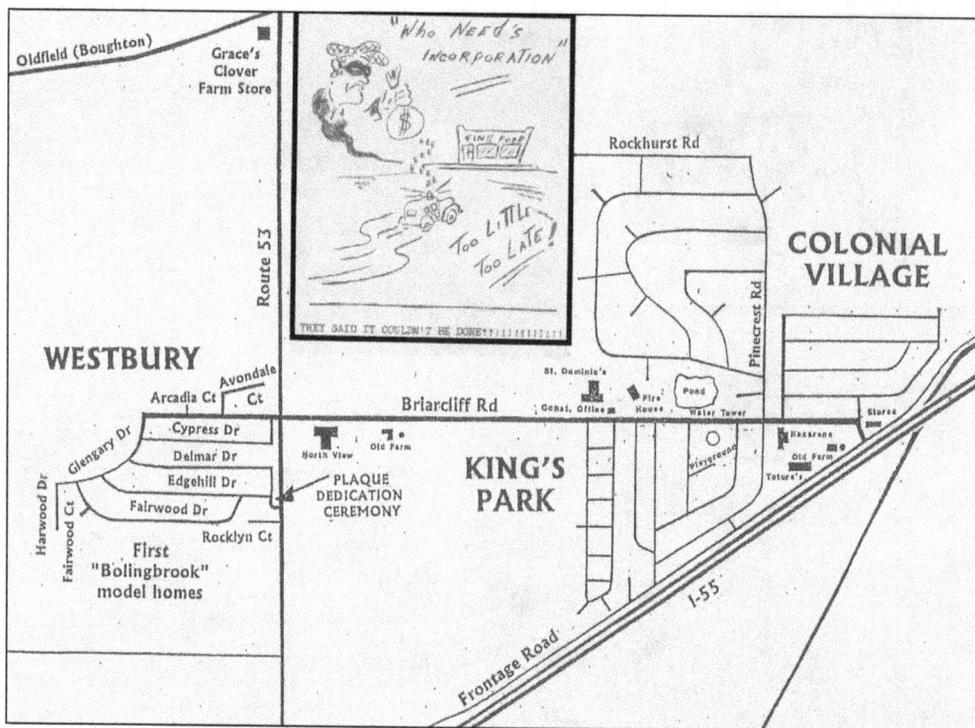

After losing the incorporation vote in 1963, the Bolingbrook Homeowner's Association printed a cartoon in the *Bull Sheet* (Volume 1 Issue 7). This cartoon, shown as an inset on the map of Bolingbrook's three original subdivisions of Westbury, Colonial Village, and King's Park, kept the incorporation issue alive. On October 6, 1965, the three subdivisions became the Village of Bolingbrook. The chart below shows the results of the vote in September 1965. In 1990, the village board designated this original area as a historic district and dedicated a plaque at the site of the Freedom Fountains, Briarcliff Road and Route 53.

BOLINGBROOK INCORPORATES
vote totals

	YES	NO	TOTAL
Westbury	130	157	287
Section 1	210	150	360
Section 2	179	89	268
Section 3	225	164	389
Totals	**744**	560	1304

The first flag was designed by village trustee William Plimmer. "Bolingbrook" was placed at the top in bold script of gold thread on a silk kelly green background surrounded by gold fringe. A large X was made in the middle of the flag indicating pathways. The past followed I-55 from Joliet to Chicago, while the future followed Argonne National Labs to Weston, now Fermi Lab.

One might pass it every day driving east on Briarcliff Road, a 1941 farmhouse next to St. Dominic's Church. First it was the Schrader farmhouse, then the construction office of the Dover Construction Company, and then a rectory for St. Dominic's Church. When Bolingbrook incorporated in 1965, St. Dominic's Church offered the rectory to the village. The new village offices had the clerk, Nona Thompson, upstairs and the police department on the main floor. Two jail cells were eventually built in the basement. In 1972, a new village hall was built on Boughton Road.

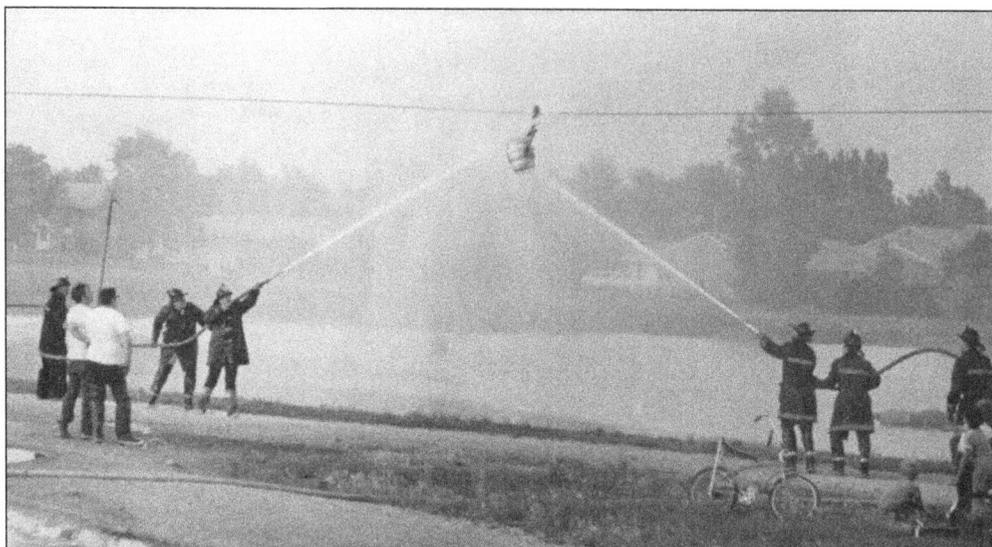

Members of the Bolingbrook Fire Department hone their hose and water pressure–setting skills in a water ball tournament in the 1970s. At left in the white shirts, Chief Terry Droogan (left) and Mayor Robert Schanks (right) monitor their progress. The object of the exercise was to get the barrel completely over to the opponent's goal. Competitions were hosted by area fire departments throughout the southwestern suburbs. These contests no longer take place due to safety and liability considerations.

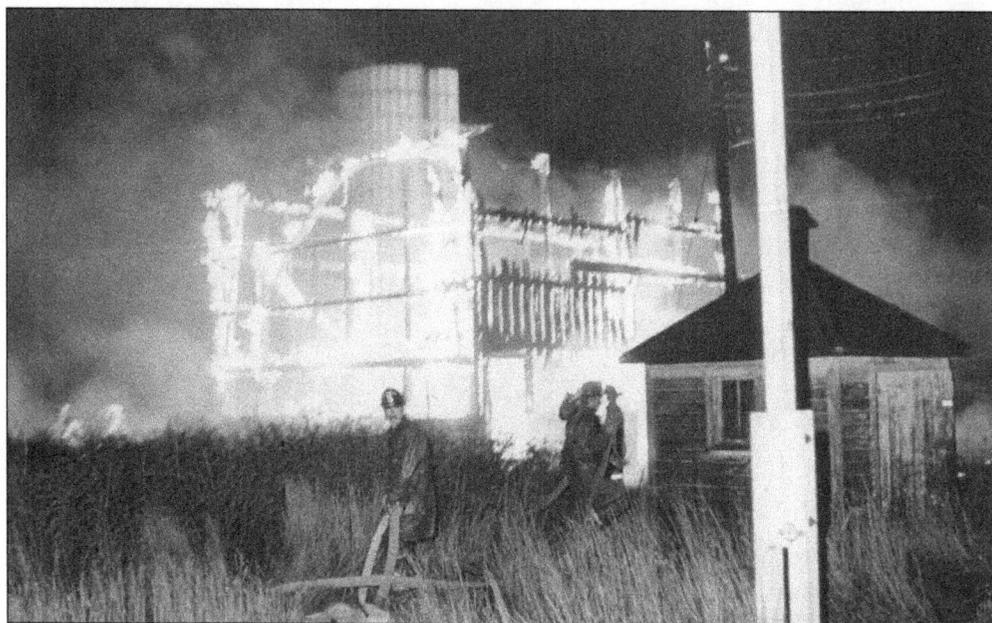

The Bolingbrook firemen battle to save a barn in 1973. The property was located on East Boughton Road, close to the present-day location of Fire Station No. 2. Lt. Ron Spindel, Bill Pheneghar, and Jim Rome maneuvered their hoses through high grass to extinguish the raging fire and protect the surrounding buildings. At this time, the Bolingbrook Fire Department was largely made up of volunteer firemen who were paid on a per-call basis.

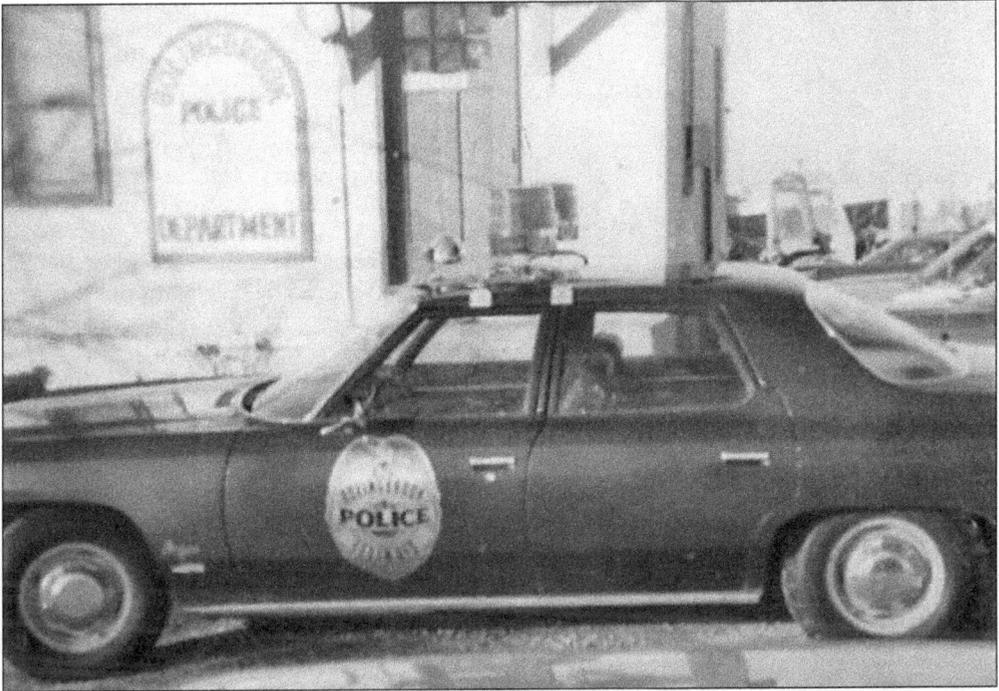

One of the early police squad cars is parked in front of the village hall after the formation of Bolingbrook's police department on July 1, 1966. The emblem on the building is a reproduction of a police officer's shoulder patch. Before the establishment of Bolingbrook's police department, police services were provided by the Will County sheriff. Edward Gaidzik helped set up volunteers and organize the first police squad, and in 1970, he was hired as the full-time chief. The first squad is pictured below; from left to right are (first row) Joseph Math, Bill Sommers, Marvin Cross, Russell Giovenco, Robert Seward, and Ray Maratea; (second row) Robert Kampf, James Franecki, Don Madden, Robert Ewald, Jim DeWaine, and Robert Morosky. Not pictured are Chuck Long, Chuck King, and Ed Girard. (Above, courtesy of Richard Ellingsworth.)

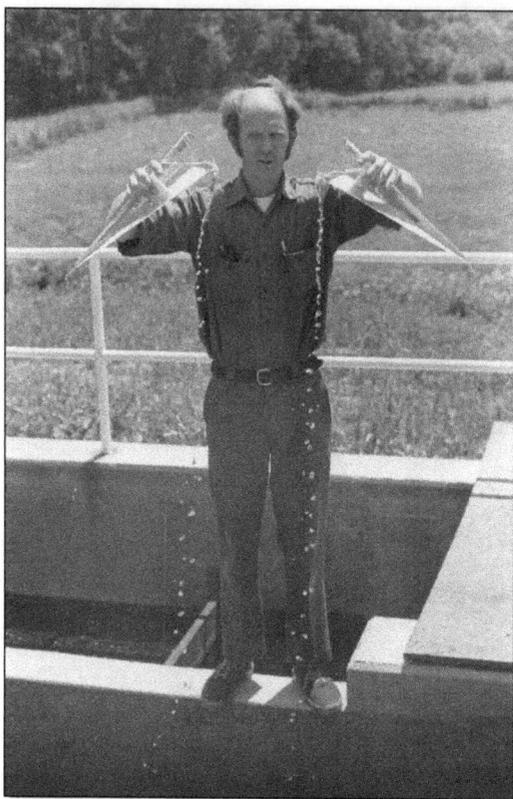

Bill and Mary Beth Moore moved to Colonial Village in February 1964, and Bill volunteered with the fire department. In 1971, he obtained his Illinois water and sewer licenses and was hired full time to open the Village Sewer Plant on Royce Road and water well near Hillcrest Cemetery. Moore retired in 2000. He also served as a scoutmaster for Boy Scout Troop 32, helping many of his scouts achieve the rank of Eagle Scout.

Bob and Jeri Morosky volunteered for the original police department. Bob was hired full time in 1968, and in 1972, the sergeant transferred to the public works department. Known as "Mr. Fest," Morosky and his crew set up village festivals. He installed Bolingbrook's first internal traffic signal at Boughton and Pinecrest Roads (1977) and streetlights in the historic district. He also designed Bolingbrook's holiday street lighting before his retirement in 1998.

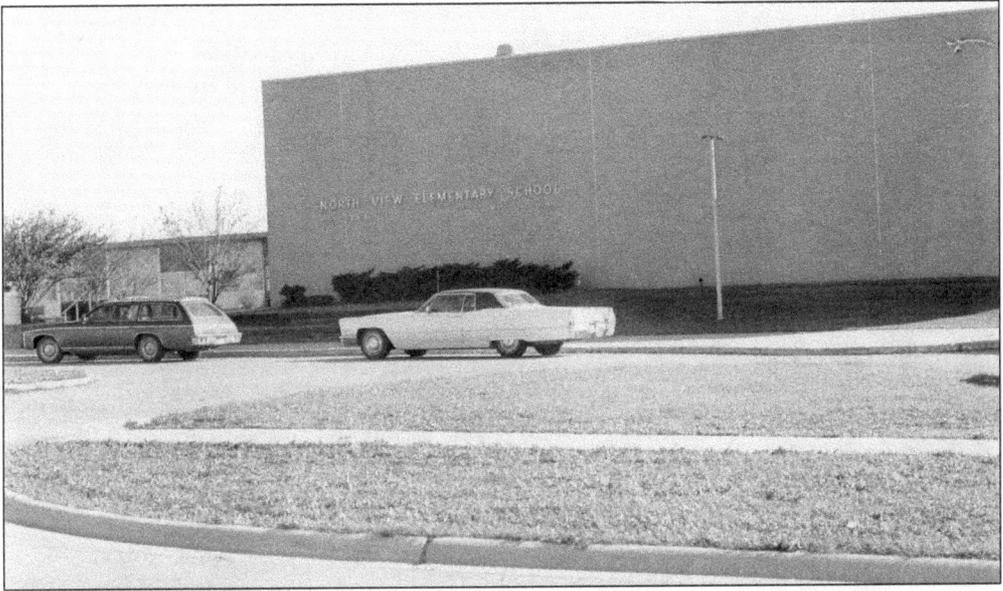

North View School, Bolingbrook's first elementary school, opened its doors on January 27, 1964. The school served as a hub of community activity, hosting governmental and club meetings, roller skating, dances, bingo, and church services. District 365U has since grown from those humble days to 12 elementary schools, five middle schools, and two high schools. North View closed in 1991, and New Song Church purchased the building for services, a Montessori school, a free health clinic, and a meeting place for 4-H.

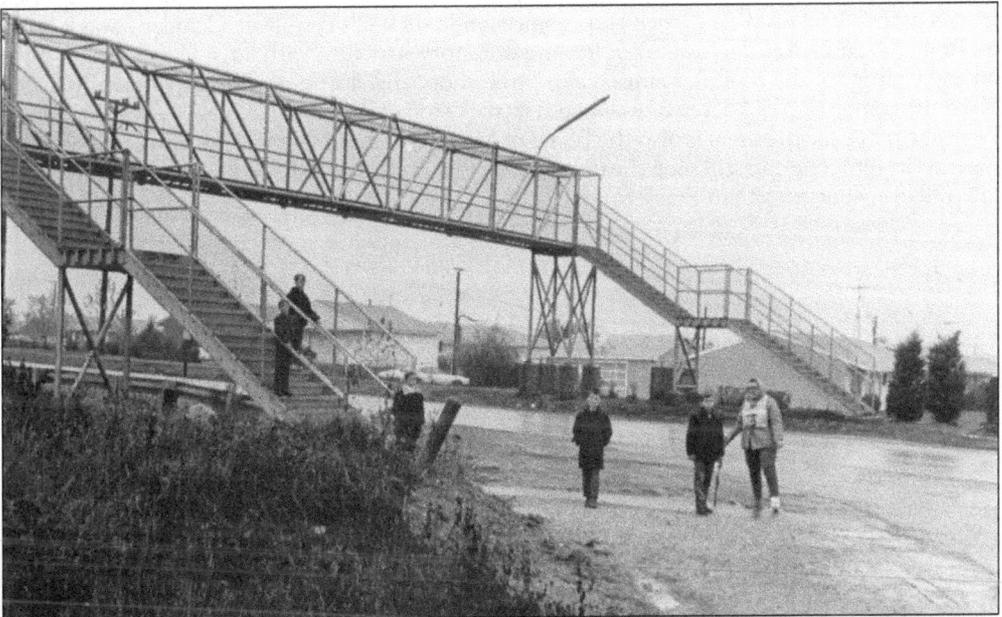

In 1963, a footbridge was built spanning Route 53 at Briarcliff Road to allow children who lived west of Route 53, in the Westbury subdivision, to cross over the busy road to go to North View School. In 1977, Route 53 was widened to four lanes, making the footbridge obsolete. It was dismantled, stored, and eventually sold for scrap. Pictured here is Mrs. Fredrickson (far right), the bridge crossing guard, with some of her charges.

33

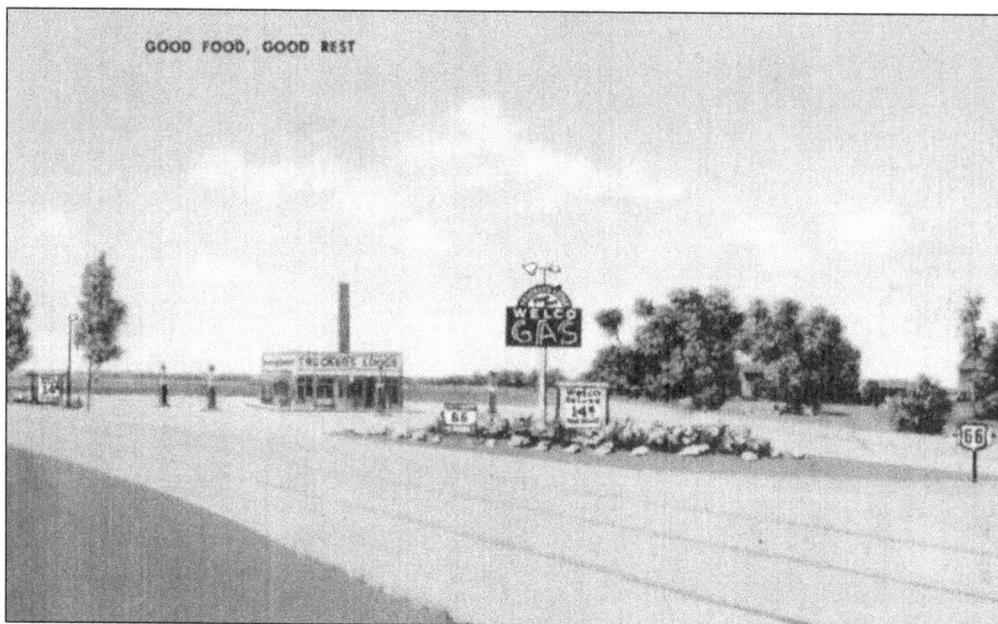

GOOD FOOD, GOOD REST

Montana Charlie Reid was a cowboy, circus performer, petroleum company owner, and a flea market proprietor. The Welco Truck Stop, named for Reid's Wells Petroleum Company, was located on Route 66 and Alternate Route 66. It was a one-story structure with large plastic Angus bulls on each corner of the roof. A lounge, café, barbershop, and sleeping rooms welcomed truckers. With the completion of I-55, easy access to the truck stop ended, and it closed. Welco Corners, a longtime name for the area, is also the home to Montana Charlie's Little America Flea Market. Opened in 1965, one can still shop the flea market every Saturday and Sunday from spring through fall. (Above, courtesy of Jon Sonderman.)

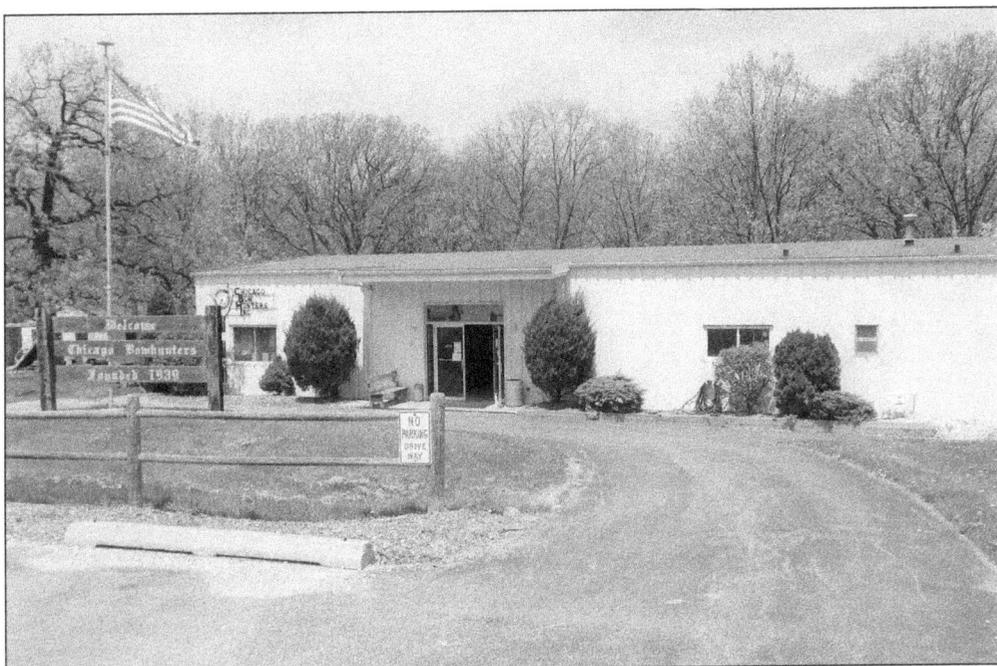

The Chicago Bow Hunters Club was founded in 1939, and moved to Bolingbrook in September 1965 after purchasing 32 acres here. The original clubhouse was moved from Oak Brook in 1966 and used until a new clubhouse was built in 1977. When the club came to Bolingbrook, its roster totaled 88 members. As of June 2014, membership has grown to 286. (Courtesy of Dale Holquist.)

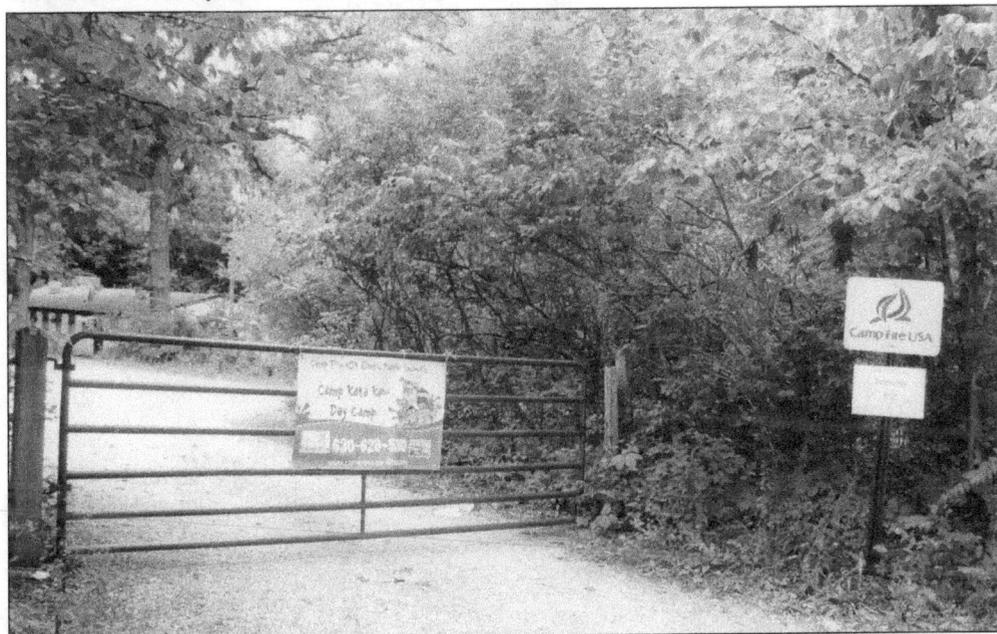

Camp Kata Kani opened in 1956, and is owned and operated by the Salt Creek Campfire Council. Located on almost seven acres near Hidden Lakes Trout Farm, the summer camp is open for boys and girls ages 5 to 15. It offers a variety of activities, including archery, fishing, field trips, crafts, games, and cook-outs.

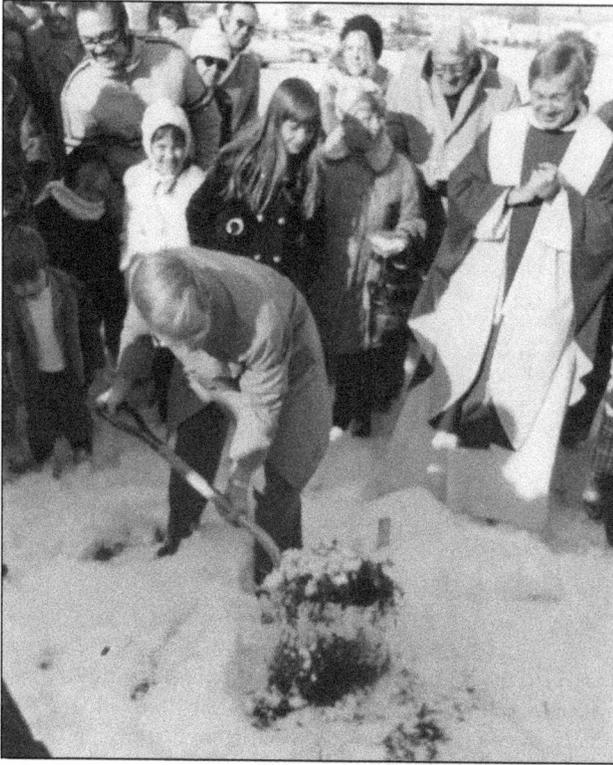

Fr. Frank Anksorus, Bishop Joseph Imesh, and many parishioners attend a groundbreaking ceremony for the new St. Dominic Catholic Church building, located at 440 East Briarcliff Road. The church was dedicated in 1982, and prior to its construction, the congregation worshipped across the parking lot in the old St. Dominic's, dedicated in 1965. This building is now St. Dominic's School.

In the early 1970s, Bolingbrook's roads were not what motorists experience today. The section of road pictured here is Schmidt Road looking north from Lily Cache Lane (formerly 107th Street). The road surface was blacktop laid down over a gravel base for a smooth ride. The stop sign has been replaced with a signal light controlling a four lane road.

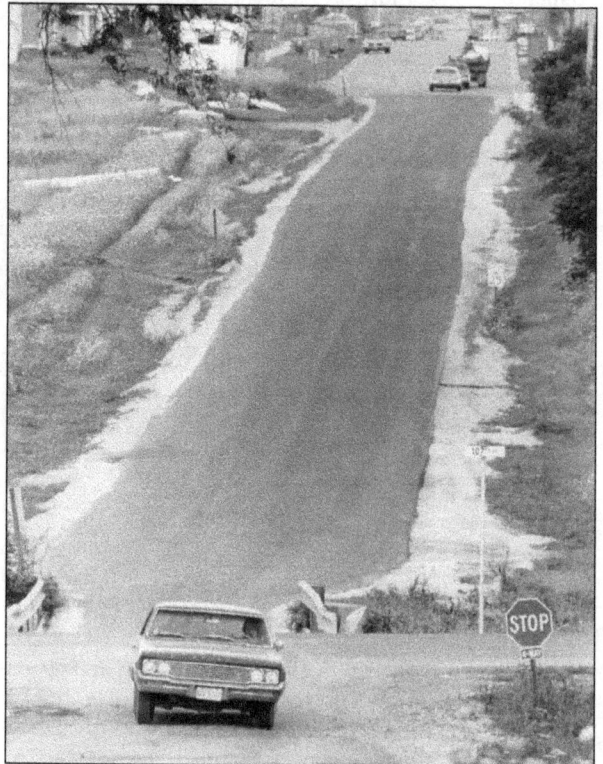

Four

SECOND WAVE

From modest beginnings, Bolingbrook grew. Incorporation brought a housing boom, and a second wave of residents added 100 children a day to the school system and increased the population to 40,000 people by the end of the 1970s. During those years of rapid growth, Bolingbrook lost its rural image, as the farmers sold to developers and moved away. The 2001 rural historic structural survey of DuPage Township had approximately 17 farm sites in the area. In 2014, only two farms remain under cultivation. Bolingbrook's expansion resulted in new and innovative programs to benefit the community; the village was among the first communities to use a 45/15 year-round school system to put school facilities to better use. An indoor amusement park and mall, Old Chicago, and an indoor wave pool showed other communities Bolingbrook was not afraid to try new ideas. The economic development commission marketed Bolingbrook using cereal boxes, board games, and Channel 11 television pledge days. New legislation, such as the Park Donation Ordinance passed by local legislators, improved community services by providing more open areas for recreation in the village. From a rural beginning, Bolingbrook grew rapidly and began to resemble the surrounding communities with all their amenities.

In 1972, Bolingbrook's second village hall opened just east of Route 53 on Boughton Road. It had room for village administration, police, planning and zoning, public works, and the village board. In 1980, a new town center opened, and the village sold the building on Boughton Road to Brook-Ridge Funeral Home. Today, the second village hall building is home to the All Saints Anglican Church.

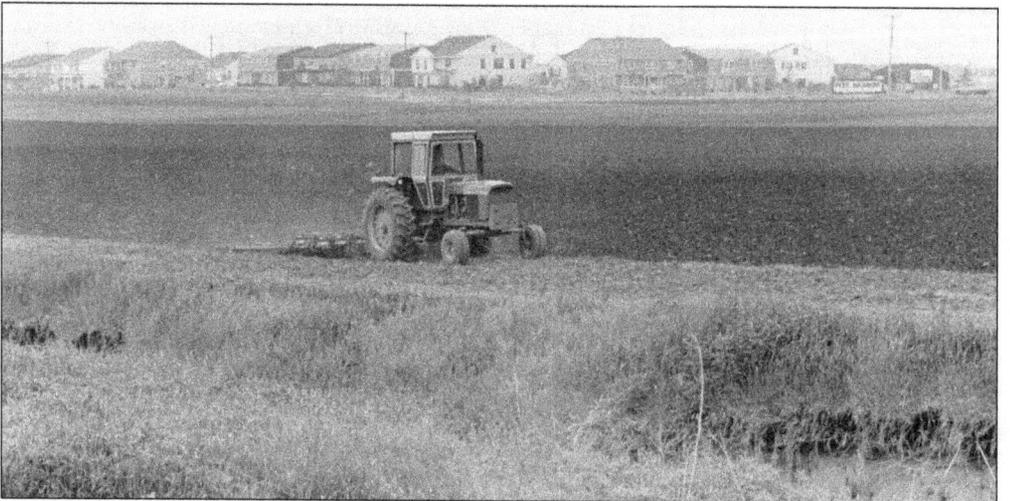

To see tractors on one side of the street and new homes on the other side was a common sight throughout Bolingbrook in the 1970s. Shown here is Lily Cache Lane just west of Route 53. With an ample amount of farmland, Bolingbrook is the perfect place for expansion.

Designed as a cereal box, the economic development commission wanted a marketing tool to let businesses know Bolingbrook was the right location for commercial and industrial development. Stressing the convenient proximity to Chicago, "New Improved" Bolingbrook would make an ideal place for manufacturing, distribution, warehouses, and office centers. Village ingredients included friendly people, excellent transportation, cooperative village government, and available land.

Want to be a wheeler-dealer? Then the Game of Bolingbrook is just the ticket. Sponsored by the Bolingbrook Jaycees in the 1980s, the game was a marketing tool to showcase Bolingbrook and its businesses. Players could buy and sell local businesses and invest in the community. Names like JEBCO Furniture, Kerkstra's Cleaners, and Chicken Licken were just a few of the properties that could be bought and sold.

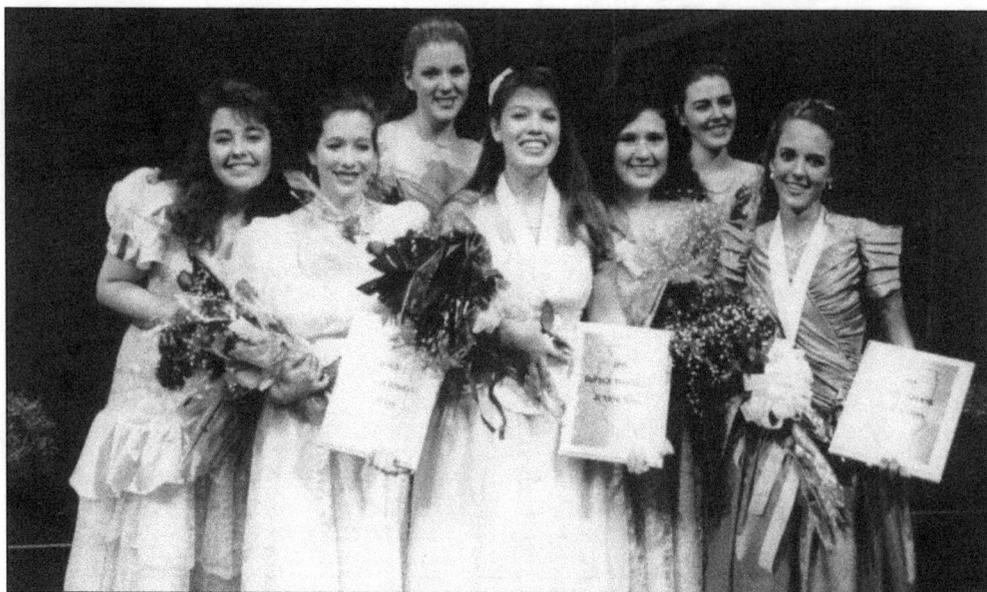

The Bolingbrook Junior Miss Program started as early as 1977. Participants are judged on scholastic achievement, interviews, creative and performing arts, poise, appearance, and physical fitness. Bolingbrook was host to the local program and eventually the state program for over 25 years. Pictured here in 1995 are, from left to right, Rebecca Bolger, Marie Rutkowski, Victoria Fisher, Manda Hamilton, Samantha Becker, Kelly Mason, and Melinda Oftedahl. Longtime supporter Kim Peterson asserts, "The program embodied a spirit of being your best self."

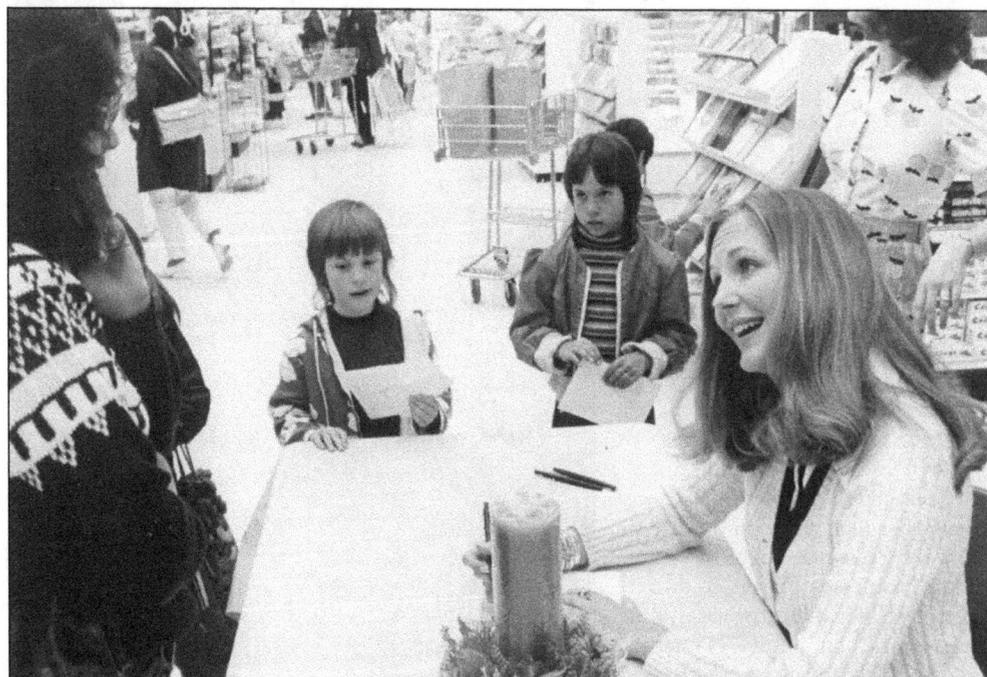

Jewel-Osco held a Bolingbrook grand opening in late 1973. Shown here is Rebecca "Becky" King at the store on Boughton Road and Route 53. King was Miss Colorado 1973 and crowned Miss America in September 1973. She was signing autographs as part of the new store's celebrations.

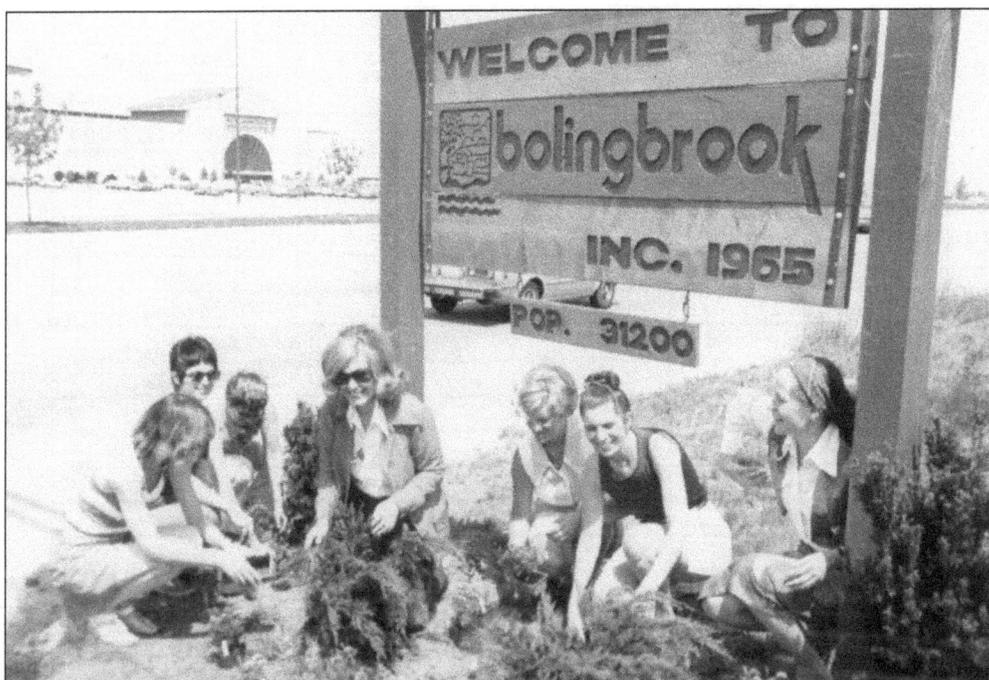

Pitch in for Pathways was the annual spring cleanup sponsored by the Bolingbrook Federated Women's Club. Volunteers planted flowers, picked up trash, and enjoyed free hot dogs supplied by the club. Notice Old Chicago in the background, the lowercased "bolingbrook," and population of 31,200, which date this photograph to the late 1970s. Bolingbrook became an official Arbor Village around 1990.

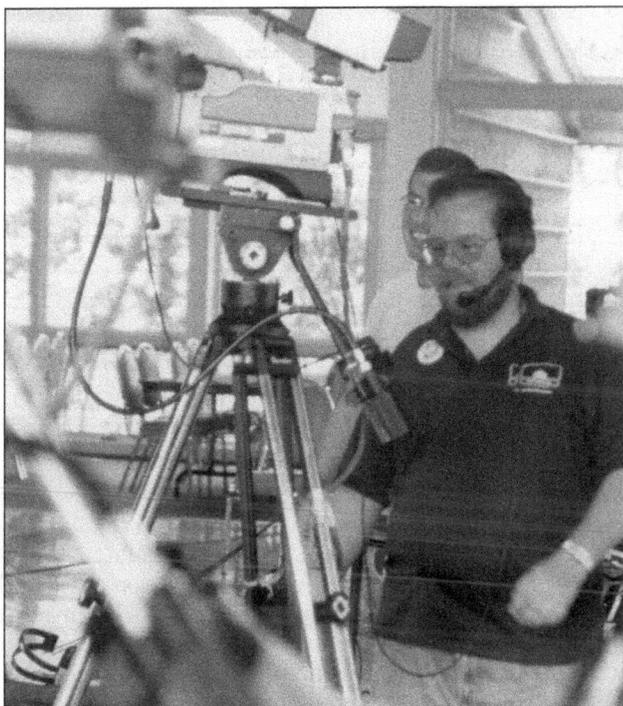

Jim Singer, president of Bolingbrook Community Television (BCT), is pictured here working a camera at the Levy Center for the American Cancer Society Telethon. In 1979, BCT was established as the Bolingbrook Video Club by Marty Rennels. Their production studio is located at the town center, and when the organization began, it videotaped village board meetings and little else. Today they record and produce numerous sporting and community events.

Single Family Detached

Subdivisions	# of Units	Start Date	Developer
Balstrode	241	1972	Kaufman & Broad
Cavallo Farm	48	1977	Kaufman & Broad
Cherrywood	385	1971	U.S.Home
Cherrywood East	416	1977	U.S.Home
Cinnamon Creek	624	1972	Kaufman & Broad
Falcon Ridge	320	1976	Surety
Feather Sound 1	80	1977	Medema
Heritage Heights	79	1978	Annico Dev
Home Run	205	1972	Pres Malone
Indian Boundary	202	1978	LBJ Dev.
Indian Oaks 10-11	290	1977	Hoffman
Indian Oaks 1-9	1042	1971	Hoffman
Ivanhoe 11	65	1979	Surety
Ivanhoe 1-5	718	1971	Surety
New American Homes	153	1976	Kaufman & Broad
Peppertree	232	1975	Kaufman & Broad
Robinhood Way 1	36	1976	Hoffman
St. Andrews Woods 1	95	1979	D.F. Hedg
Sugarbrook 5-6	275	1971	Kaufman & Broad
Winston Woods 2-5	664	1971	Centex
Winston Woods 1	76	1971	Centex
Woodleaf	111	1976	Hoffman

Single Family Attached

Subdivisions	# of Units	Start Date	Developer
Brookpoint	11	1976	Centex
Clusters	196	1975	Surety
Country Manor	292	1974	U.S Homes
Dunhill Estates	35	1979	1st Consol.
Pine Meadows	422	1972	Kaufman & Broad
Robinhood Way 1	14	1972	Hoffman
Winston Village	648	1971	Centex

Apartmments

Subdivisions	# of Units	Start Date	Developer
Brentwood	789	1971	Vavrus
Greenleaf	321	1975	Norman
Innsbruck	475	1971	Norman
Winston Oaks	16	1971	Centex

Helping to fuel Bolingbrook's population explosion was an influx of builders who saw the region as an open land of opportunity. Kaufman and Broad, Hoffman, Surety, and Centex all had substantial housing developments in the area. From 1970 to 1979, more than 9,400 units of housing were built in Bolingbrook. By comparison, the 1960s saw 1,252 units built. The official 1970 population was 8,504; by 1978, the population was 34,686.

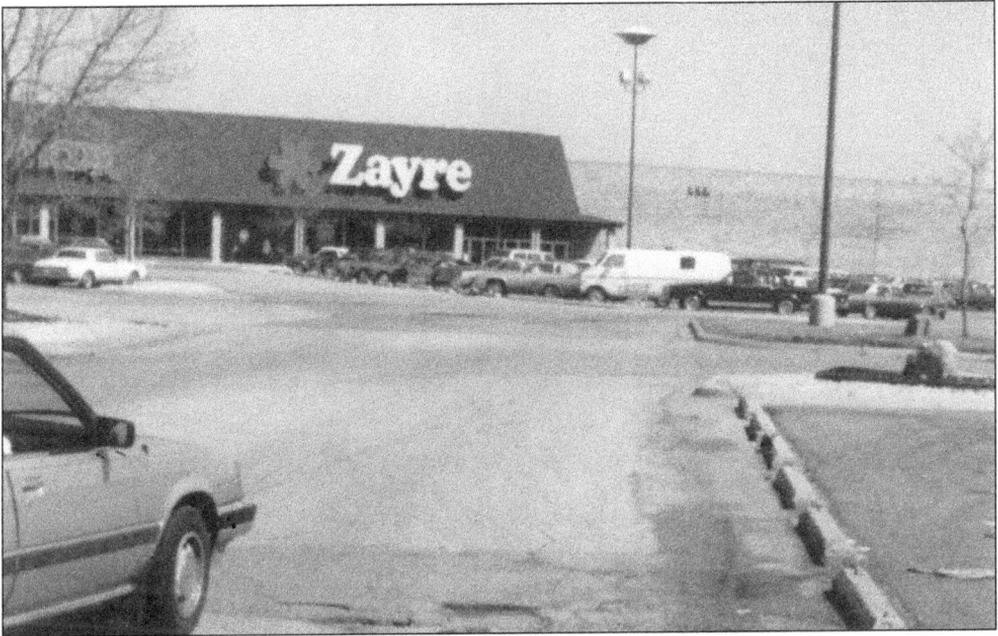

The 1970s saw an enormous population and housing explosion. In 1971, the Zayre store opened in what would become the Bolingbrook Commons shopping center. By June 1972, an A&P grocery store and 12 other businesses would open in the center. The Oaks Plaza opened in 1975, North Pinecrest Plaza in 1977, and the Indian Oaks Plaza (pictured below) in 1978. Independent business owners saw Bolingbrook as a great place to locate.

For The Month Of MARCH

Double Stamps

For The Month Of March
On All Tires

'BOB' HERB'S SHELL
SERVICE

RT. 53 & 66 LEMONT, Ill. 739 7854

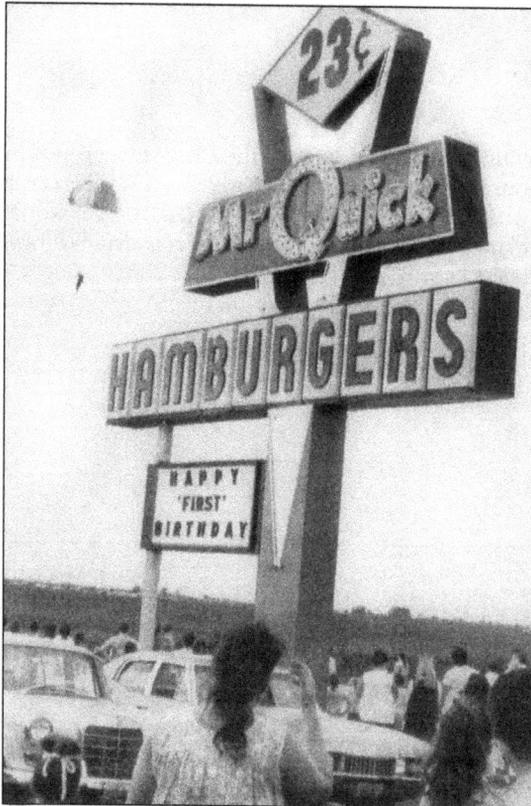

Bob Herb's Shell Station was one of the earliest businesses in Bolingbrook, dating to the 1960s. This service station, located on Route 53 and Frontage Road, is still operating at that location today, although ownership has changed several times. When the station opened, it offered customers towing service, repairs, and—wonder of wonders—free air. (Courtesy of Beacon Newspaper.)

In 1969, Mr. Quick hamburger restaurant opened on the corner of Route 53 and Commons Drive. It was one of Bolingbrook's first fast-food restaurants. Pictured here is Jerry LoPiccalo parachuting to the ground to celebrate Mr. Quick's first birthday. It remained Mr. Quick until 1984 and is currently Family Square Restaurant.

44

Five

OFF TO SCHOOL

DuPage Township pioneers valued education, establishing Hickory School in 1832 and continuing a tradition of academic excellence to this day. In 1953, the township had nine one-room school districts with 10 schoolhouses, 375 pupils, and 22 teachers. That same year, voters passed a $300,000 bond to build a centralized school building to house all the children. A contest to name the school district was won by a student, Donna Kay Chilvers, with the winning entry Valley View School. In 1964, North View School was the first Bolingbrook school to open in District 96. Once Bolingbrook incorporated, the population grew rapidly. In 1968, faced with enrolling up to 100 students a day and mandatory kindergarten, the school board proposed a year-round school system. When implemented in 1970, neighborhoods were assigned a track, either A, B, C, or D, according to a four-tiered track calendar. The system had students attending school in a cycle of 45 days in and 15 days out on four different tracks year-round. The 45/15 school system lasted for 10 years. In 1980, the school district returned to the traditional nine-month schedule because of declining enrollment and teacher union contract considerations. Richard Kavanagh was school board president at the time.

About the same time, high school students attended Lockport West High School, but pressure to separate from Lockport prevailed, and a new High School District 211 was formed. Lockport West High School became Romeoville High School. In 1972, voters overwhelmingly passed two school issues: combining elementary district 96 and high school district 211 and issuing bonds to build more schools. Hence Valley View School District 365U was born, and all schools were on the year-round system. Currently there are two high schools, five middle schools, twelve elementary schools, an early childhood center, the Phoenix Experience, and the Secondary Transition Experience Program in Valley View School District 365U. Photographs in this chapter are courtesy of Valley View School District 365U and the Historic Preservation Commission collections.

PUPIL CALENDAR

VALLEY VIEW 45-15
CONTINUOUS SCHOOL YEAR PLAN

Developed by
Research & Development Office
Valley View School District #96
Lockport, Illinois

Group A Group C
Group B Group D

ECD — Emergency Closing Day

© Valley View School District #96 — 1971

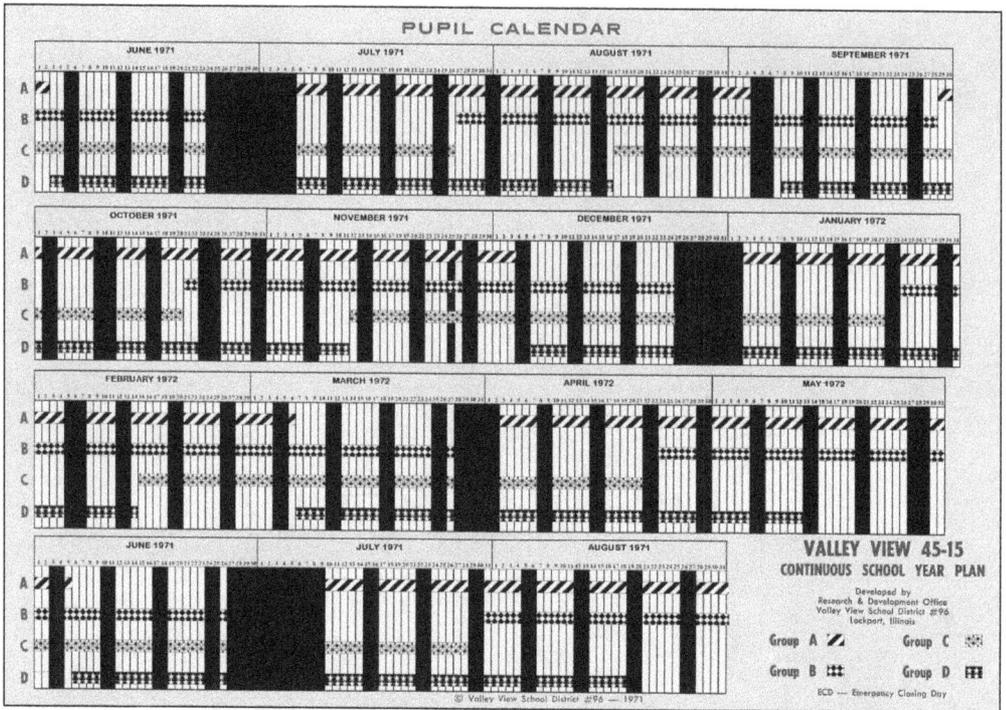

This chart of the 45/15 school system shows the complexities that families with school-age children had to deal with. Their routines had to change to meet the demands of the system. For working parents, daycare issues had to be resolved, and vacations did not necessarily have to be taken during summer months. Teachers benefited by having a year-round job or other work schedule, and town employers would hire students according to their off-track availability.

After consolidating one-room schools into the Valley View School District, Ken Hermansen (left) was hired as the first principal and sixth grade teacher of Valley View School. He became the first superintendent and was instrumental in starting the 45/15 system. During the transition to year-round schools, A. Vito Martinez (right) served as the president of the seven-member Valley View School District Board of Education. West View Middle School was renamed A. Vito Martinez School in 1991.

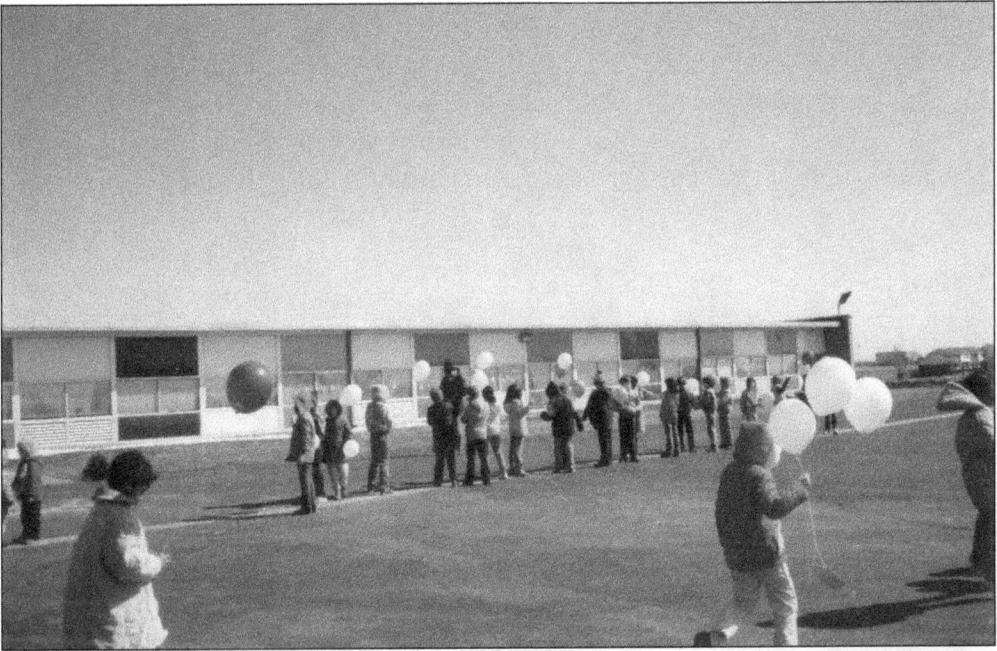

Students at North View School prepare to launch postcards by balloon. Cards were returned from Illinois and Indiana, giving the students a great lesson in geography and communication. North View School remained open from 1964 through 1991; beginning with grades one through eight, it later housed early childhood and special education students in addition to kindergarten through grade five.

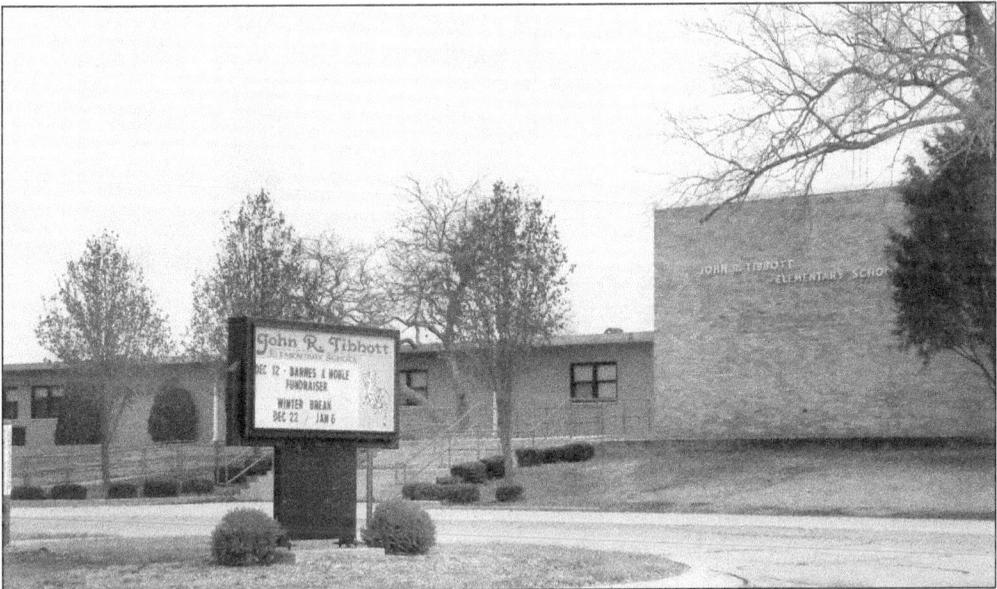

John R. Tibbott Elementary School, formerly Brook View School and Bolingbrook's second elementary school, opened in the Colonial Village subdivision in February 1969. The school was renamed John R. Tibbott in 1991 after its longtime principal, who served from 1973 until his retirement in 1988. The school is known for its cultural festivals, produce garden, peace pole commemorating 9/11, and the No Excuse program.

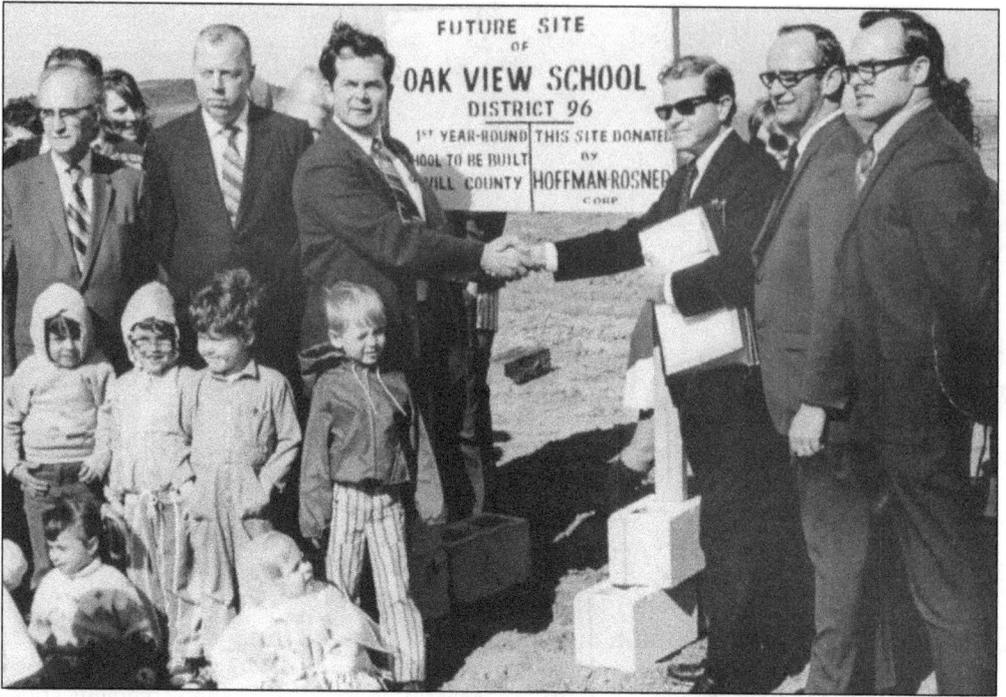

The 1972 groundbreaking for Oak View School took place in the Indian Oaks subdivision. It was the first school constructed with the open classroom concept—classrooms without walls. A fire partially destroyed the school on New Year's Eve 1980, after which the building was renovated. It is still open today. One of the major reasons Illinois lawmakers passed sprinkler requirements in schools was the Oak View fire. In 2008 and 2009, Oak View School was a Spotlight School, receiving an award for academic achievement from the Illinois State Board of Education.

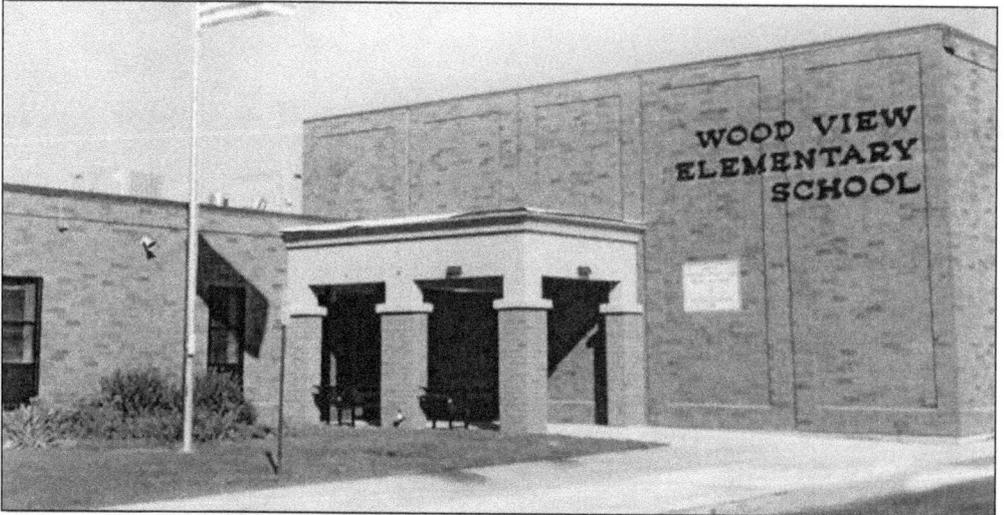

In the 1987–1988 school year, Wood View School was awarded a Certificate of Merit for progress toward excellence in education by the US Department of Education's Elementary School Recognition Department. This award is displayed at Wood View along with a letter from Gov. James Thompson congratulating the school. Wood View opened in 1974 and is located in the Winston Woods subdivision.

The dedication plaque for Bernard J. Ward School features a painting of Ward. The school opened in 1975 for grades six, seven, and eight. The school is named after Bernard J. Ward, who was a board member of the original School District No. 96 for 14 years. His wife, Eileen, also taught in the district for over 48 years. In 2004, the school was converted to house kindergarten through fifth grade. (Courtesy of Independence School.)

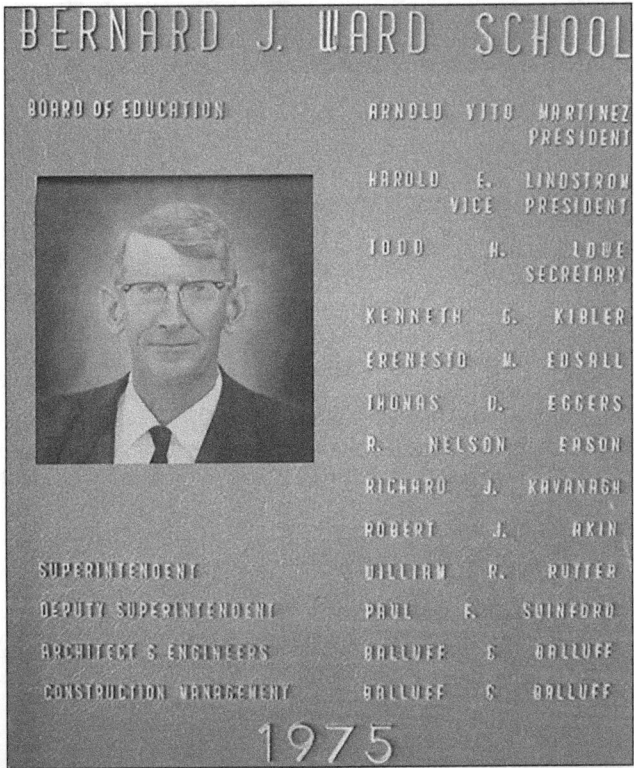

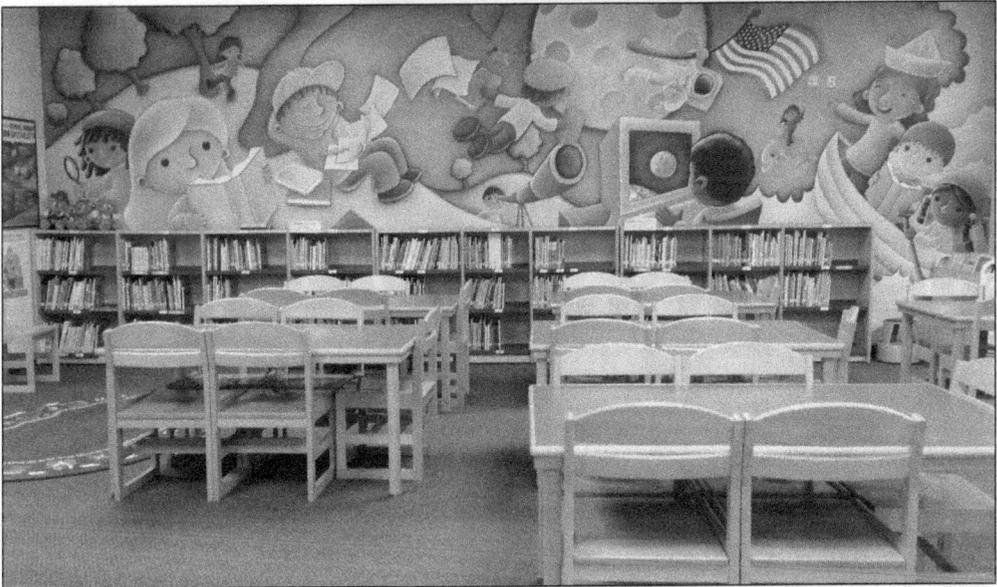

A mural painted in the library of Independence School represents its opening in 1976 during the celebration of the United States bicentennial. The site first housed the Bolingbrook Park District White House headquarters, which was torn down. Bill Kurtis, noted television journalist from Independence, Kansas, was the speaker at the dedication. Bolingbrook's bicentennial commission buried a time capsule on the school site to be opened in 2076. Originally built with the open concept, the school has been renovated back to a traditional classroom style.

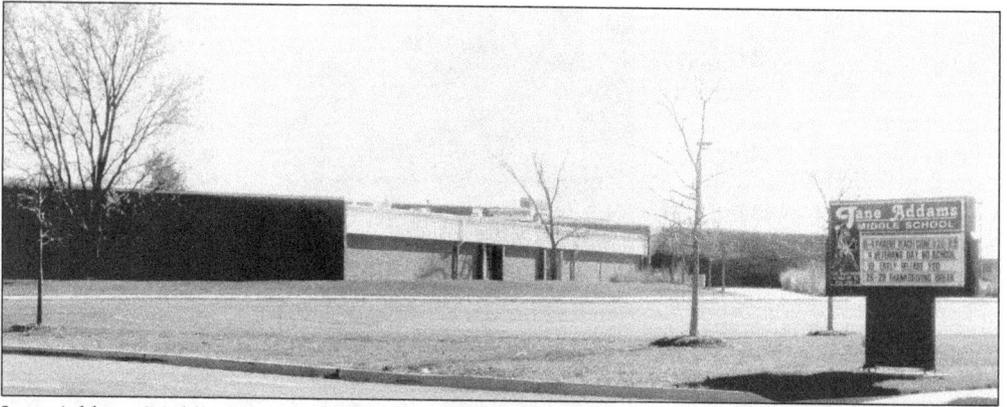

Jane Addams Middle School opened in 1976. The school is named after Jane Addams, who with Ellen Gates Starr founded the world-famous social settlement Hull House in Chicago's Near West Side in 1889. Known for her peace efforts, Addams won the Nobel Peace Prize in 1931.

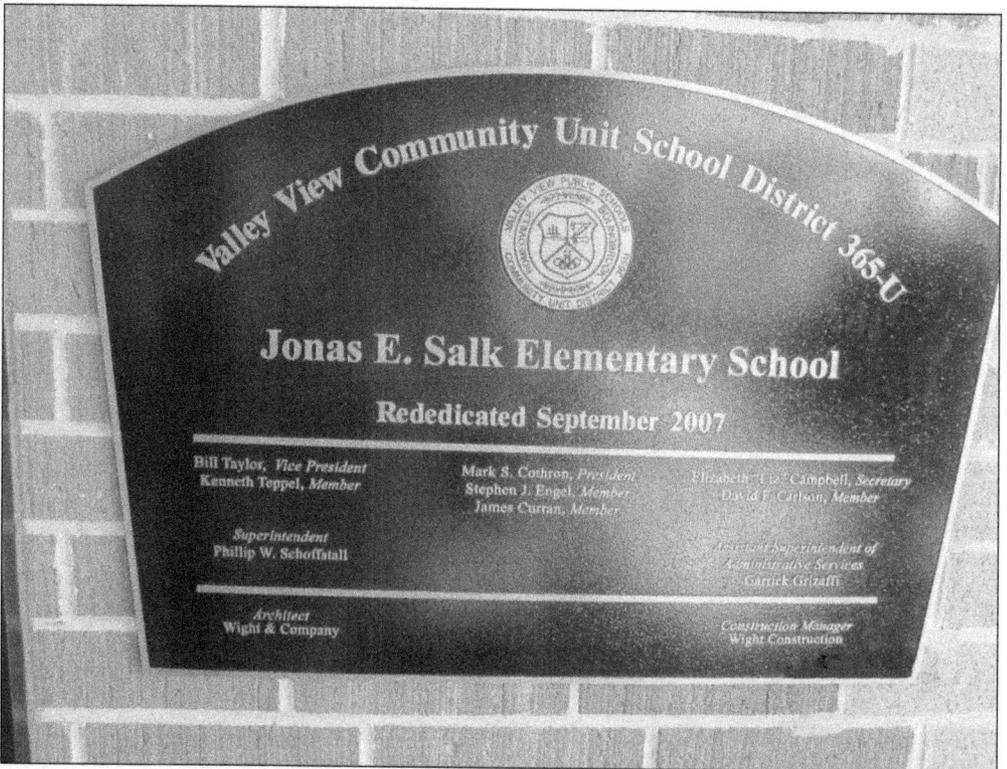

Opened in 1977, Jonas Salk Elementary School is named after medical researcher and virologist Jonas Edward Salk, who discovered and developed the first successful polio vaccine. Jonas Salk School currently has 671 students in three different programs: general education, bilingual education, and Challenge. Jonas Salk has been one of the locations for the district's Challenge program since 2004.

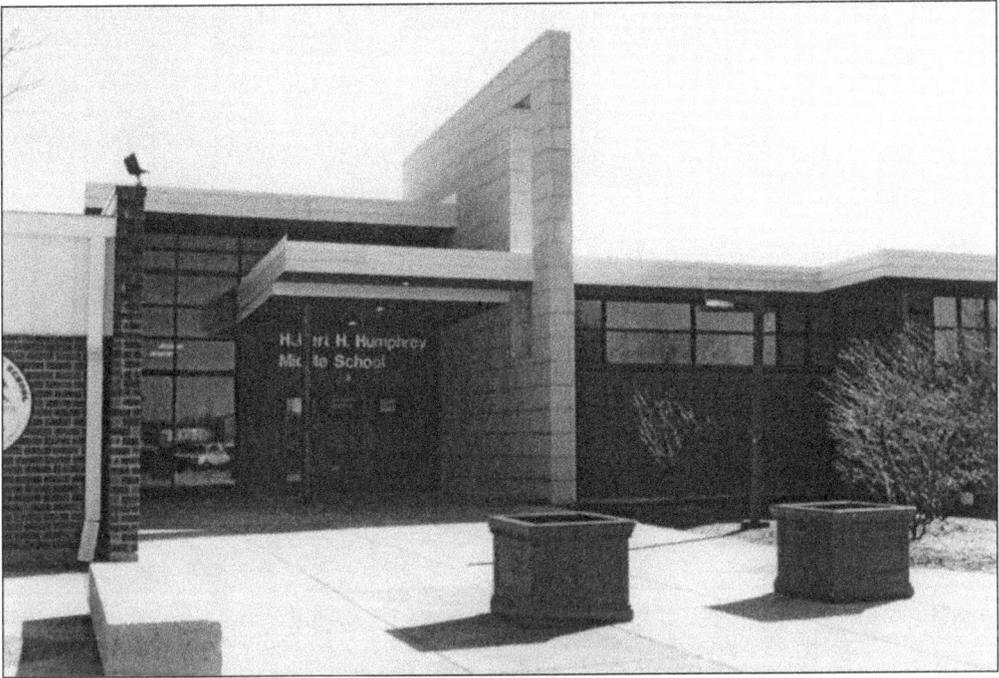

Hubert H. Humphrey Middle School, located on Falconridge Drive in eastern Bolingbrook, opened in 1978. It was the third middle school, housing grades six through eight. Humphrey's school colors are forest green and gold with a warrior mascot. Hubert H. Humphrey was a senator from Minnesota and the 38th vice president, under Lyndon B. Johnson, from January 1965 to 1969.

During construction of a new school on the west side of Bolingbrook that was to be called Big Rock, Jamie L. McGee, a seventh and eighth grade teacher and math specialist, died. Upon its opening in 1980, the board of education named this new school after McGee in recognition of his dedication and contributions to the students of the Valley View School District.

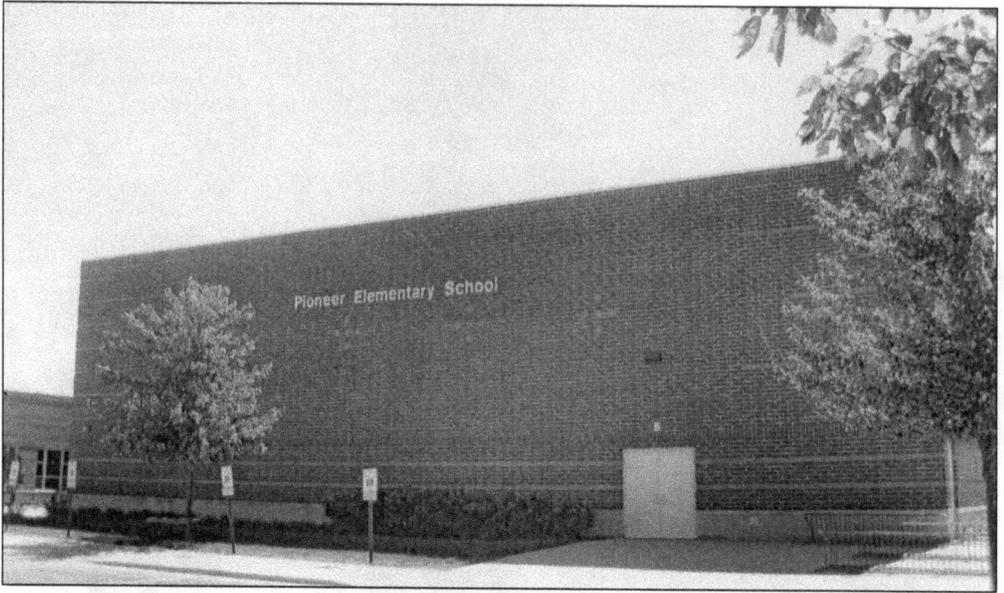

Pioneer School, located near the Indian Chase Meadows Park west of Weber Road, was dedicated on October 8, 2000. Enrollment is 850 students in kindergarten through eighth grade, the school mascot is a timber wolf, and their colors are silver, blue, and gold. The name commemorates the early settlers of the area.

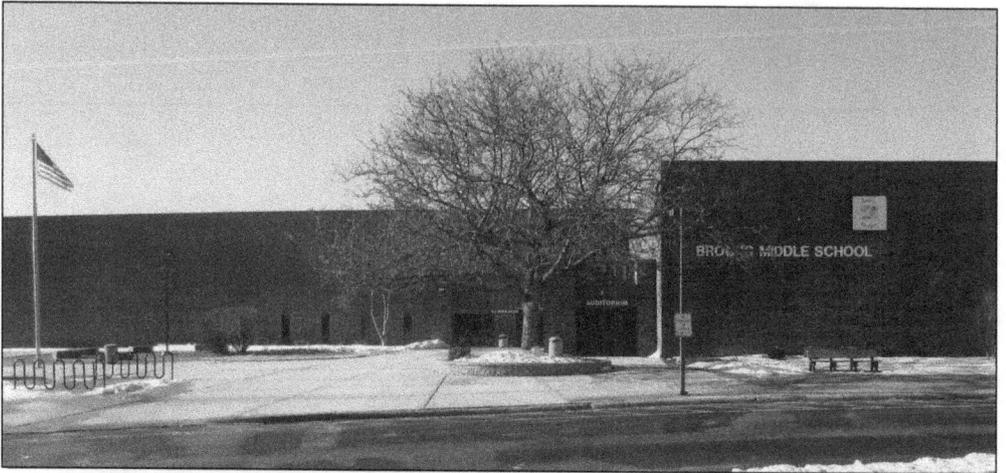

Brooks Middle School is Bolingbrook's newest middle school, located in the old Bolingbrook High School and opened in 2004. It was the state's first middle school to receive a National Counseling Award. RAMP (Recognized ASCA Model Program) designation was awarded to Brooks Middle School's counseling department by the American School Counseling Association in 2014.

In 1974, the original Bolingbrook High School was built. In the 1975 yearbook, *Treasures*, were photographs that compared the school to a ship. The building was the "hull partially completed, set sail on August 26, 1974. The Cargo: students filled with pride and ambition. Destination: the future." This tied in with their pirate mascot, the Bolingbrook Raiders.

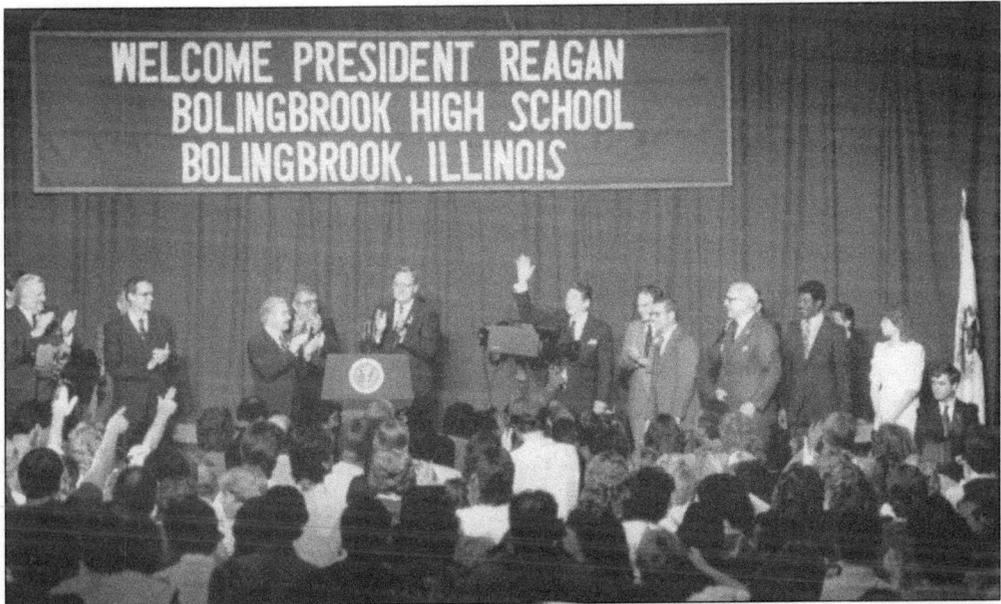

On October 16, 1984, Pres. Ronald Reagan spoke at Bolingbrook High School, congratulating the 49 students receiving the Presidential Academic Fitness Award. Gov. James Thompson, on the right, introduced the president to the excited student body and guests. President Reagan was given a No. 1 Raider jersey. An asphalt road was built for Reagan to go directly from his helicopter to the school by limousine.

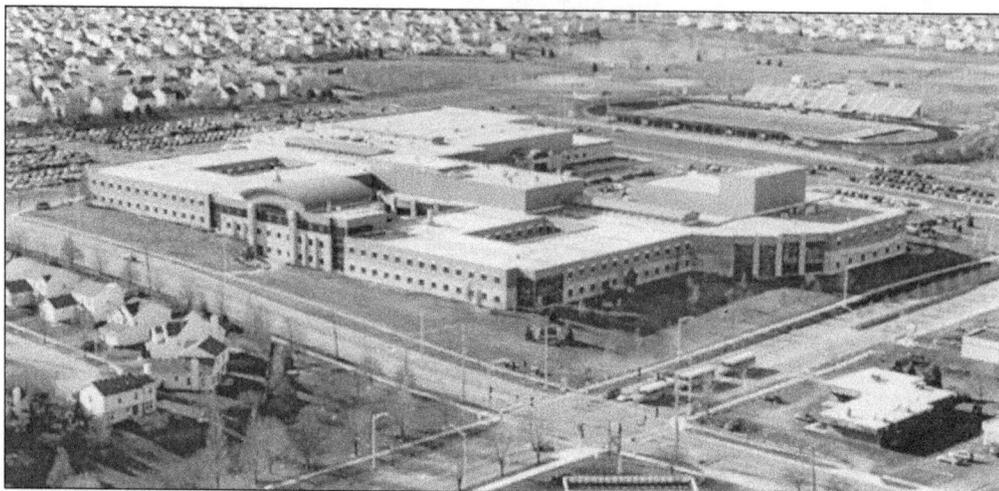

Opened in 2004, the new Bolingbrook High School is 562,000 square feet on 72 acres. The three-story brick, concrete, and masonry building has massive windows allowing for naturally lit concourses. Before the new high school was built, many Bolingbrook students were bussed to Romeoville High School. A referendum overwhelmingly passed, allowing Bolingbrook students to be housed in one facility.

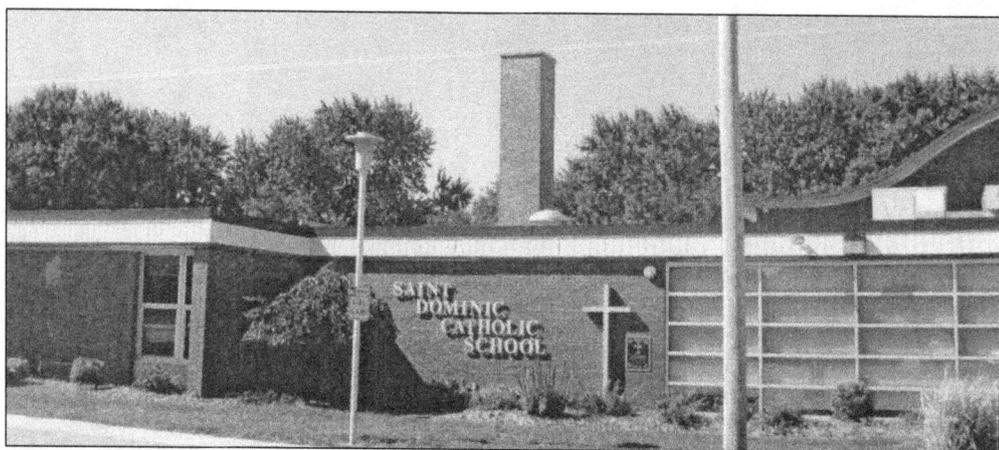

St. Dominic School opened its doors in 1966 for grades one through three. The school added grades in subsequent years, until by 1976 it went from grades one through eight. The school gym was utilized on Sundays for masses and other church services until a permanent church was built across the parking lot in 1982. St. Francis and St. Dominic Parishes share the same school facilities. Over the years, St. Dominic School has won numerous awards for academic excellence.

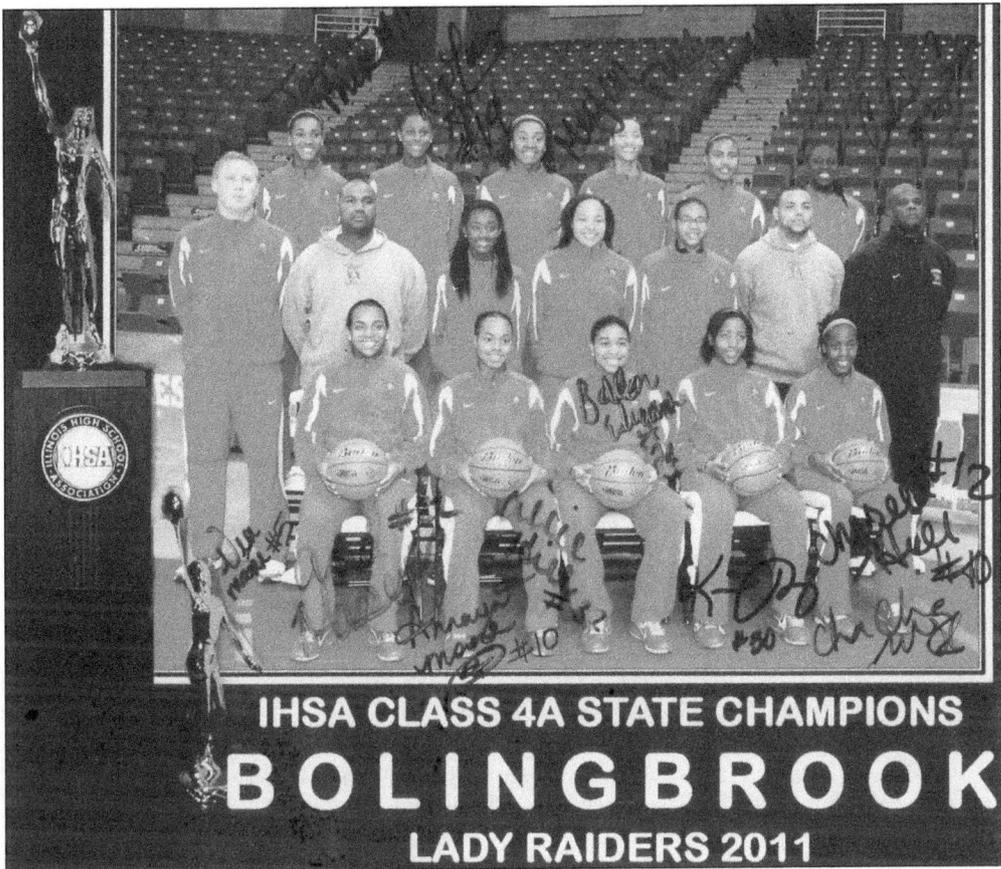

IHSA CLASS 4A STATE CHAMPIONS

BOLINGBROOK

LADY RAIDERS 2011

The year 2011 was a benchmark for Bolingbrook High School sports. On March 5, 2011, the Lady Raiders basketball team defeated Zion-Benton 71-42 to win the Class 4A Illinois state championship. This was the third consecutive state basketball championship for the Lady Raiders, who earned their first in 2006. November 26, 2011, saw the Raider boys' football team emerge victorious, defeating Loyola Academy for the Class 8A Illinois state championship, posting a winning score of 21-17.

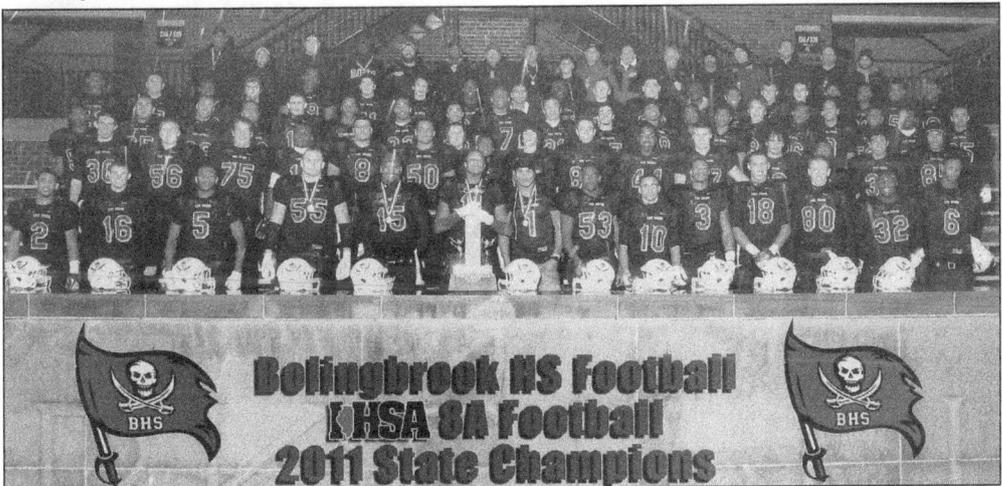

Bolingbrook HS Football
IHSA 8A Football
2011 State Champions

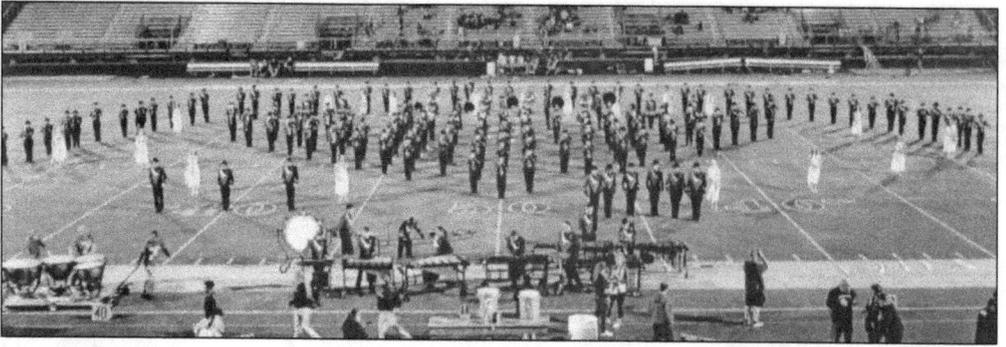

The Bolingbrook High School music department has been very active over the years, having grown into a large performance program, including four choral ensembles, two marching bands, one pep band, three jazz bands, and six concert bands. The BHS Sunrise Singers have received the honor and distinction of being selected to perform at the Illinois Music Educators Association Allstate Performance in January 2015. Most recently, the Marching Raiders took first place in the Wheaton Marching Band Festival in 2014, and Jazz Band 1 has received a first-place rating at the Western Illinois Jazz Festival and the Annual Jazz in the Meadows competition. (Both, courtesy of the Bolingbrook High School Music Boosters.)

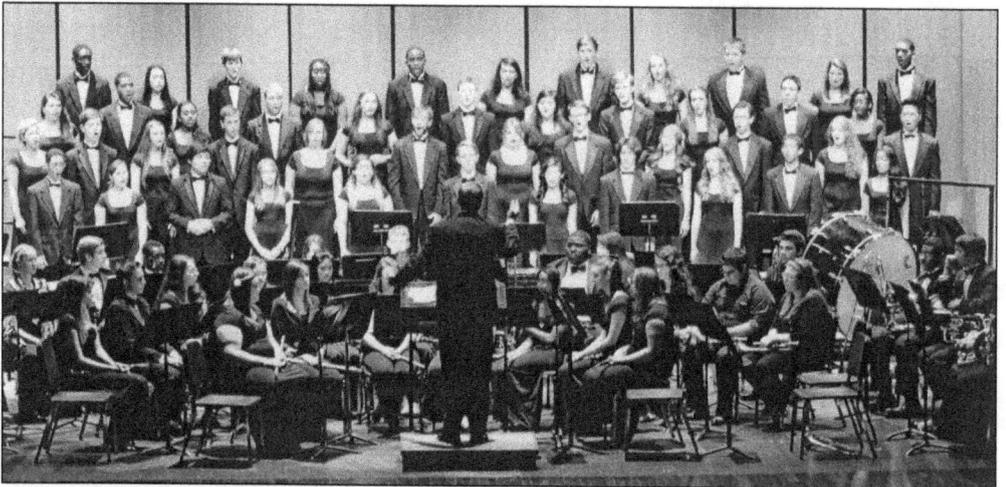

Six

Readers, Players, and Flyers

Bolingbrook was growing rapidly. As a new community comprised of a young population, the residents wanted lots of opportunities for their families to grow without traveling great distances. Fountaindale Library offers many programs, a large computer lab, and technology for all ages. On the lower level of the library is Studio 300. This state-of-the-art digital media center includes sound- and video-recording centers and production tools including cameras, lights, and microphones. There is a bookmobile that travels to specific sites within the village, including schools and the senior center, to provide library materials to those who may not be able to get to the facility.

Innovation has always been the trademark of the Bolingbrook Park District, from providing recreation for students on the 45/15 year-round school system to opening the first indoor wave pool and the green Hidden Oaks Nature Center. It is a two-time National Gold Medal Award winner for excellence in parks and recreation management. John Annerino served as park district president for about 25 years and laid the groundwork for many of the programs. He went on to become a Will County board member and chairman and DuPage Township supervisor. The Bolingbrook Athletic Council, established in 1976, is comprised of nine youth sport organizations for the purpose of coordinating field usage, coaches' certifications, and facilities assignments through the Bolingbrook Park District. Each organization is independent of the park district and financially self-sufficient.

Bolingbrook's Clow International Airport offers residents the opportunity to explore aviation. The airfield was established in 1957 and operated by Oliver Boyd Clow, who affectionately called it an international airport. When it was surrounded by Bolingbrook, Clow sold off several pieces of land for retail use and finally agreed to annex into Bolingbrook. Wiseman-Hughes, a suburban builder, wanted to buy the airport to build homes and more retail. The village board at that time wanted it to remain an airport and authorized the purchase of the 75 acres for $13 million. As a courtesy to Clow, the board renamed the airport Bolingbrook's Clow International Airport.

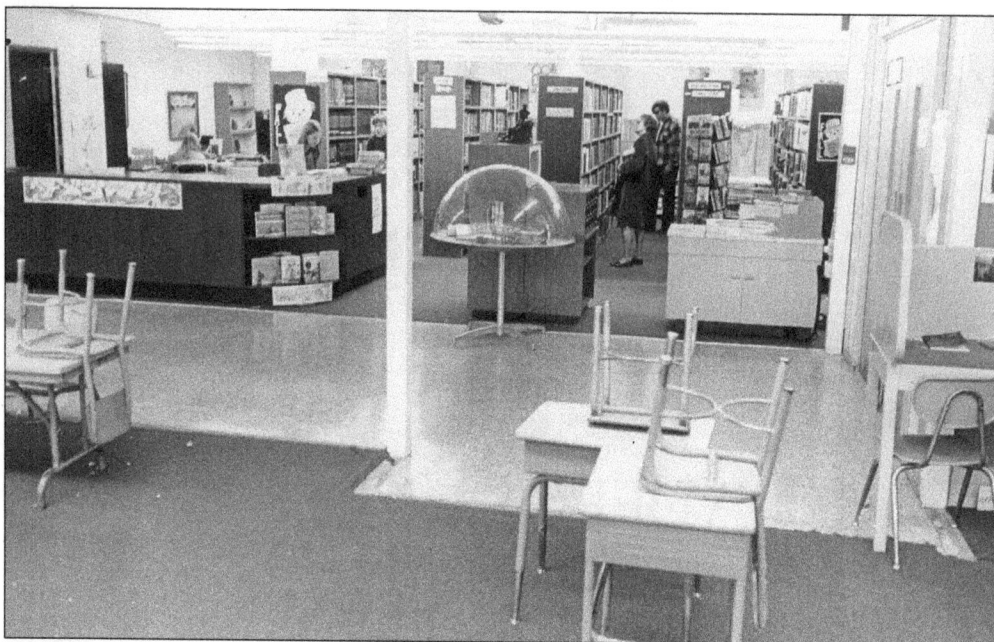

The Fountaindale Public Library District was officially created on January 20, 1970, by a public referendum supported by the Romeoville and Bolingbrook Jaycees. The first five years, the library was housed in a classroom corner at Park View School, now R.C. Hill Elementary School, in Romeoville. This tiny library opened to the public at 3:15 p.m., after school was dismissed, and stayed open until 9:00 p.m. Mary Healy served as its director.

In 1972, a bond referendum was passed by a 2-1 margin authorizing construction of two identical libraries, one in Romeoville and the other in Bolingbrook. Bolingbrook's Fountaindale Library opened in September 1975 on Briarcliff Road. The buildings were purposely oversized to accommodate the Valley View School District administration in Romeoville and DuPage Township offices in Bolingbrook.

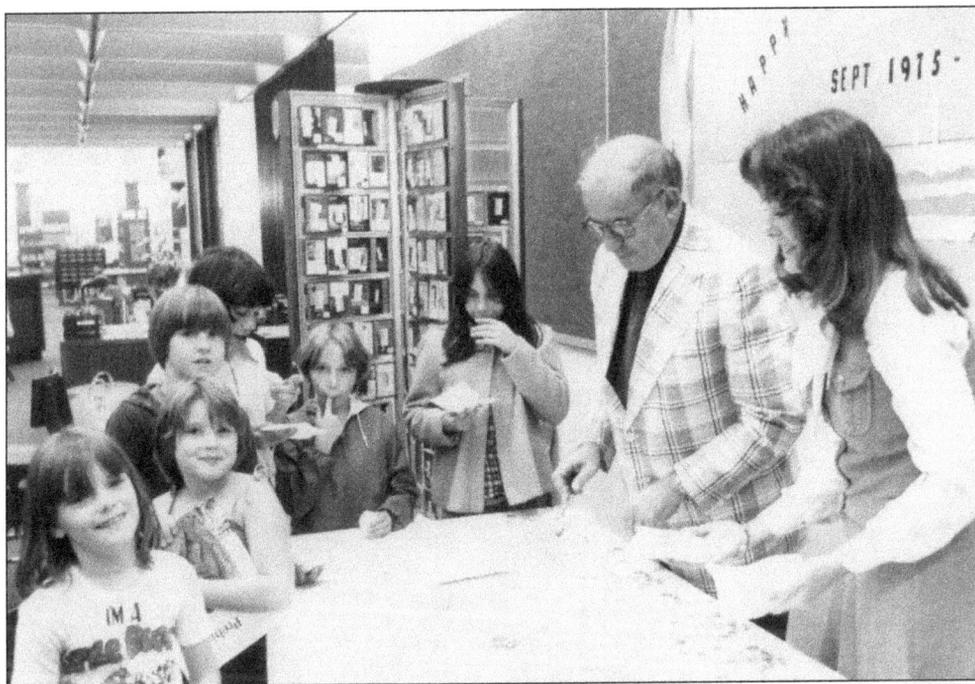

Alex Todd, Fountaindale Library's first full-time director, is pictured here cutting a cake for children at the library's first anniversary, in September 1976. Todd was hired as director in 1972 and retired in June 1997. The name Fountaindale was submitted by Jim Bingle in the district naming contest. The name stems from an area along the DuPage River with natural springs.

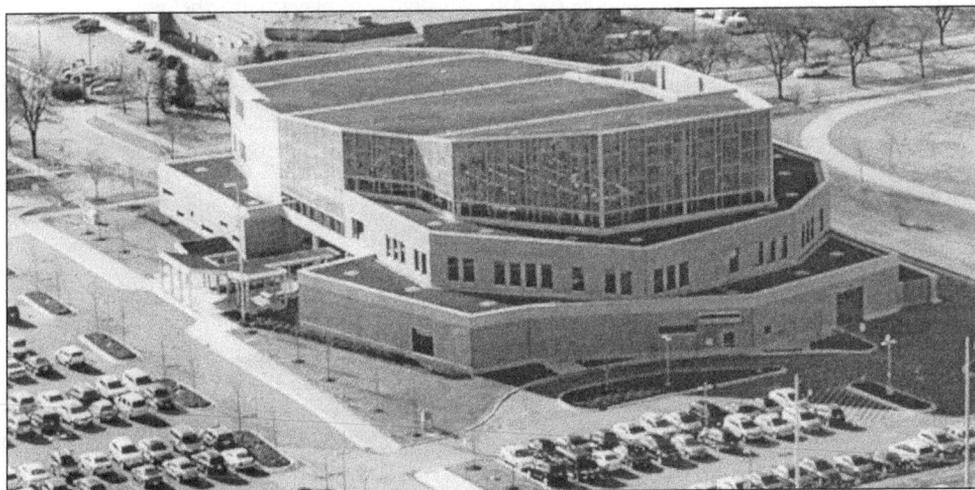

In 2008, Bolingbrook's Fountaindale Library barely passed a referendum authorizing $43 million for construction of a new library. With the passage of the referendum, changes were made to the district's boundaries, annexing Romeoville's library into the White Oak Library District. Construction of the new building began at the library's Briarcliff Road location in 2009. The new building opened in 2011, with the parking area completed a few months later.

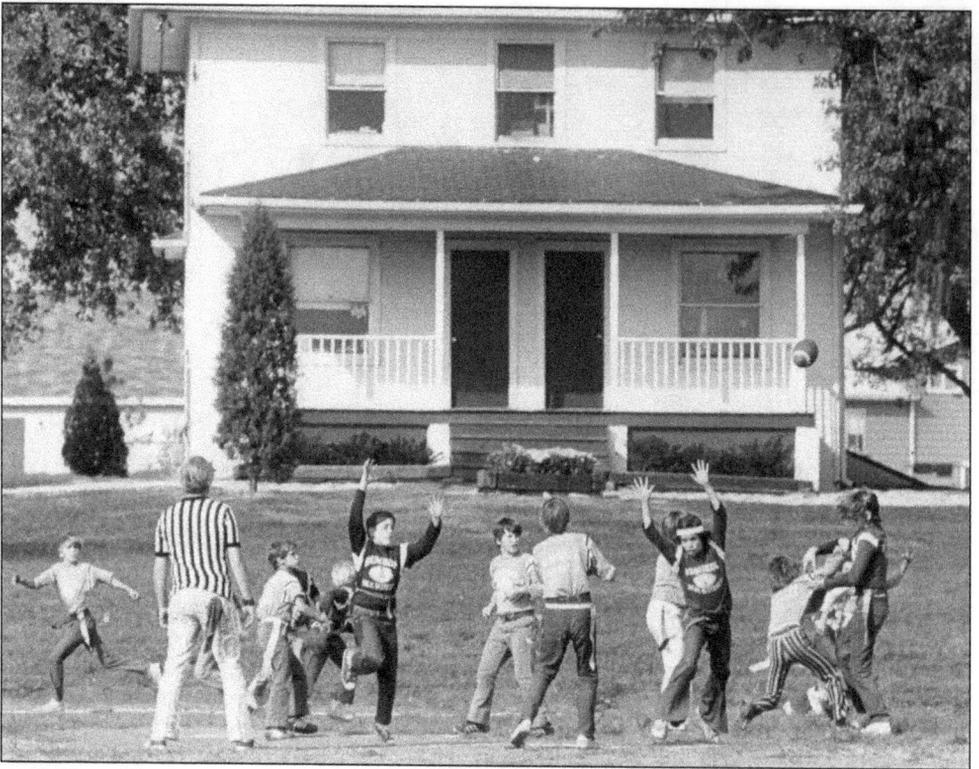

Children are pictured above playing at the White House, Bolingbrook's first park district headquarters and recreation area. The house had been the Bill Mather farmhouse, which was bought by Kaufman and Broad developers and donated to the village. With funds from Johnson & Johnson, the house was renovated into the district headquarters in 1970. Initially, residents volunteered to build play areas around the White House such as the football field and playground (below). During the winter months, the area was used for ice skating and hockey. The site was later sold to the Valley View School District, and the house was torn down for Independence School.

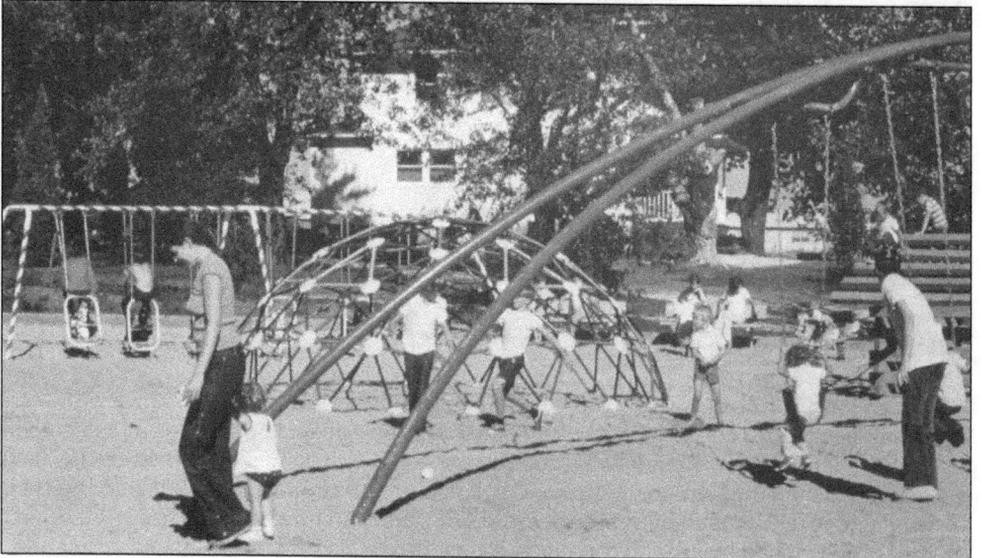

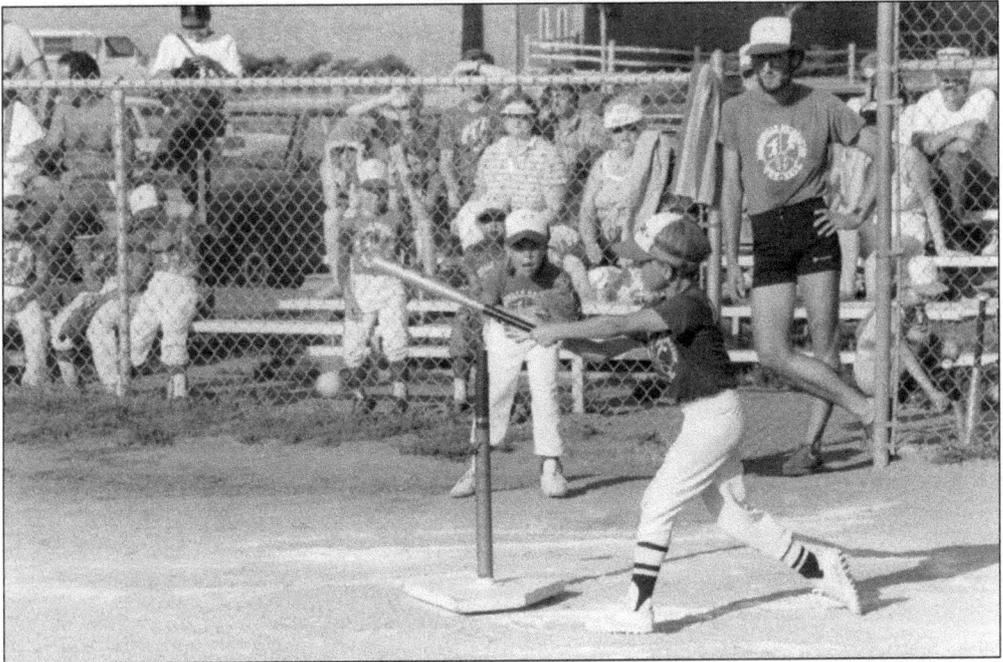

A little slugger takes a swipe at a baseball. Since 1972, the Bolingbrook Tee-Ball Association organizes T-ball teams of boys and girls ages four through eight to teach them the fundamentals of baseball. Bolingbrook may be the unofficial capital of T-ball. Parents enjoy watching their youngsters at play, picking daisies in the outfield, running bases in the wrong direction, and attempting to catch a pop fly. Summer evenings are filled with the joyful sounds of youngsters scoring for the team or getting a base hit.

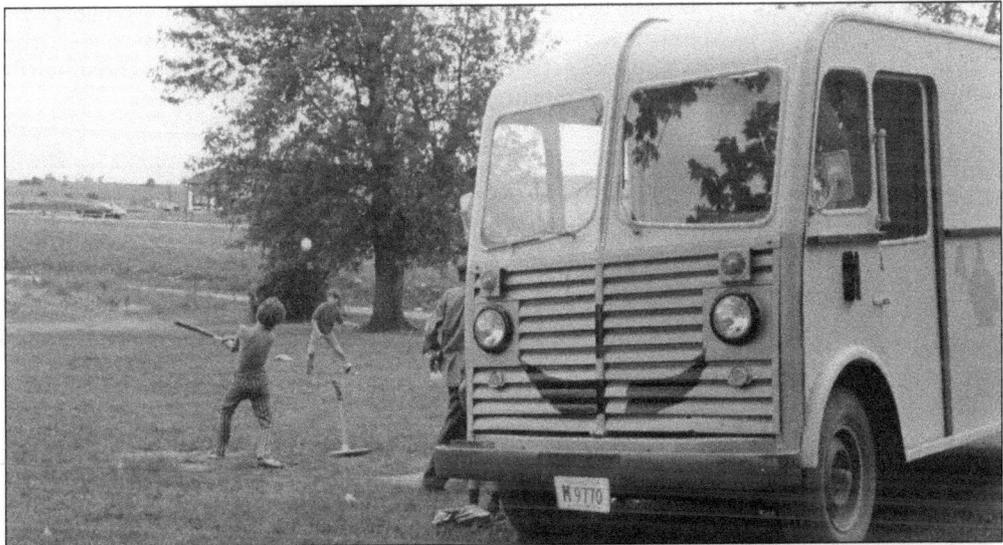

Boys play a pick-up baseball game behind Bolingbrook's Sportsmobile. School District 365U's 45/15 year-round school system challenged neighborhoods within the district with off-track (vacationing) students. The park district answered the challenge with the Sportsmobile; along the same lines as library bookmobiles, the Sportsmobile, loaded with sports equipment and games, would travel the neighborhoods, bringing activities and resources to children.

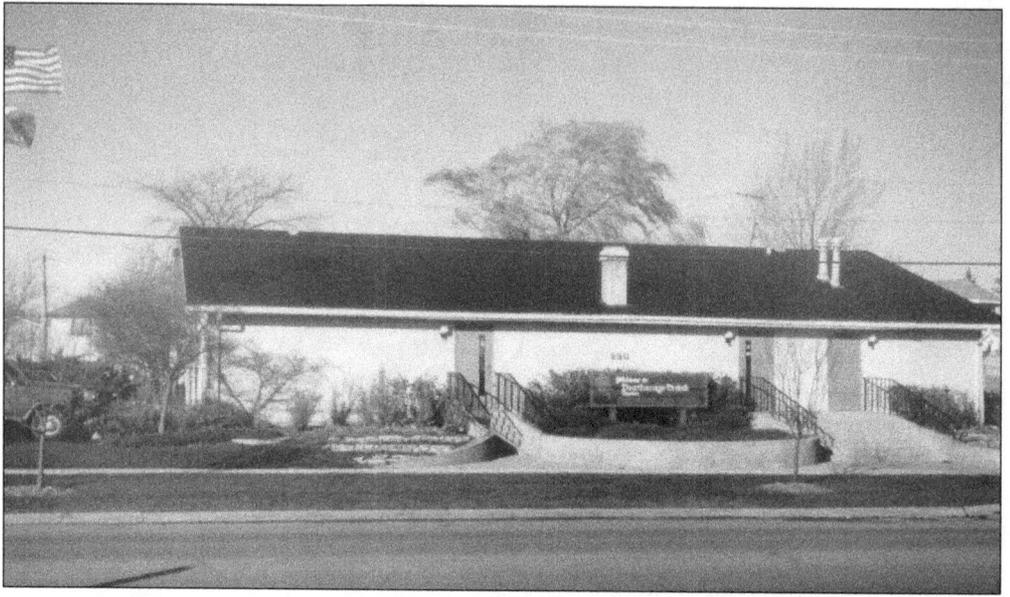

The Deatherage-Drdak Center on East Briarcliff Road, pictured above, was Bolingbrook Park District's first senior center. Located on the site of the William Wipfler Park, the building was built with volunteer labor from the Jaycees and Valley View building trade students in 1974. The name of the building came from Alan Deatherage, president of the Bolingbrook Seniors, and Paul "Pops" Drdak, president of the Romeoville Golden Agers. The senior center operated Meals on Wheels and a van for senior trips. When it moved to the Joseph and Sarah Levy Senior Center on Canterbury Lane in 1991, the building became the home of the Joliet Bolingbrook Special Recreation Association. In 1975, the 20,300-square-foot community center (below), named for Bolingbrook Park District president John Annerino, opened on Recreation Drive to meet the village's increased need for recreational activities. The Annerino Center houses the district's administration offices, basketball courts, meeting rooms, and workout facilities.

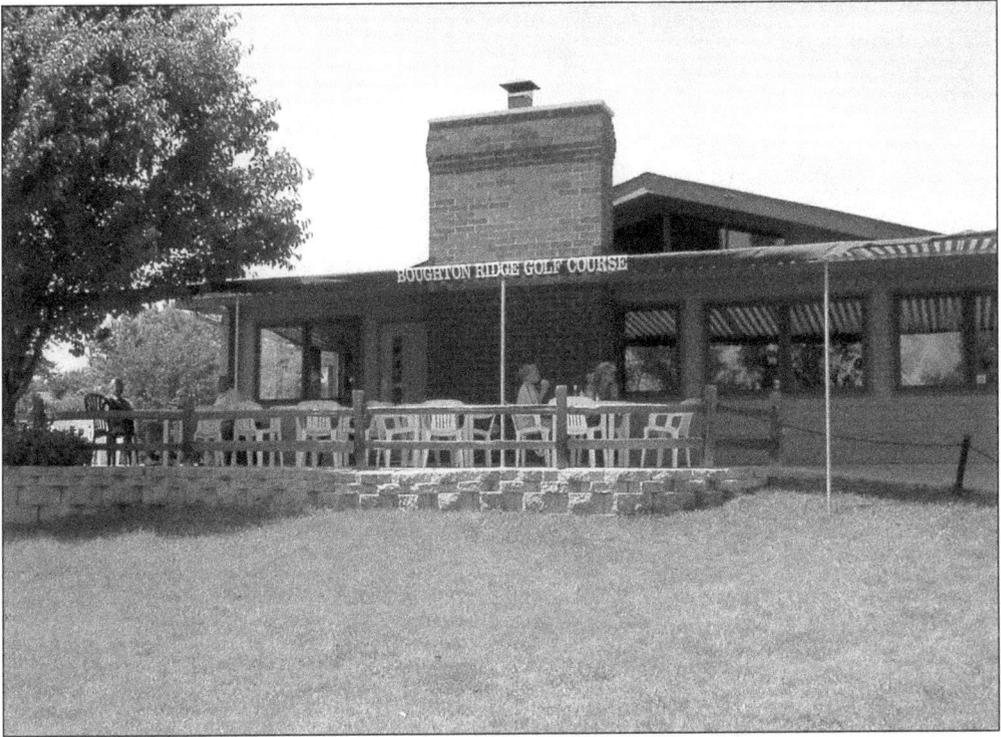

The Boughton Ridge Golf Course opened on August 14, 1981. Situated on 45 acres, the course takes shape amidst the Clusters, Ivanhoe, and Cavallo subdivisions. With water on seven holes and 21 sand traps, this 2,200-plus-yard, nine-hole, par-32 executive golf course provides plenty of challenge. The clubhouse and 10th Hole pub were replaced in 2008 with a new clubhouse and Ashbury's restaurant and banquet facility.

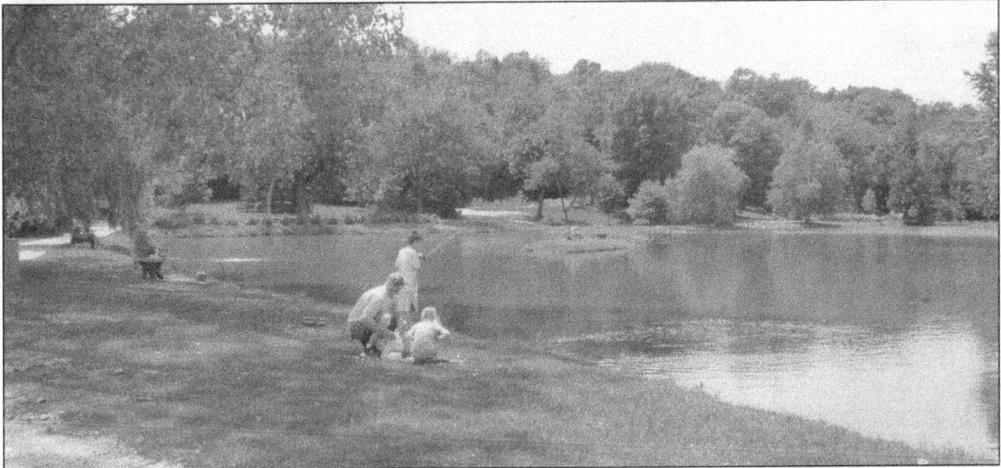

A father fishes with his children at Hidden Lakes Historic Trout Farm. Former owner Dan Bromberek operated the D&H Trout Farm and ran a sportfishing business. In 1988, developer Bill Palmer and Mayor Claar alerted the district of the sale of the 15-acre site. The park district leased the property from CorLand and eventually purchased the property. It is not uncommon to see deer roaming this 15-acre wooded site, and the lakes are stocked with fish through fishing permit sales. (Courtesy of the Bolingbrook Park District.)

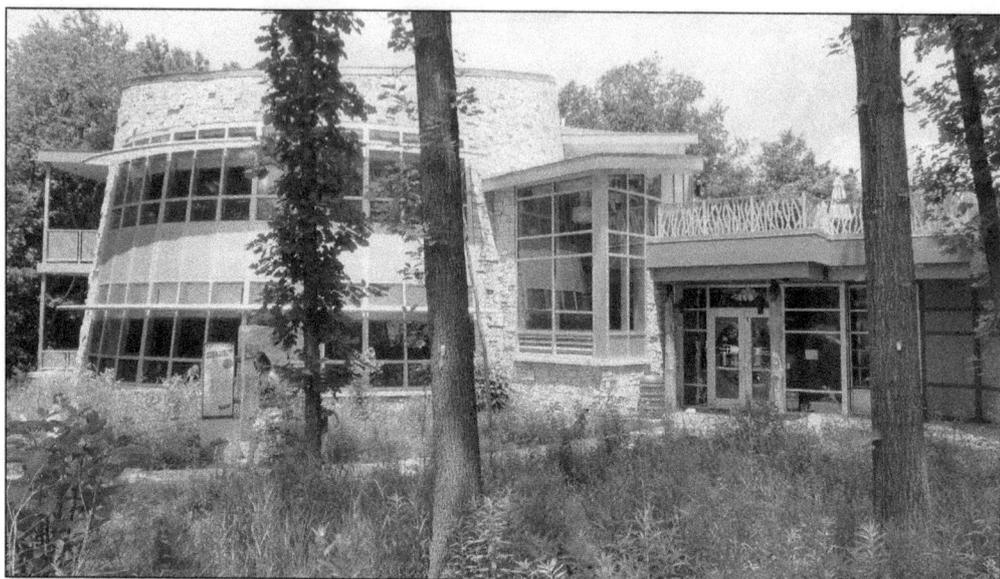

Hidden Oaks Nature Center serves as a national model for interpretive programming, environmental education, and stewardship. It opened on June 20, 2009, at the entrance of Hidden Lakes Historic Trout Farm. Hidden Oaks Conservation area incorporates a nature center, Hidden Lakes Trout Farm, and the James S. Boan Picnic Area in a woodland setting. (Courtesy of the Bolingbrook Park District.)

There are three major legs to the Bolingbrook Park District bike path system: DuPage River Greenway, ComEd Greenway, and Lily Cache Greenway. DuPage Greenway is a 2.5-mile path along the DuPage River's east branch from Royce Road near Route 53 to Indian Boundary Park. ComEd Greenway goes from the DuPage Greenway at Whitewater Drive to Remington Lakes Sports Complex. It connects to Lily Cache Greenway at Lily Cache and Orchard Roads. (Courtesy of the Bolingbrook Park District.)

The Bolingbrook Recreation and Aquatic Complex and the Pelican Harbor Outdoor Aquatic Park opened on Lindsey Lane in 1996. They offer a variety of activities for all ages, such as sports, music, and art for children ages three to five and swimming, gymnastics, and horseback riding for ages six and up. Programs for adults include dance, sports, golf, and fitness. (Both, courtesy of the Bolingbrook Park District.)

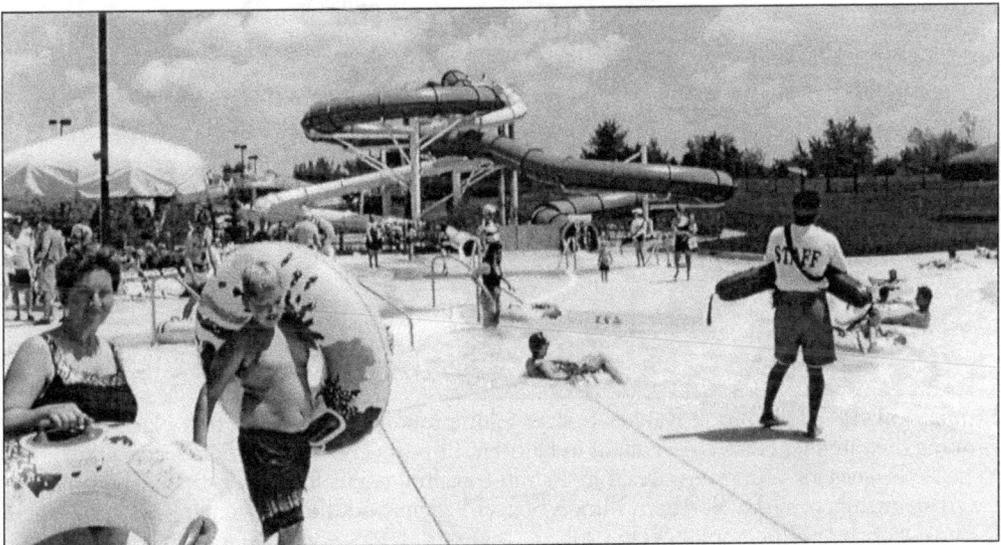

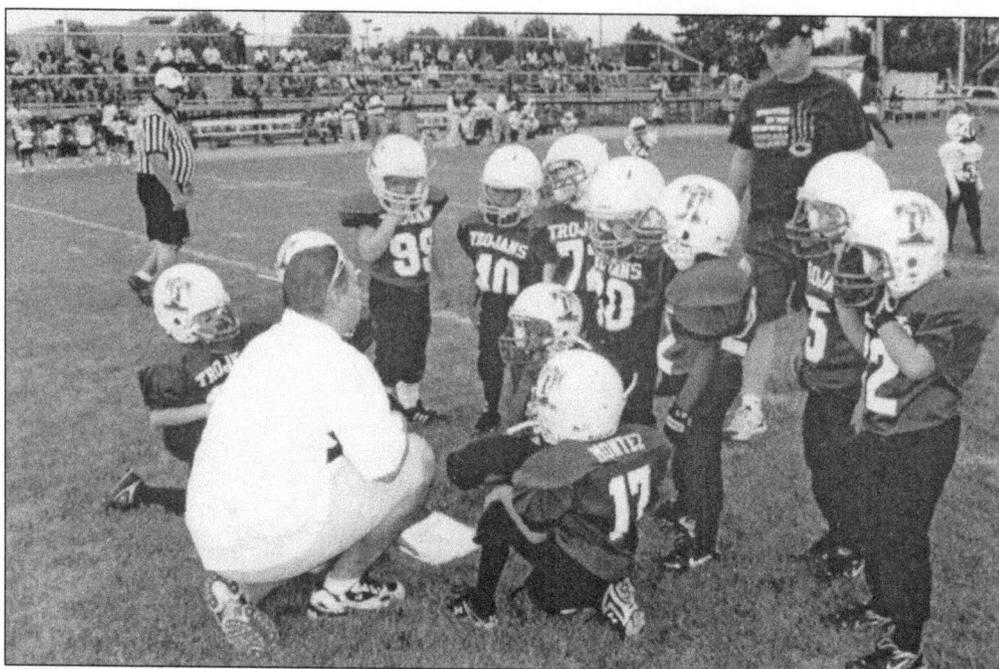

The 2008 Junior Peewee football team huddles with their coach. The team is part of the Bolingbrook Trojan Youth Athletic Association. A member of the Pop Warner football program, the Trojan Association has won national championships in 1992 and 1994 and been runner up on six other occasions. (Courtesy of Trojan Football.)

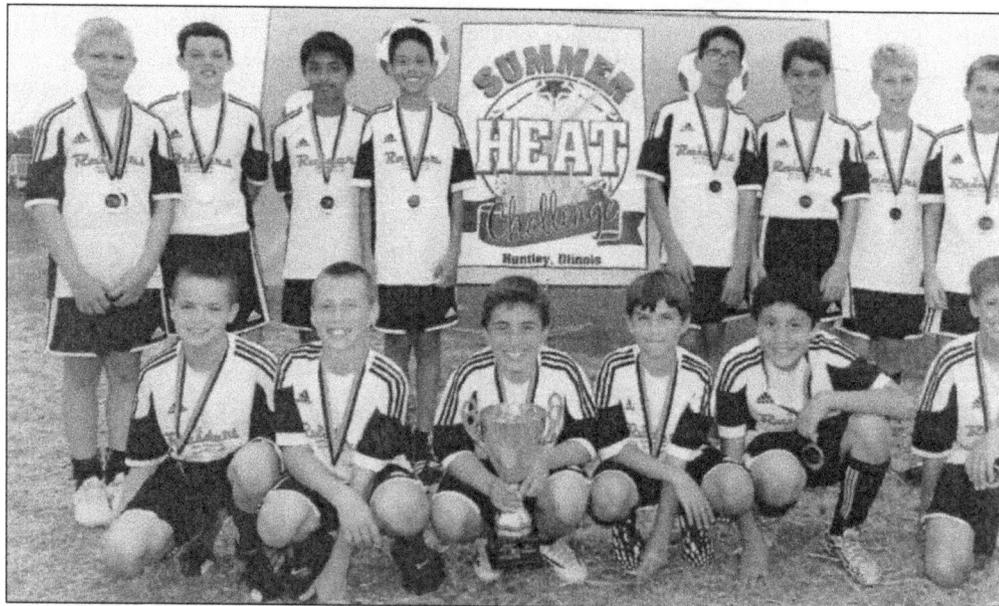

Members of the Bolingbrook Raiders Soccer Club proudly display their first place trophy for winning the Summer Heat Tournament in Huntley, Illinois. The Bolingbrook Soccer Club offers in-house leagues for youngsters ages 4 to 14 and traveling teams for ages 7 to 18. The traveling teams are members of the Northern Illinois Soccer League and Illinois Women's Soccer League. (Courtesy of the Bolingbrook Soccer Club.)

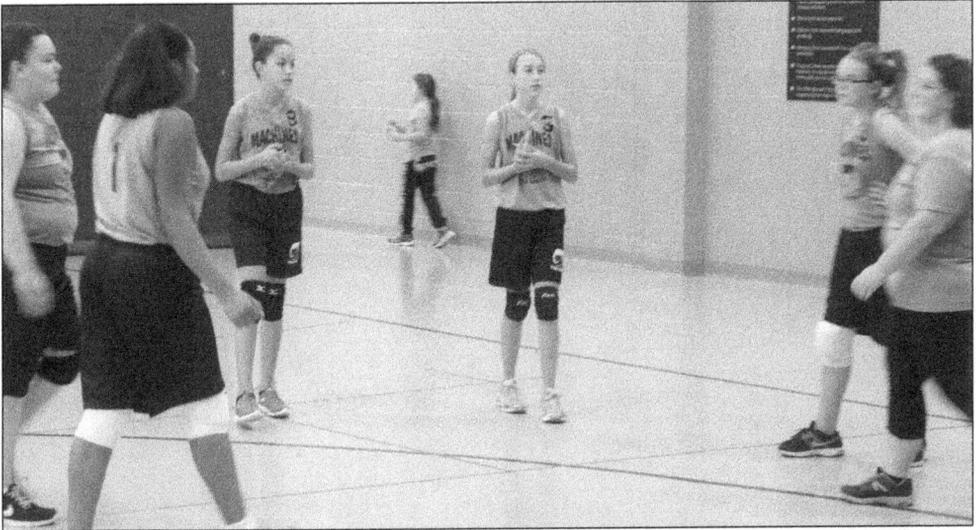

A Panther Sports Club volleyball team gathers on the court. The Panther Sports Club runs programs in softball, volleyball, and basketball for girls from ages 7 to 18. Becky Jensen, a local resident, founded the Bolingbrook Panthers Sports Club. (Courtesy of Scott Fagust.)

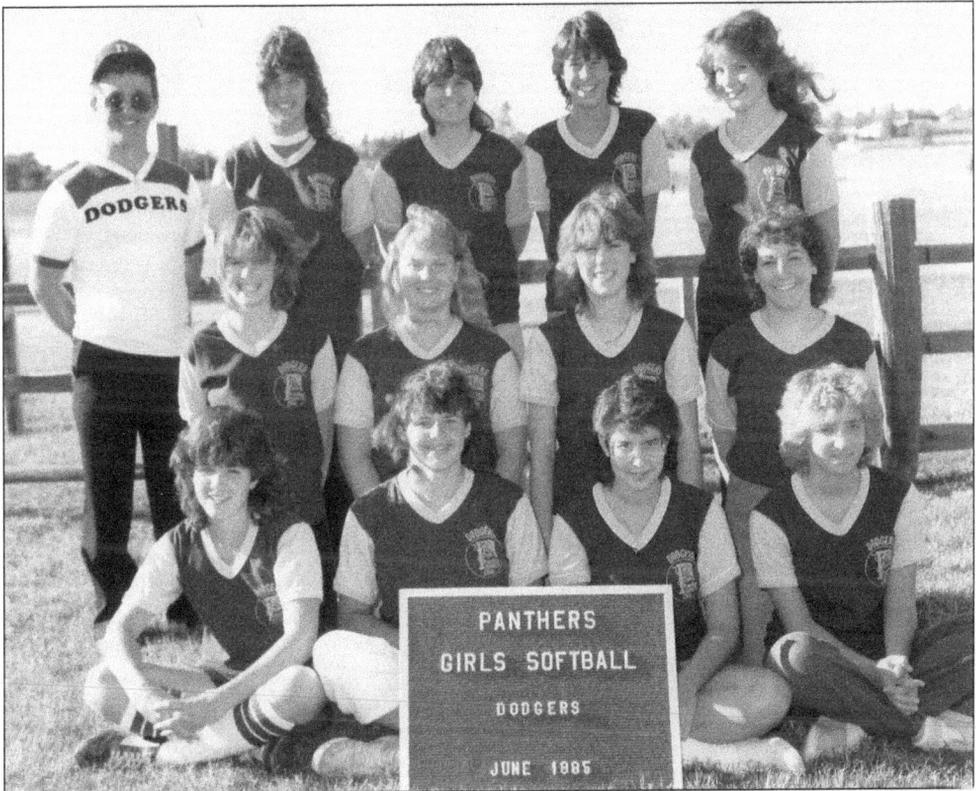

Representing the Panther Sports Club girls' softball program from 1985 are the members of the Dodgers team, coached by Al Legittino. Bolingbrook sports programs have always offered boys and girls ages 5 to 18 an equal opportunity to compete at levels that match their abilities. Al Legittino coached his daughters and granddaughters in this program. (Courtesy of Al Legittino.)

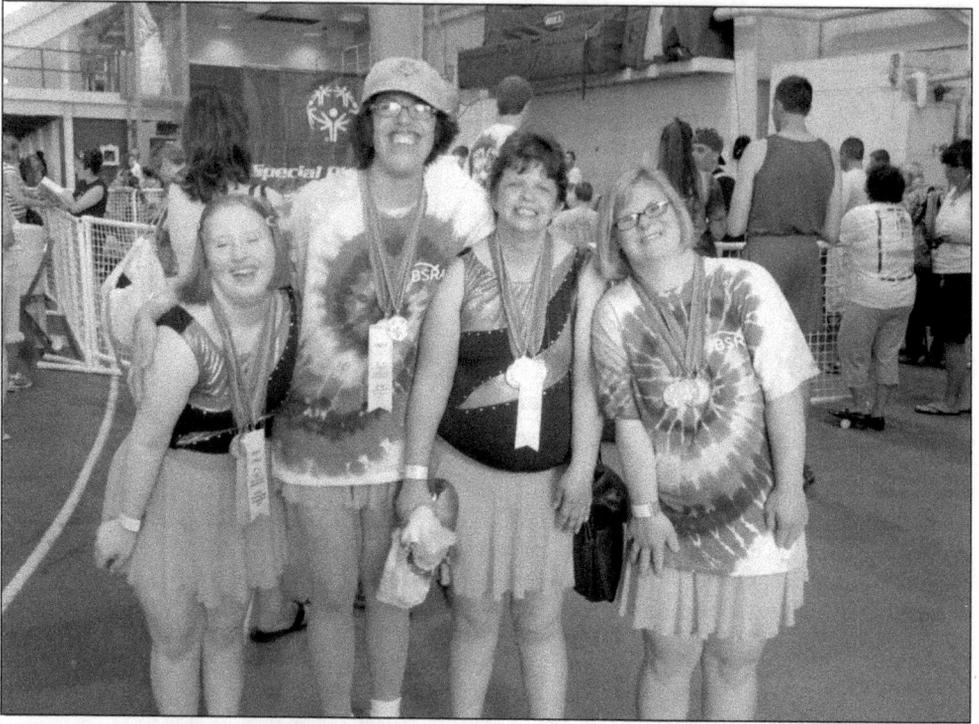

As a partnership between Bolingbrook and Plainfield Park Districts, the Lily Cache Special Recreation Association serves the special needs population in both communities. It provides recreation and programs for residents with disabilities, including social events, seasonal camps, and trips to Special Olympic events. (Courtesy of the Bolingbrook Park District.)

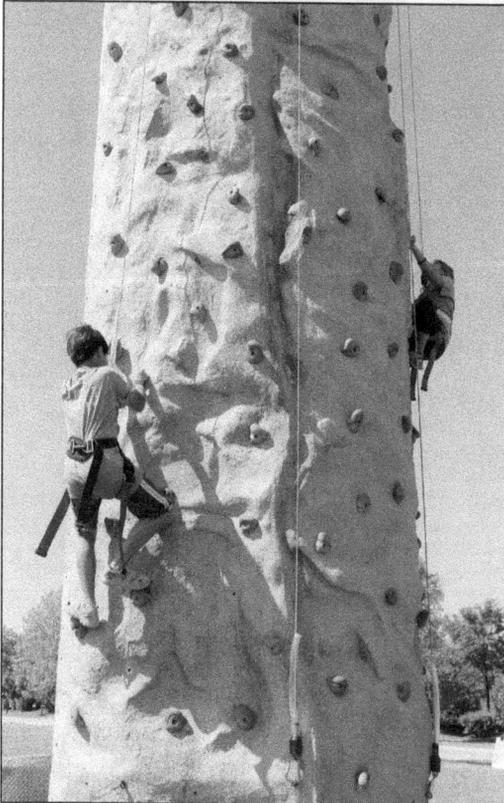

Children are pictured here testing themselves on a climbing wall, just one activity kids can experience at Bolingbrook Park District's Camp Stepping Stone, Camp Alotta Fun, and Teen Time Fun Camp. Children ages 3 to 14 can enjoy camp activities during the summer. The camps emphasize kindergarten readiness skills for preschoolers, along with arts, crafts, games, sports, and field trips for older children. (Courtesy of the Bolingbrook Park District.)

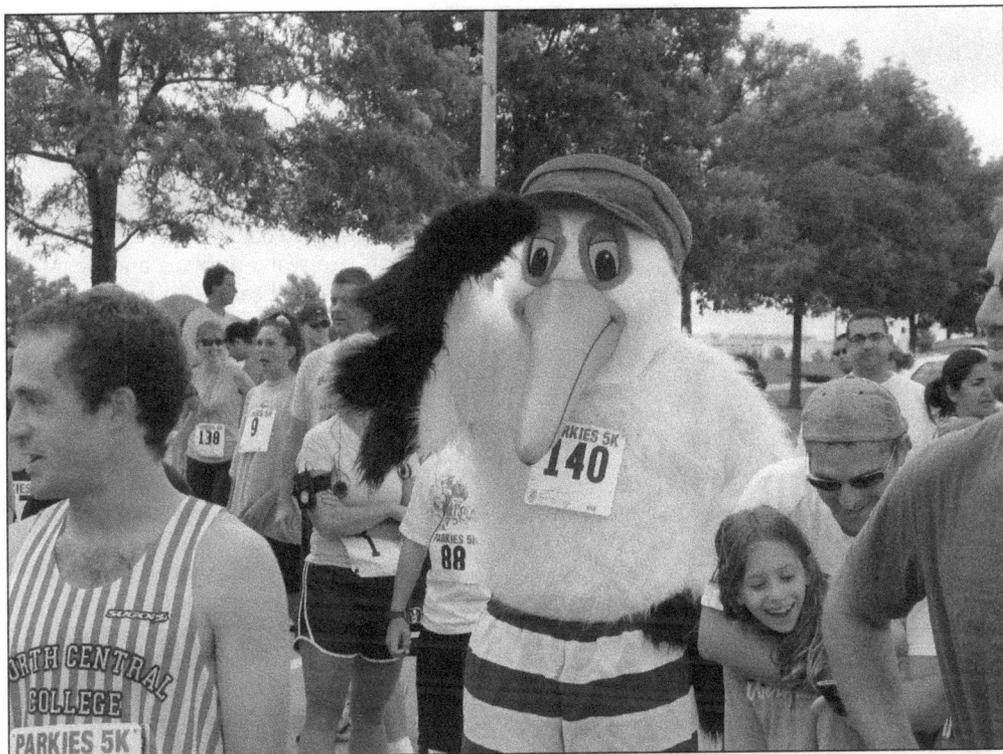

At the end of the summer, the park district puts on its final big event before the children go back to school, the Last Blast. It is sponsored by the Bolingbrook Park District at the Bolingbrook Recreation and Aquatic Center and Pelican Harbor Complex. It features a 5K run, car show, food, music, and fireworks. Parkie, the Pelican Harbor Mascot, is always a fun visitor at the event. (Both, courtesy of the Bolingbrook Park District.)

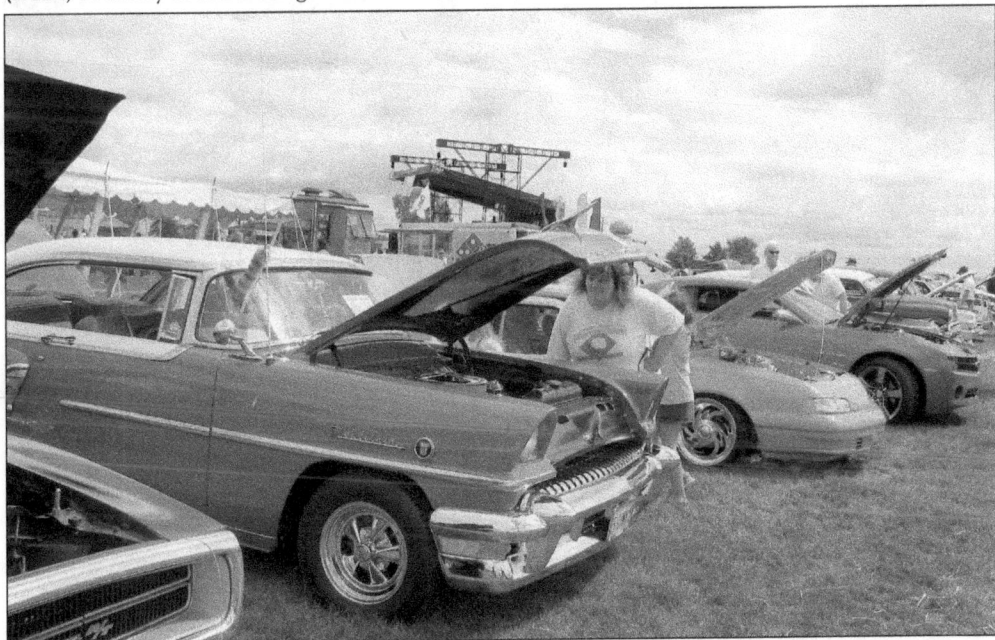

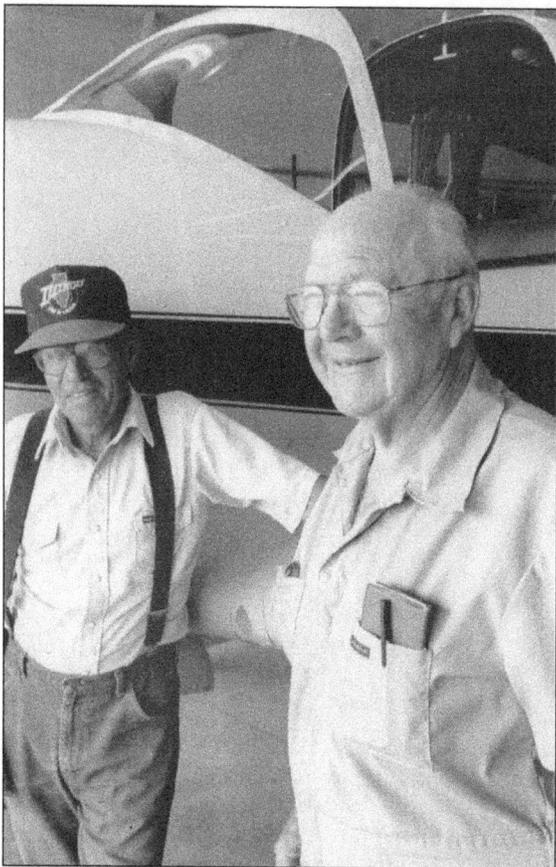

Walt Chilvers (left) and Oliver Boyd Clow stand in front of Clow's 1948 Ryan Navion airplane at Clow International Airport. Born in Wheatland Township, Boyd Clow was a dairyman and farm implement salesman. In 1958, he traded a used combine for a Taylor Craft two-seater airplane and cleared a patch of soybeans for a landing strip. Shortly afterwards, people began asking to park their planes on the site. The field remained a restricted landing area until 1972.

An early 1960s aerial view of Clow Airport shows the farm and sod landing strip. For a time, the Chicago Glider Club was based there, and in 1973, the runway was paved and became Clow International Airport. Clow chose to include international in the name because about half of the glider pilots using the airport were from Europe. At that time, a customs department was unnecessary to be an international airport. In 1999, Boyd Clow sold the airport to Joe DePaulo.

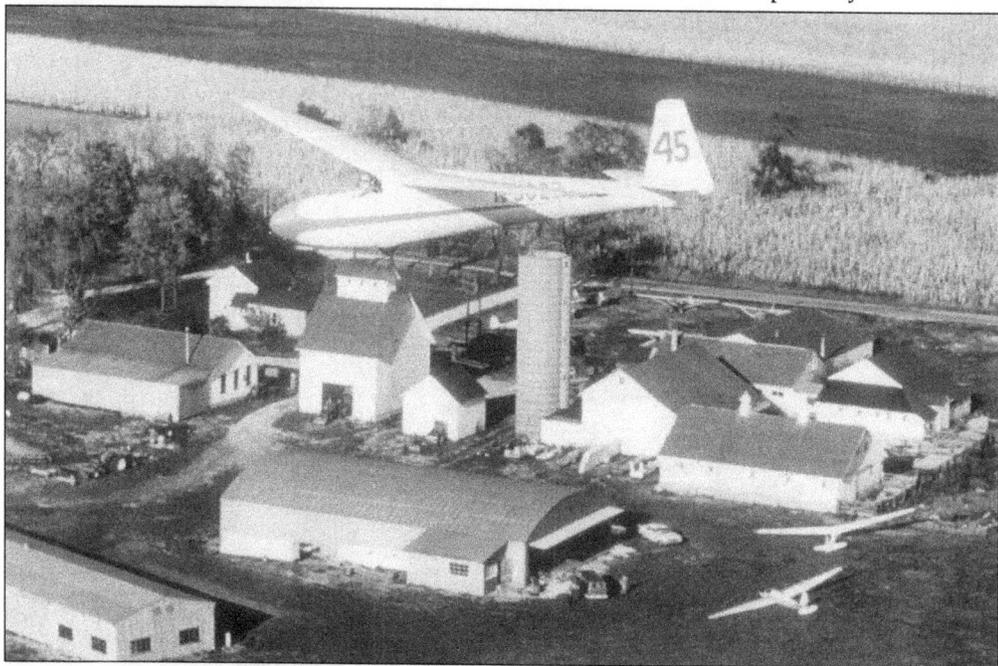

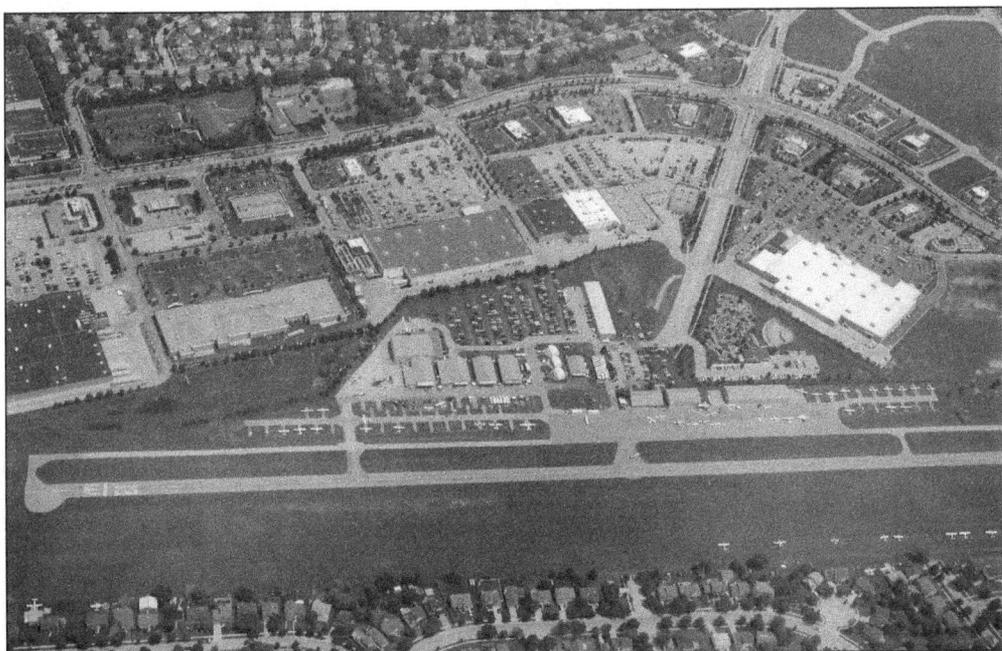

Bolingbrook's Clow International Airport was purchased by the village from Joe DePaulo in 2005. With a runway 3,400 feet by 50 feet, the airport offers landing, hangar, tie-down, and maintenance facilities. A&M Aviation offers flight instruction, airplane rental and sales, and charter flights. One can also watch the airplanes while enjoying a delicious meal at Charlie's Restaurant. (Courtesy of Shaw Media.)

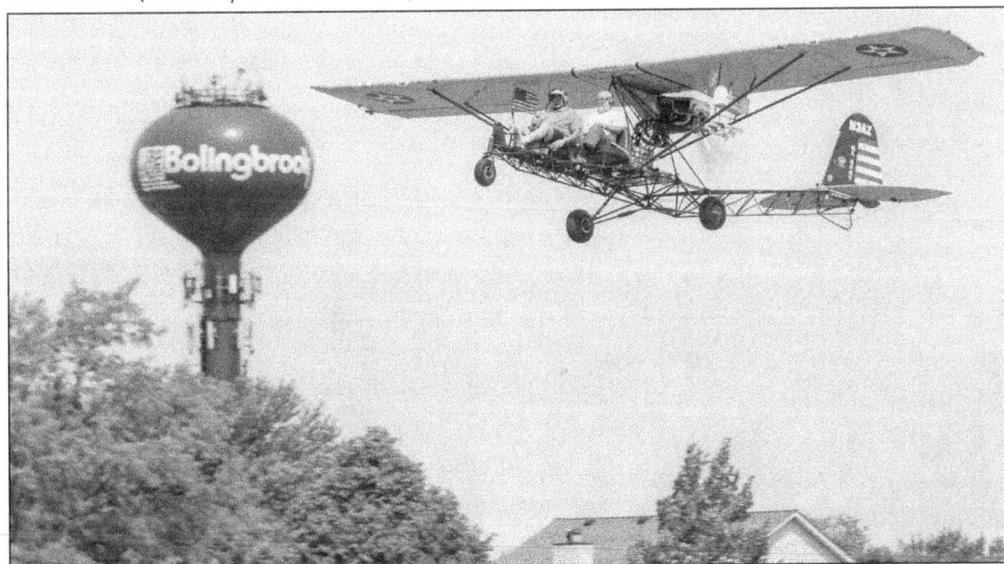

Flying high at the 2014 Cavalcade of Planes is Arnie Zimmerman. For years, Arnie and his Breezy could be seen flying over Bolingbrook and at Clow Airport. He was always willing to give rides to anyone interested. On the Fourth of July, one could see him starting the fireworks celebration at the Bolingbrook Golf Club. The Breezy is an experimental aircraft first flown in 1964 by designer Carl Unger. Sadly, in 2014, Breezy N3AZ was destroyed in a crash in Oshkosh, Wisconsin. (Courtesy of Shaw Media.)

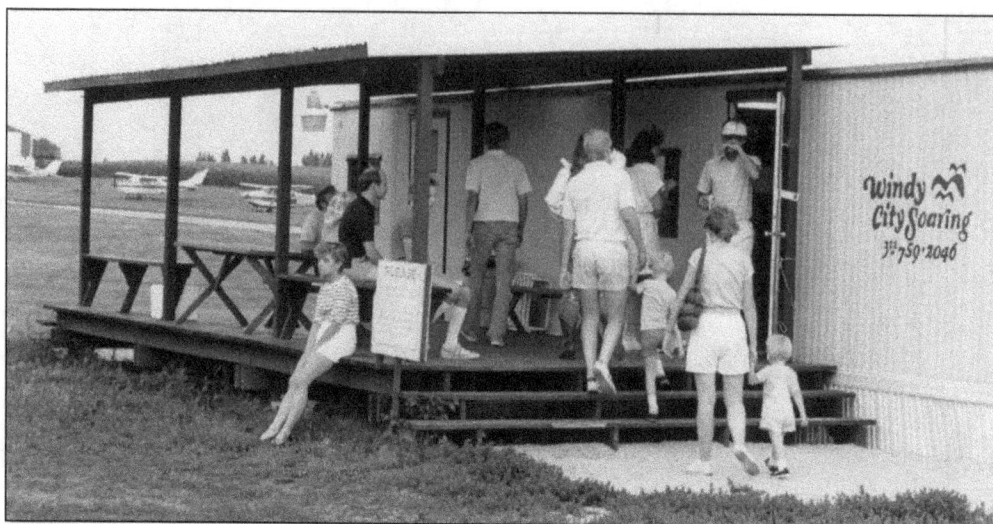

Windy City Soaring was started in 1971 by Burt Meyer and a small group of investors who wanted a school to train glider pilots. Ron Ridenour became sole owner in 1977 and operated the school for 14 years. When Ridenour sold the business, he had seven gliders and three tow planes. Windy City Soaring gave glider rides and offered flight instruction and rentals to glider pilots. They flew between 5,000 and 6,000 flights per season, which ran from April 1 through November 15.

Pictured here is part of Clow Airport along Naperville Road in the mid-1970s. To the far right is a house, and a hangar and barn can be seen at center. To the far left is Michael's Automotive. When Naperville Road, now Weber Road, was widened, Tony's flower stand moved into this area. The 1992 movie *Folks*, with Tom Selleck, was filmed at the airport.

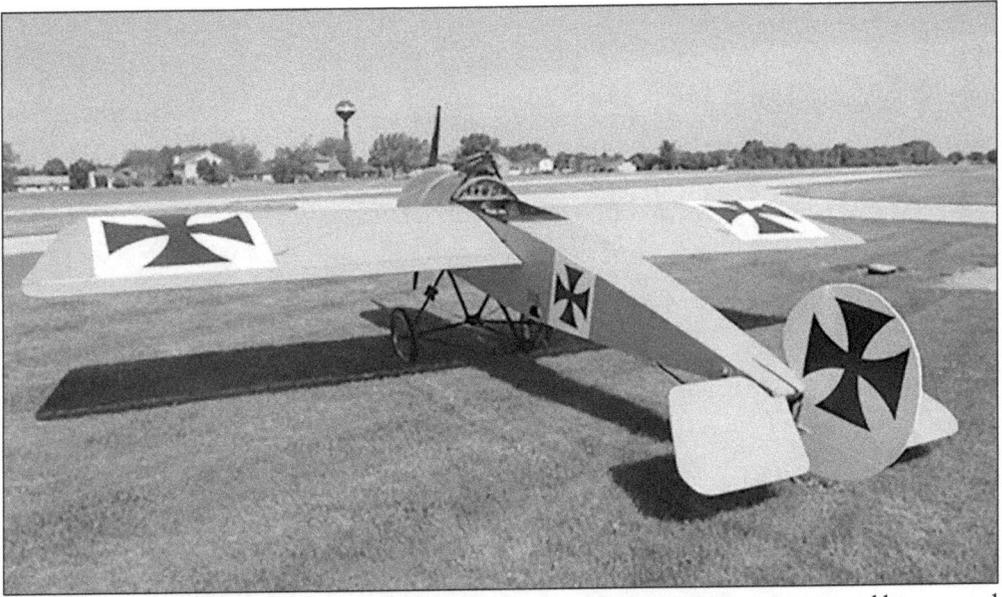

Started in 2004, the Illinois Aviation Museum is dedicated to preserving aeronautical history and ensuring the future of aviation through education and community involvement. Pictured here is a three-quarter-scale replica Fokker E3, built by the Aero Builder's Club. A successful test flight took place October 8, 2008. The Fokker E3 is one of several aircraft on display in Hangar One, current home of the museum at Bolingbrook Clow International Airport. (Courtesy of Illinois Aviation Museum.)

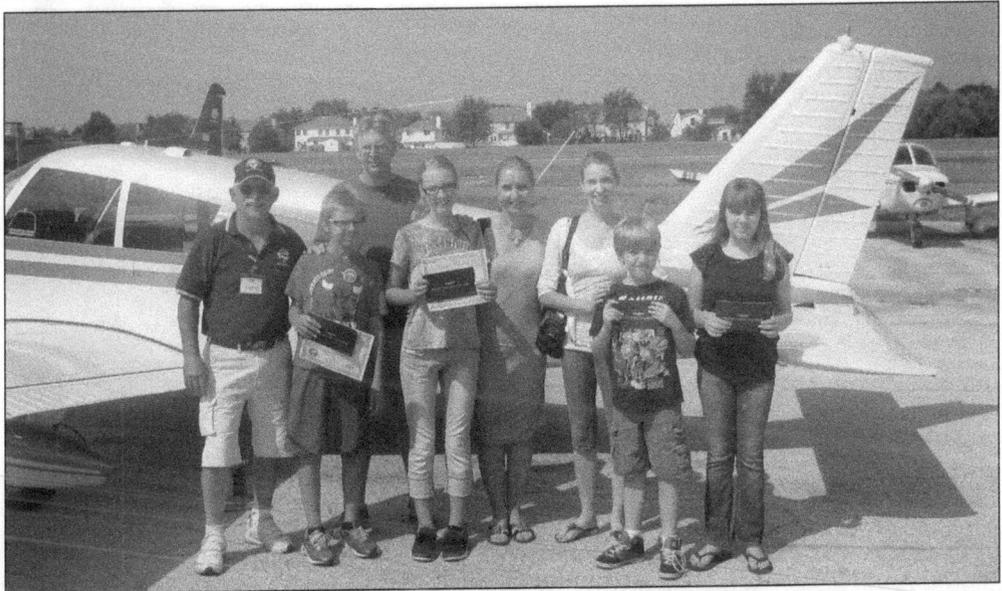

From April through October on the second Saturday of the month, one can find the local Experimental Airplane Association (EAA) Young Eagles Chapter 461 at Bolingbrook's Clow International Airport. The Young Eagle Program gives free flights to children ages 8 to 17 with local EAA volunteer pilots. Children can learn and experience what pilots do on the ground and in the air. Pictured from left to right are pilot Steve Russell, young eagles Kevin and Natalie O'Callaghan, Zach and Audrey Bisplinghoff, and their parents.

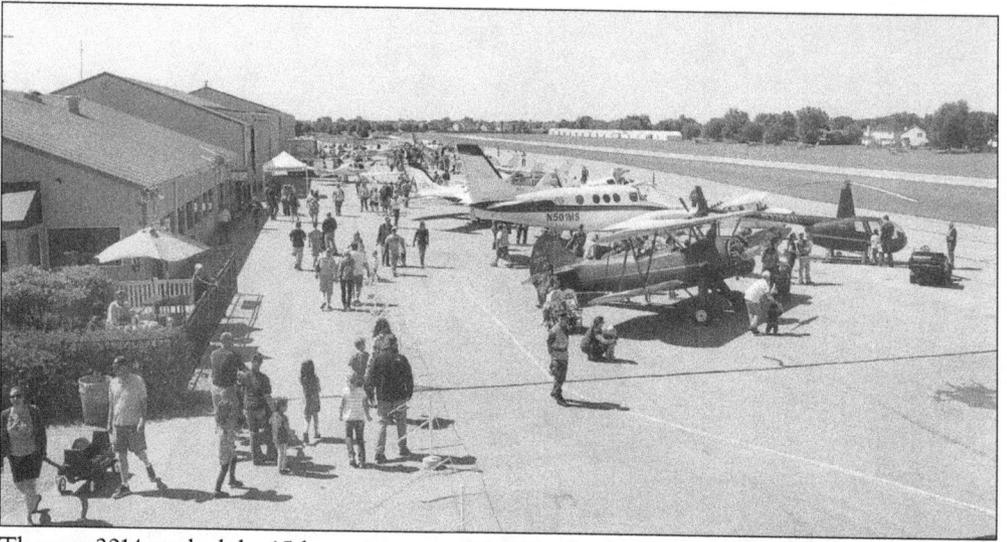

The year 2014 marked the 15th anniversary of the Cavalcade of Planes. The two-day event allows the public to get close to airplanes on the ground and enjoy skydiving, formation flying, and helicopter demonstrations. Vintage aircraft and military planes dot the skies with flights. Over 50,000 landings and take-offs a year occur at Bolingbrook's Clow International Airport. In 1989, it was named Illinois Airport of the Year.

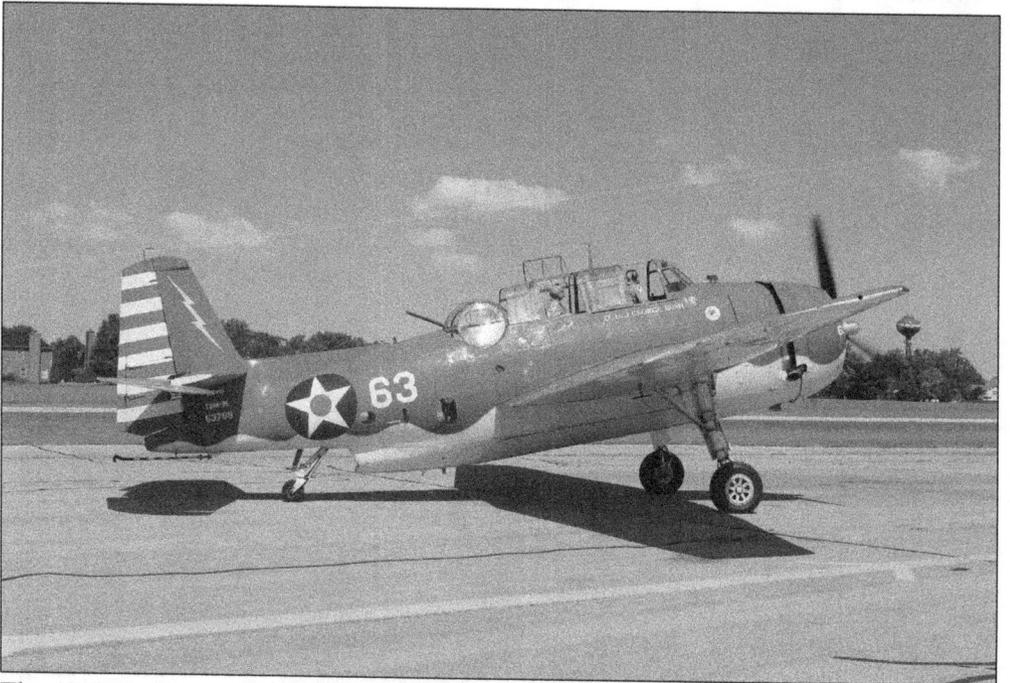

This 1945 World War II Avenger torpedo bomber is usually on display at the annual Cavalcade of Planes at Bolingbrook's Clow International Airport. Owner and pilot Tom Buck states he has been coming to the event for at least six or seven years. He provides a nice static and aerial display.

74

Seven

TOWN CELEBRATIONS

Bolingbrook has always held a variety of celebrations. Activities such as parades, picnics, plays, concerts, and the Festival of Lights ringing in the Christmas season bring a sense of community to the residents. Early on, these events were held throughout the village, with the parades and Festival of Lights often beginning at the Annerino Center and ending at the old high school. When the Robert L. Bailey Town Center opened in 1980, it provided a more central location for celebrations. Over the years, more and more events have been held there, including Cinco de Mayo, Pakistani Independence Day, Gospel Fest, Boy and Girl Scout camping events, carnivals, plays, and concerts. Musical performances behind the village hall utilize the performing arts center (dedicated October 1999), with a large hill for seating and even sledding in the winter. Memorial Day and Veterans Day services occur at the memorial in front of town center. As Bolingbrook has grown, different celebrations are held outside of the town center; the Festival of Lights has moved to the Promenade, and the Fourth of July celebration is held at the golf course.

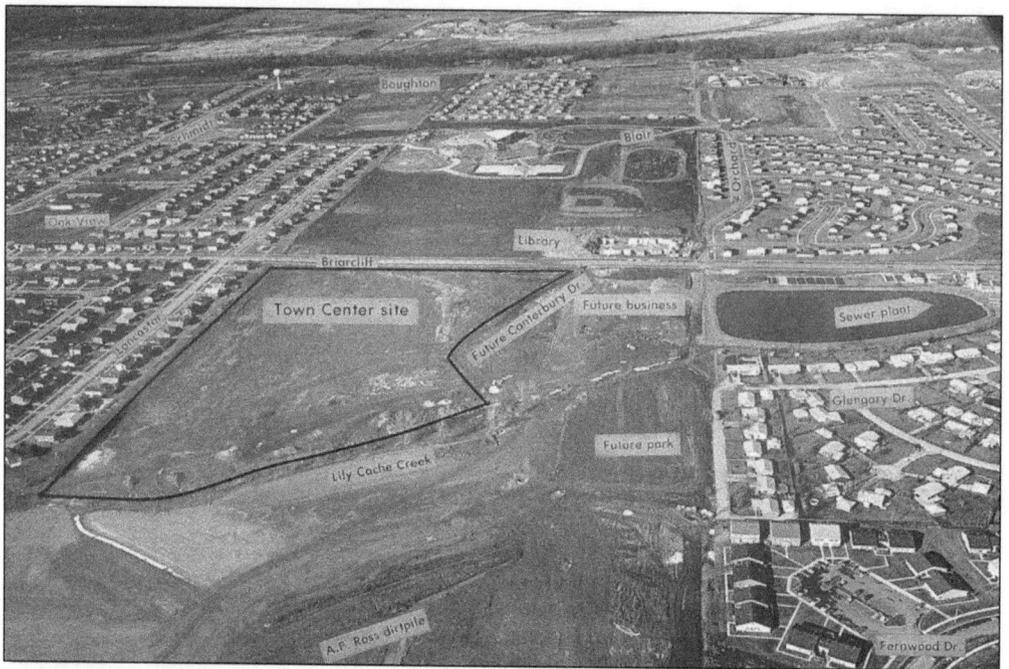

In 1973, a town center committee was formed to plan a government complex with a band shell and open space. Serving as members of the committee were Nora Wipfler, William Sandiver, Gerald Shea, Jo Lentz, and Barbara Kovach. In April 1975, Nora Wipfler was elected mayor, and the village board agreed to purchase 27.36 acres for $429,552 from Consolidated Properties. It was surrounded by a water reclamation plant to the east, a high school (now middle school) and a library to the north, and Lily Cache Road to the south. The photograph below shows the current view of the town center. The water reclamation plant has been replaced by James Meyer Park, named for a village trustee and Bolingbrook's first state representative. The picnic shelters at the park were built by Greycore.

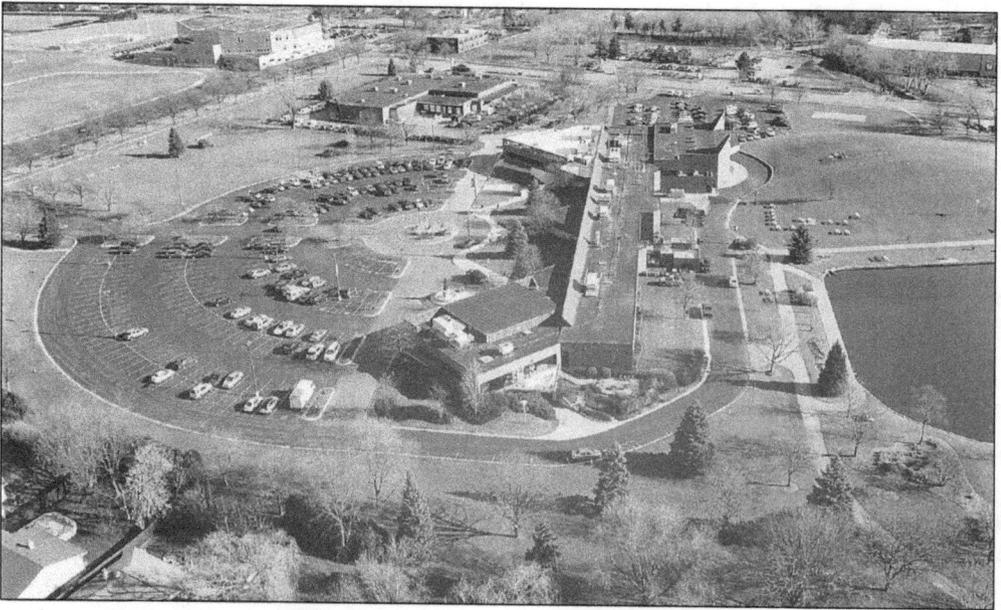

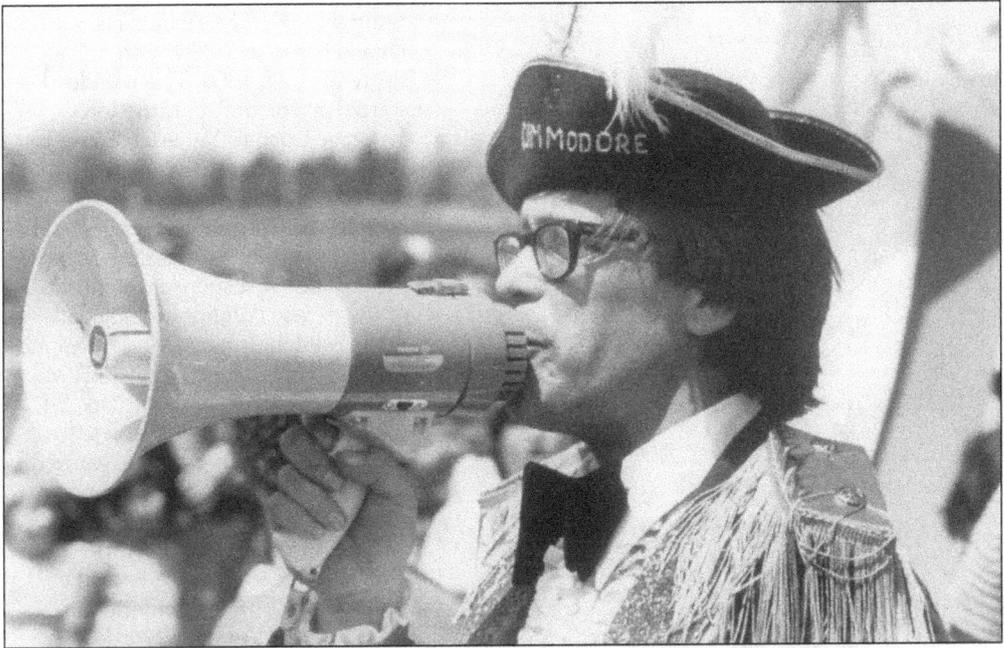

Inspired by Chicago disc jockey Steve Dahl's comment about "Bolingbrook by the Sea," the Bolingbrook Yacht Club was started. In spring, the Bolingbrook Yacht Club would hold its annual Cornfield Regatta. Pictured above is Commodore Terry Little, founder of the yacht club, directing the boats through an obstacle course. The boats could be no more than eight feet long, five feet tall including mast, and three feet wide, and had to have a six-person crew. Below is the Wozny family and friends running through part of the 10-station obstacle course. Judging was based on speed, accuracy, style, and general tackiness. The trophy was the Fabulous Flying Pink Flamingo. The yacht club sailed for at least 10 years, beginning in 1980. (Above, courtesy of the Bolingbrook Historic Preservation Commission; below, courtesy of the Wozny family.)

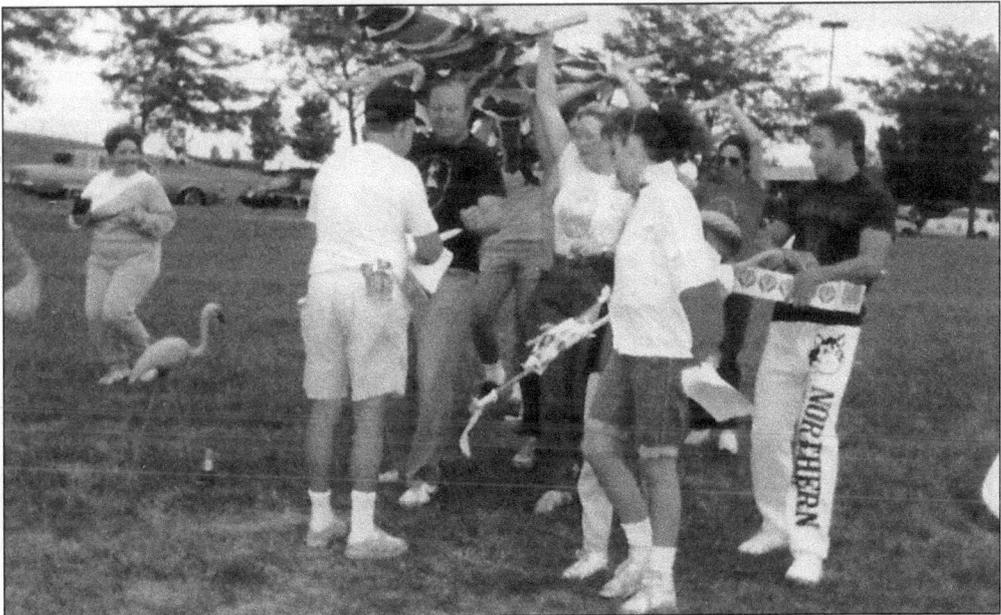

Bolingbrook's First Anniversary Parade began at 2:00 am on September 25, 1966. The parade started at Tortura's parking lot, down Frontage Road to Venetian Drive to Pinecrest Road to Lawton Lane to Kingston Road to Briarcliff Road and back to the Tortura's parking lot. The North View Civic Organization was the parade's first sponsor. Members of the parade committee included Joe Rojek (chairman), Mrs. Raymond Svacka, Mrs. Robert Piotrowski, Mr. and Mrs. William Walters, Mrs. Ed Uselmann, and Mrs. Joe Rojek. Over the years, different groups organized the parade, including the Women's Auxiliary of the Bolingbrook Police and the Jaycees. Eventually, the village assigned the parade to the Bolingbrook Parade Commission. At left is Rita Aiken, a North View School kindergarten teacher, walking in the 1976 bicentennial parade. Below is the float of the Indian Oaks Civic Association, celebrating the 10th anniversary of incorporation.

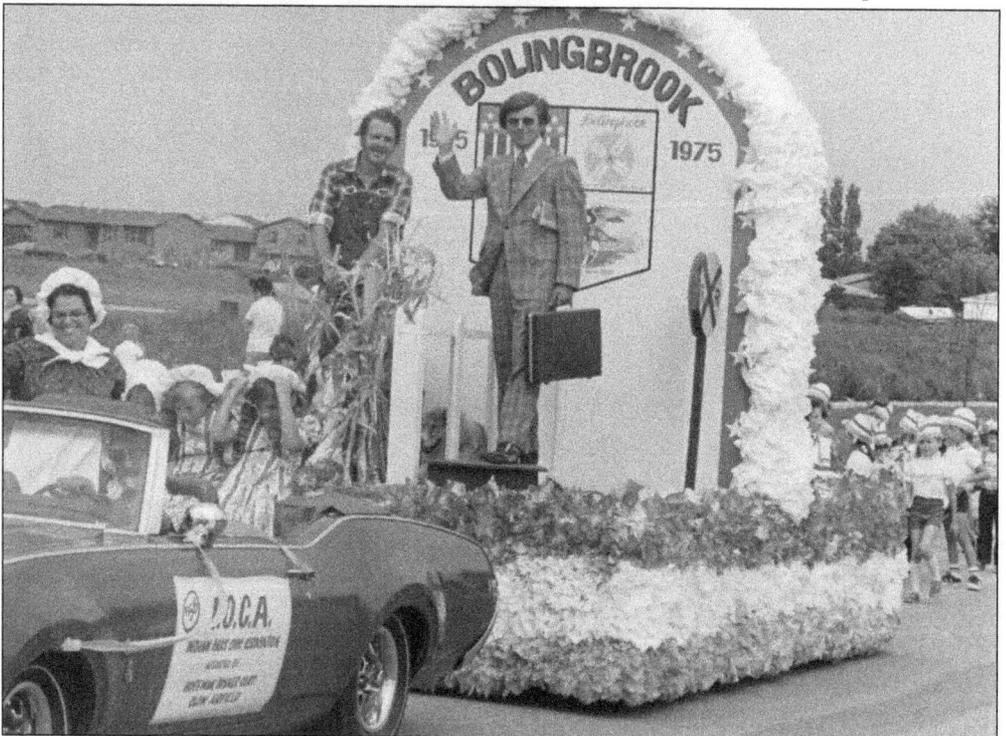

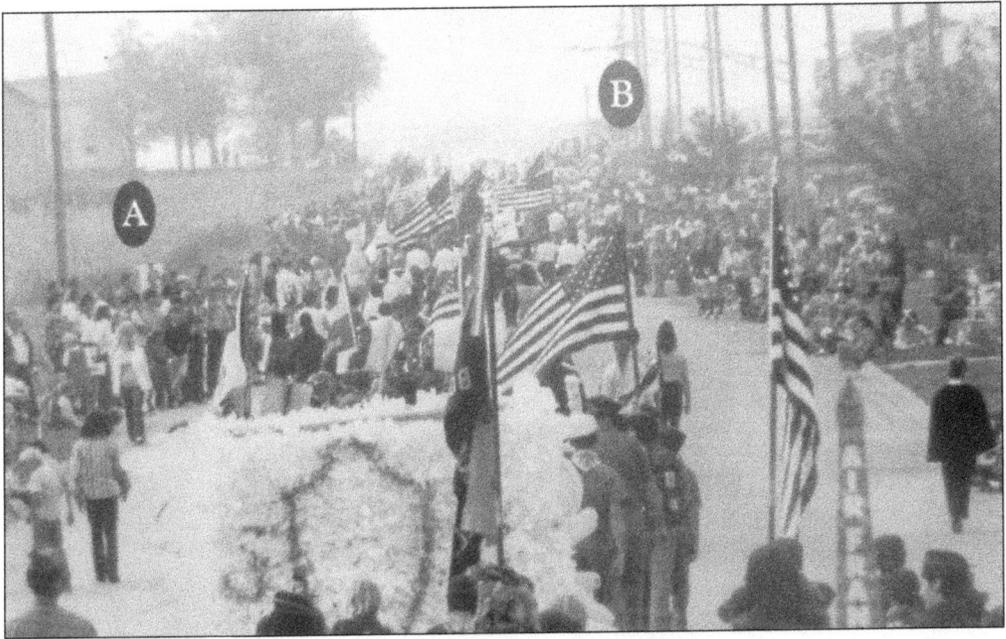

As the years passed, the Pathways Parade followed different routes to accommodate the increasing number of parade entries. Pictured above is the 1974 parade on Briarcliff Road, looking west toward Route 53. One can see the Edberg farmhouse (A), and notice there is no McDonalds (B). With close to 100 entries, crossing Route 53 was no longer practical. The current route is from Bolingbrook High School down Lily Cache to Canterbury to Briarcliff and ending at the Town Center. Many bands, clubs, churches, dance companies, youth groups, and organizations participate in the parade. Shown below is the Jaycees' parade float.

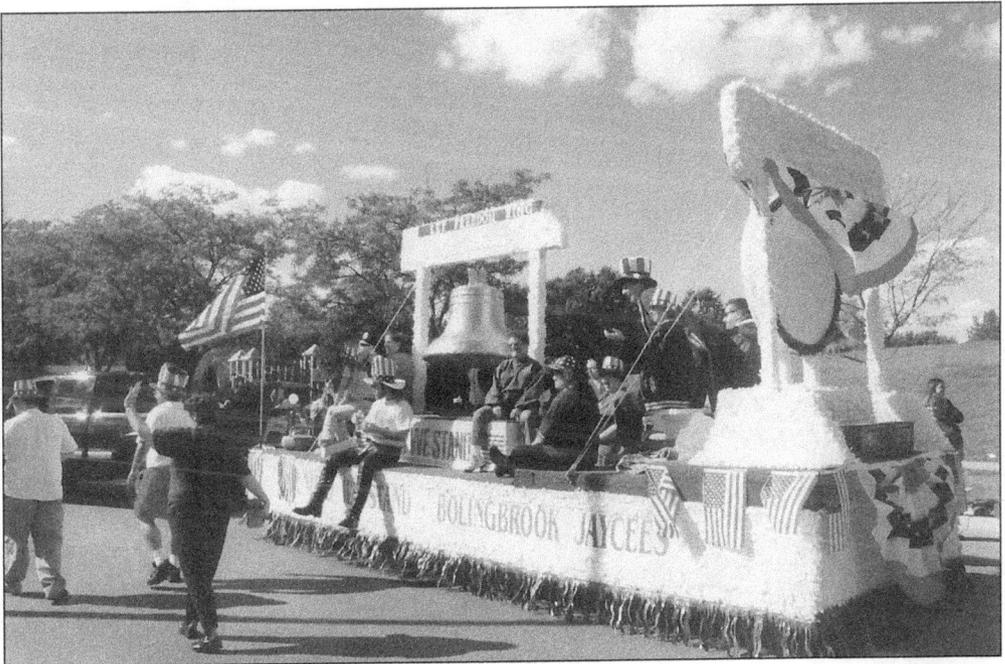

Bolingbrook celebrates Memorial Day and Veterans Day at Bolingbrook Veterans Memorial Site, located at town center. Pictured above on Veterans Day are, from left to right, Jerry LoPiccalo, Jack Flanagan, Vito Donato, John Beckwith, Jim Yocum, and Tom Wolfe. Beckwith and Yocum helped design the original memorial, dedicated on May 31, 1988. In a park-like setting, native sandstone from Chicago Elmhurst Stone Quarry forms the base of the memorial. The sculpture of bronze helmets from the US armed services represents all past armed conflicts. Since being dedicated, the memorial site has been enlarged to accommodate the growing number of attendees. Below is a Memorial Day service featuring an honor guard from the Knights of Columbus Councils No. 6521 and No. 11092 and the Air Force ROTC from Bolingbrook High School. Throughout the years, honor guards have included Boy Scouts, Girl Scouts, police and fire honor guards, and firefighters' pipe and drum corps.

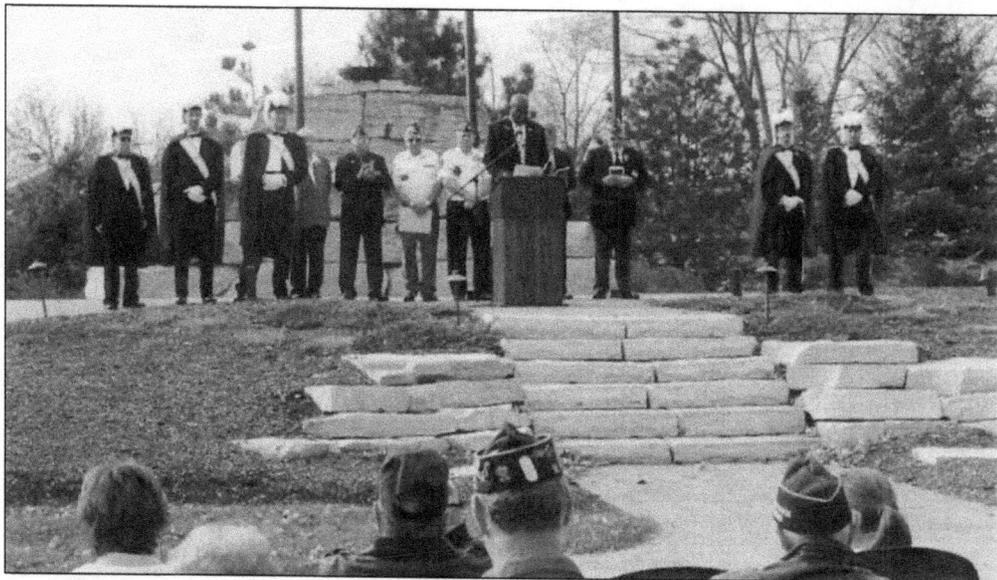

Held the last Sunday in June, the Bolingbrook Village Picnic has offered fun and entertainment to residents since 1984. Festivities are located behind village hall, around the lake and the performing arts center. Events throughout the day have included Art in the Park and a fishing derby, petting zoo, mud volleyball, and free hot dogs paid for by business donations. All items sold and displayed are from nonprofit groups to benefit their programs.

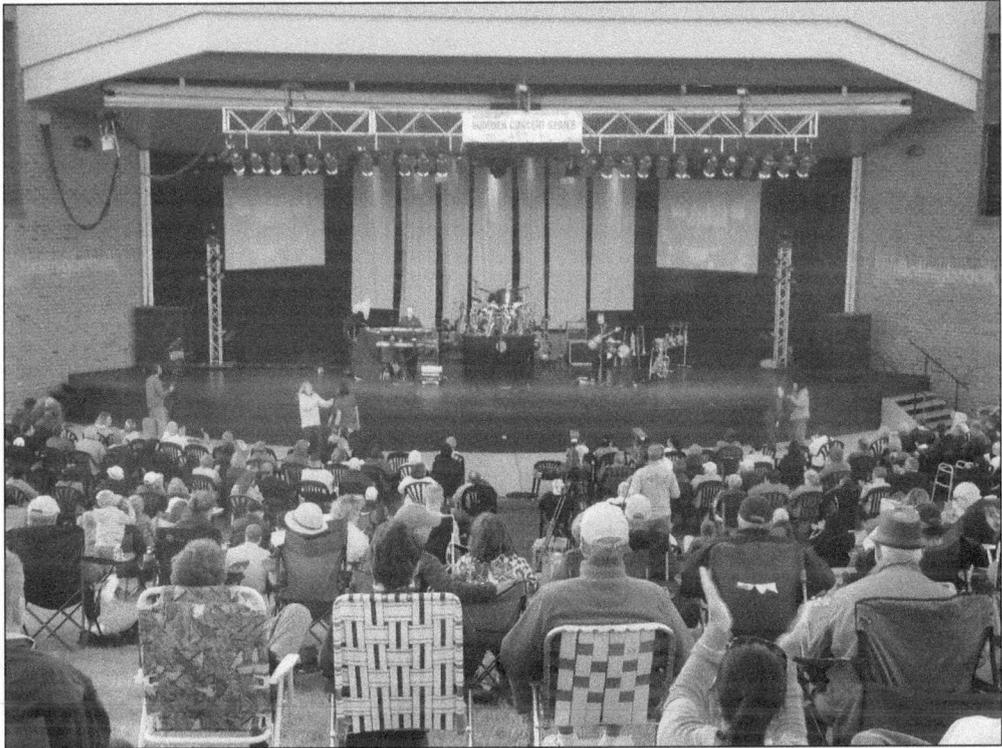

There is no end to the number of uses for the Bolingbrook Performing Arts Center. The 9,000-square-foot center has a state-of-the-art sound and lighting system. The lawn seating provides a casual and relaxed setting for the summer concerts, dance performances, Theatre-on-the-Hill plays, and ethnic festivals that are just a few of the diverse uses the center offers. Pictured here is the group New Odyssey at one of the summer concerts.

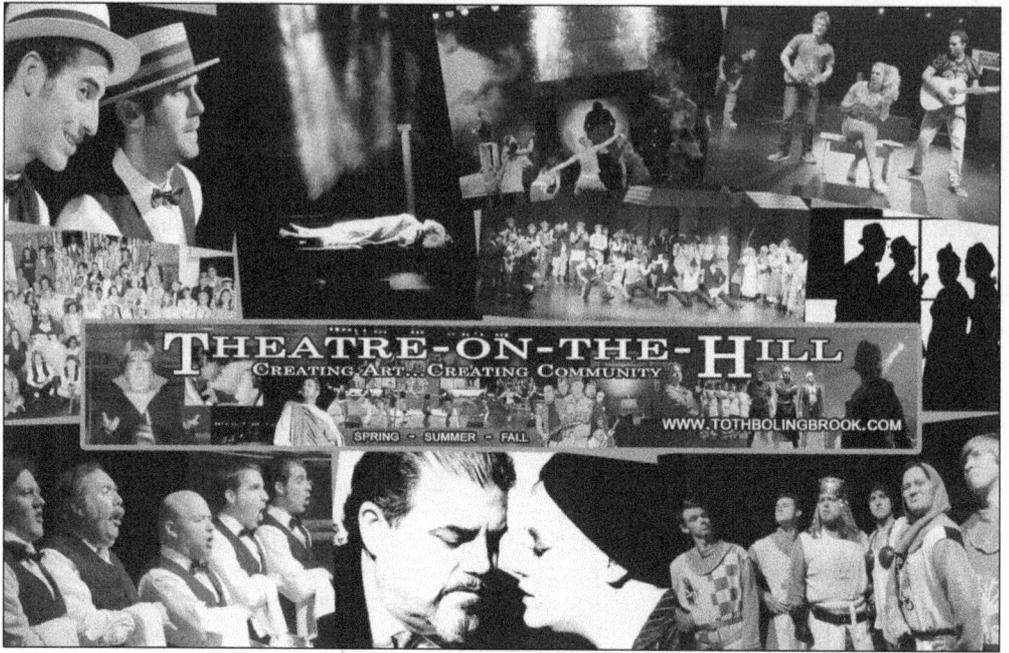

Lorrisa Julianus, Craig Engel, and Michael Fudala are the force behind Theatre-on-the-Hill, formed in 2004. It is a community theater company staging three shows a year at the Bolingbrook Performing Arts Center. The performers and crew are largely local talent and include many school-age children. Professionals and newcomers alike are welcome to audition, and there is a place for everyone regardless of experience in a Theatre-on-the-Hill production. In recent years, productions have included *The Music Man*, *Amadeus*, and *Fiddler on the Roof*. (Both, courtesy of Michael A. Fudala.)

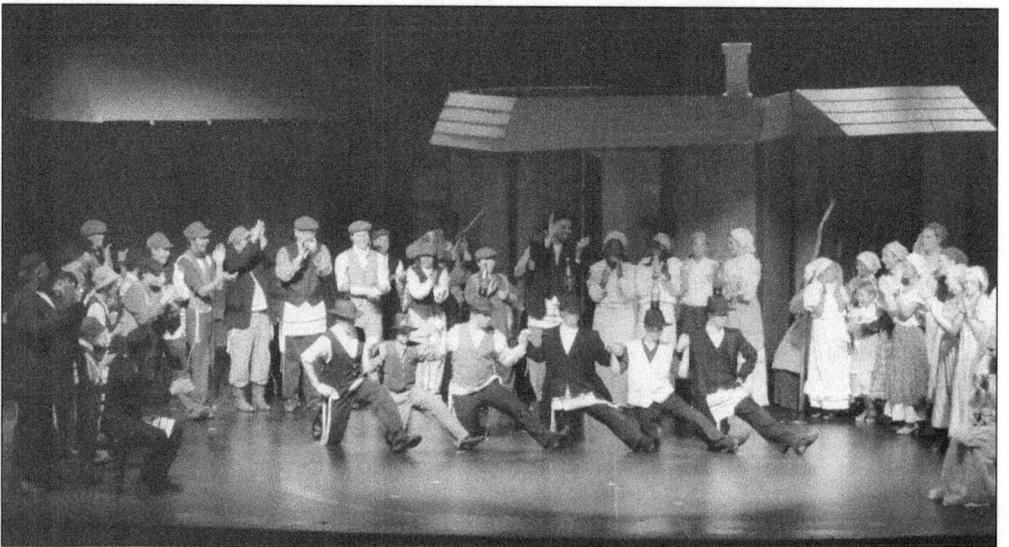

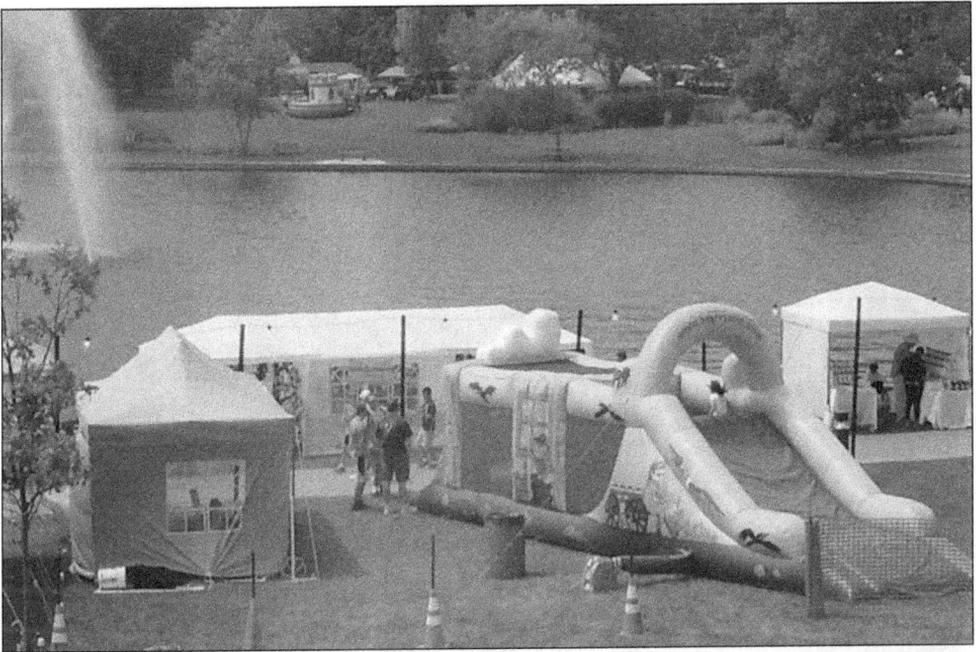

Started in 1990, the Bolingbrook Jubilee began as an expanded version of the Pathways Fest, in celebration of the 25th year of village incorporation. Several years later, the Pathways Parade moved to September, and the jubilee became a stand-alone event held in August. Traditionally, one can enjoy the Jaycee-sponsored carnival, classic car show, craft show, bingo, food, and numerous bands over a three-day period.

The Festival of Lights started out in the early 1980s as a night Parade of Lights to open the Christmas season. The parade evolved into a festival with carriage rides, hot chocolate, ice sculpturing, cookie making, greeting Santa, and a live nativity scene. Since 2008, the Promenade Mall and Village of Bolingbrook have joined together to make the Symphony of Lights tree-lighting ceremony and music show with 250,000 LED lights choreographed to the music of the Trans-Siberian Orchestra. (Courtesy of Jeanette Ginocchio.)

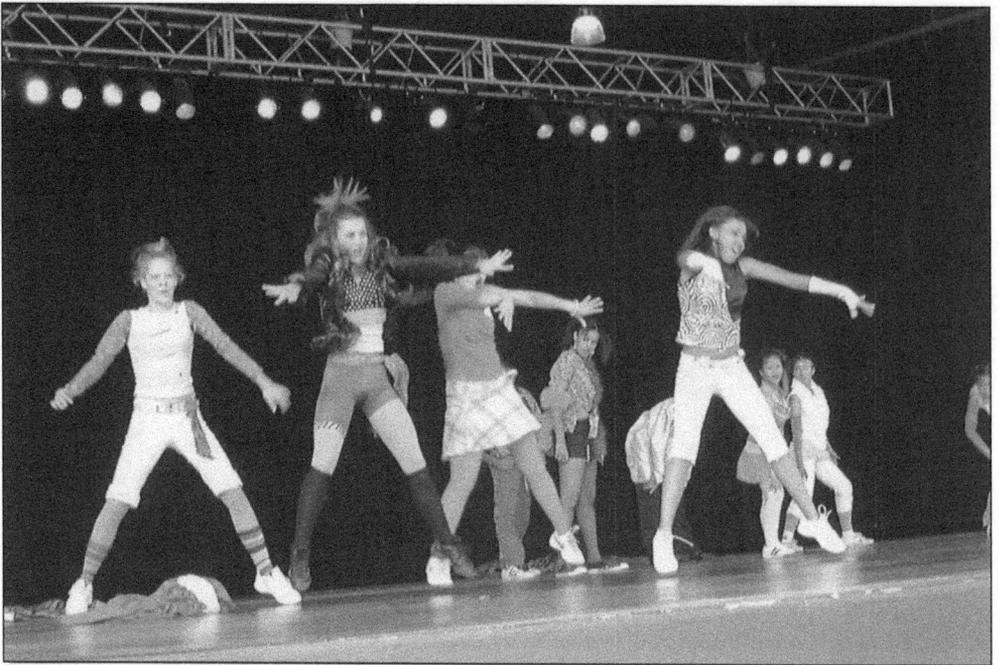

Danceforce is the Bolingbrook Park District's award-winning, nationally acclaimed performing dance company. The company is represented by Kidz Company (ages 5-10), Junior Company (ages 8-12), Teen Company (ages 10-15), and Senior Company (13 years and older). Danceforce is a year-round program beginning every summer that develops individuals in all areas of dance. They can be seen performing at many of the village events. (Courtesy of Bolingbrook Park District.)

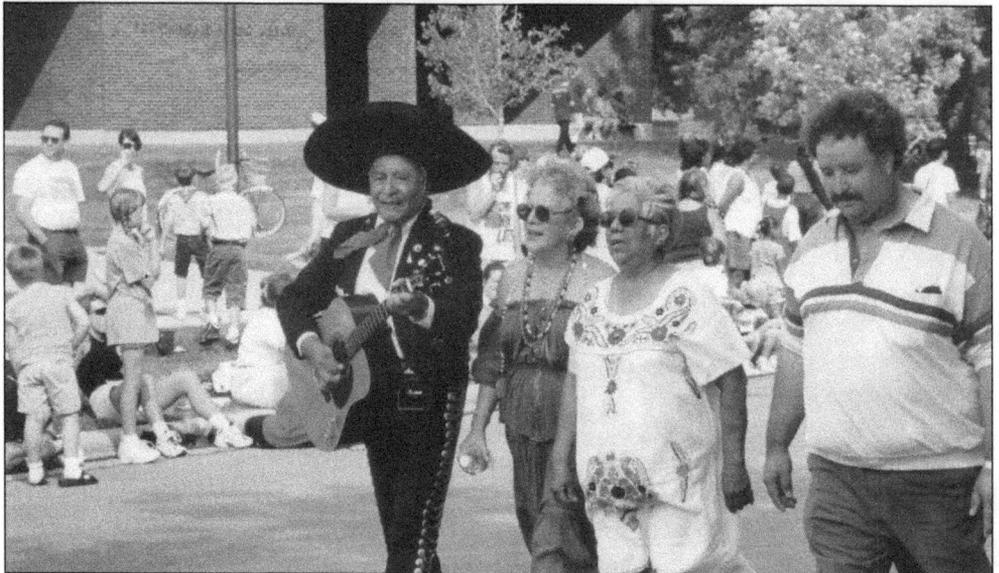

Immigrants were moving to Bolingbrook from around the world, and in the 1980s, the Bolingbrook Future Heritage Organization was chartered to offer translation services and English as a second language classes from Joliet Junior College. Rachael Cordero (center right) was honored for her services with a Village of Bolingbrook 2000 Female Citizen of the Year Award. A survey by the library shows over 28 languages spoken in Bolingbrook.

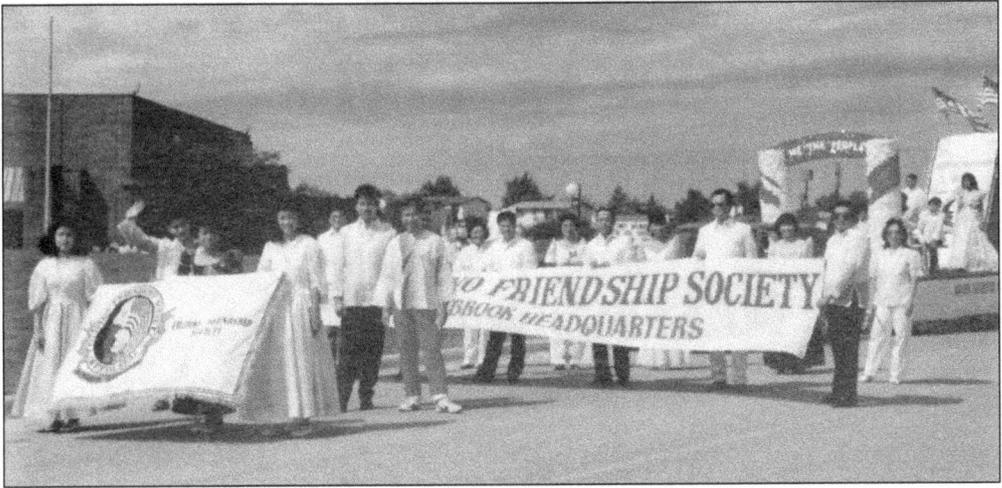

The Bolingbrook Filipino Friendship Society was founded in 1975 by Agnesio "Nick" Palmaira, who became the first president. The objective of the society is to participate in civil and social programs of the community and foster a deeper appreciation of Filipino heritage. Participation in the Pathways Parade, benefit balls in conjunction with cotillions (a Filipino tradition), and a scholarship award program are just a few of their community activities. (Both, courtesy of Romy Balcita.)

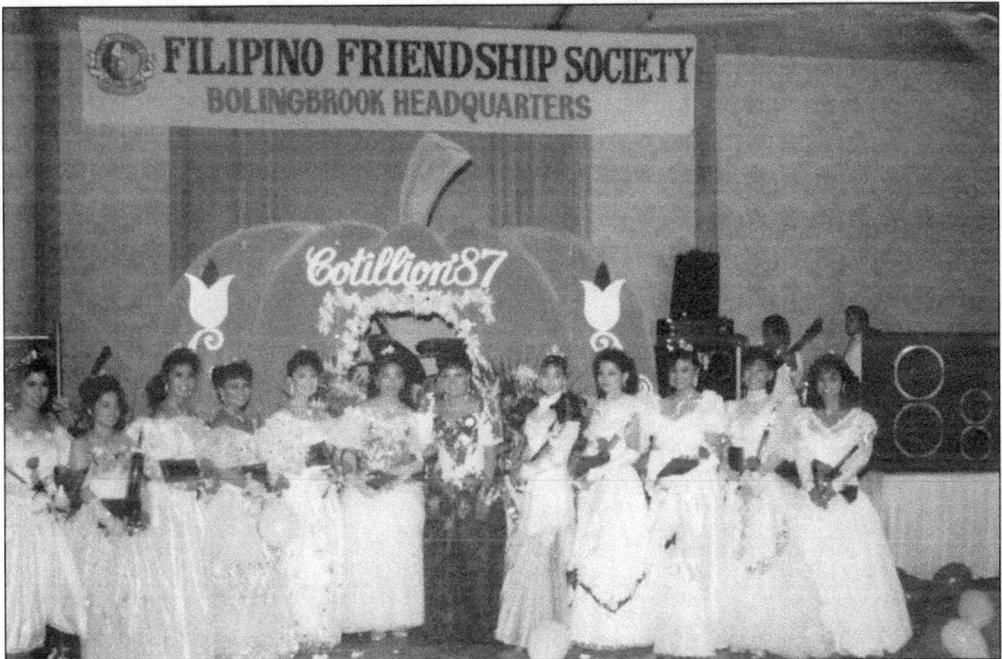

Bolingbrook is home to two cricket leagues; the Bolingbrook Youth Cricket League was developed in 2005, and the Bolingbrook Premier League was inaugurated in 2011 for adults. Dignitaries pictured below are, from left to right, Talat Rashid, Pakistan's general counsel Dr. Aman Rashid, Mayor Roger C. Claar, Prem Lavani, and Mir Ali (founder of the cricket leagues). The organization brought global exposure to Bolingbrook as it hosted an exhibition match in 2008 in support of the Chicago 2016 Olympic bid. The Association of Pakistani Americans of Bolingbrook was founded in 1991, and hosts Pakistan Independence Day programs, including the Taste of Pakistan and a flag-raising ceremony. Two mosques and Furqaan Academy serve the needs of the Muslim community. (Both, courtesy of Talat Rashid.)

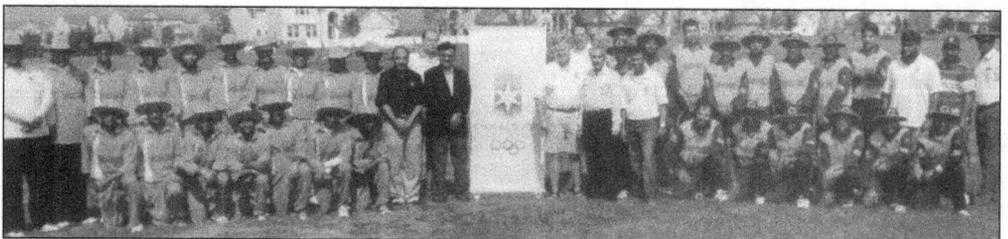

In 2000, (pictured below from left to right) DuPage Township trustee Felix George, Bolingbrook attorney Anita Kontoh Scott, and Bernard Winston founded the Black History Month Awareness Club. The not-for-profit social organization was formed to coordinate and host an annual social event that raises awareness about the history of black Americans. The event is held annually during Black History Month and is geared to all residents of Bolingbrook regardless of race and origin to assist in building bridges of tolerance and understanding. Black History Month recognizes and promotes the appreciation of centuries of African American achievement, culture, and heritage. (Both, courtesy of Bernard Winston.)

The Black History Month Awareness Club
&
The Bolingbrook Arts Council
Proudly Presents

"Live the Dream"

The 8th Annual
Community Wide
Black History Month
Celebration

Saturday, February 24, 2007

Place: Levy Center
241 Canterbury Lane
Bolingbrook, IL

Time: 4pm - 7pm

Free Admission; Free Food;
Free Door Prizes

Black History Month

Special Guest performance by:
Glennette Tilley Turner -
"Take A Walk in Their Shoes"-
The Underground Railroad
ALYO - an African Dance &
Precussion Group
Walter King Jr. -
the Magic of the Spellbinder*
Sigma Gamma Rho -
Step Show Exhibition
And Much More......
* Sponsored by the
Fountaindale Library District

Performers gather on stage at the annual Joyfest. The Joyfest program was founded in 1998 by local residents LeRoy Brown, Christen Parker, and Pastor Brown. Prior to the inception of Joyfest, the Bolingbrook Christian community sponsored an event called Gospel Fest. It began as a small indoor concert held at Jane Addams Middle School. Joyfest has grown and continues to receive support from the residents and Village of Bolingbrook. The overall success of Joyfest confirms the role of the church and the Christian community in Bolingbrook. (Courtesy of Kimberlee Owens.)

The Bolingbrook Choir began in the fall of 1973, when the church choirs of New Life Lutheran, St. Dominic's Catholic, and First Presbyterian Church of DuPage combined to perform a Christmas concert for the village. In 1977, the choir changed its name to Bolingbrook Community Chorus. With the support of the village, the community chorus has grown and annually performs a spring concert and December holiday concert.

Eight

GHOSTS

There are many ghosts roaming in the Bolingbrook area. From the pioneers who first settled the area to the businesses that started and failed, they all had an impact on the village. Pioneers set the stage in their quest for improvement and knowledge, and although there were a variety of small businesses (Grace's Clover Store, Willow Way Minuteman Store, the Cookie Jar, Brehm's Small Parts, Tony's Flowers, and Tortura's Finer Foods to name a few), incorporation heralded an opportunity for new businesses. Unfortunately, many of these businesses did not thrive. Recreational businesses included the indoor wave pool, Prairie Mountain, Fairlanes Bowling, and probably the most notable, Old Chicago, which helped put Bolingbrook on the map. Restaurants such as Cobbs, Armandos, Aurelios, Barones, the Coffeehouse, and Rockett's Carry-out have come and gone. Bolingbrook has always sought the written word, and many newspapers have been made available to the public. Local newspapers such as the *Bull Sheet*, the *Phantom Press*, the *Beacon*, and the *Met* have fallen due to new technology. Even the big box stores Kmart, Zayre, and Builders Square have shared time in Bolingbrook. Because Bolingbrook is such a young community, many residents have fond memories of these old ghosts.

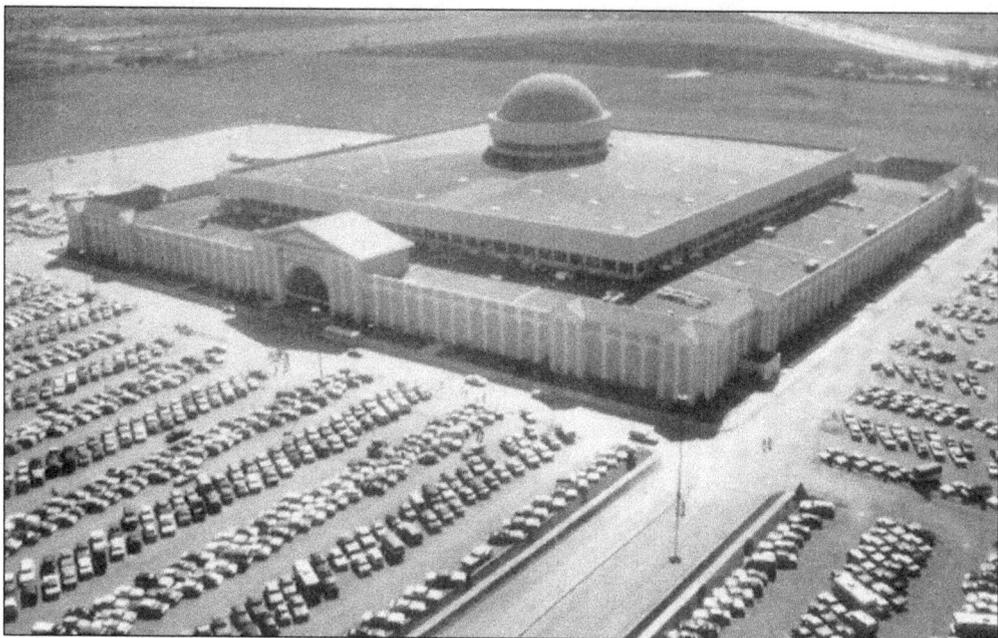

In 1973, Robert Brindle proposed a 345,000-square-foot indoor complex (above) to be built south of I-55. When Old Chicago annexed into Bolingbrook, it created a border war with Romeoville. Going south along I-55 to Weber Road, Romeoville went north and annexed the Grabow Farm. With the promise to put Bolingbrook on the map, Old Chicago opened in 1975; but, construction cost overruns put the complex into financial trouble. Trying to improve business, new rides were added, and sound baffles were installed under the dome to reduce the noise from the amusement rides. Rides in the park included one of the first corkscrew rollercoasters, the Chicago Loop; the Rotor; Yo-Yo; Flume; Chicago Cat; and Windy City Flyer. Entertainers such as Gary Puckett and the Union Gap, Chuck Berry, and the Four Tops were brought in to attract business. Restaurants in the complex included the Columbia House and the Old Chicago Biergarten.

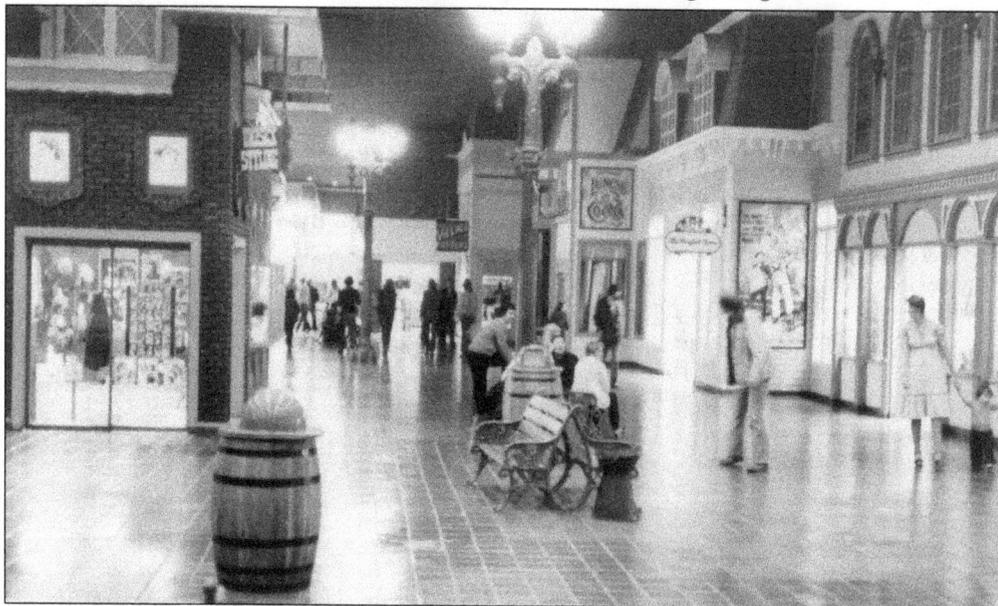

The park's mascot, Mayor Charlie Baffle (shown with a family on the merry-go-round above), welcomed visitors to the amusement park. Movie director Brian DePalma shot a scene for the movie *The Fury* at Old Chicago. These and other entertainments such as the high-wire walker (below) could not stave off financial doom. Additionally, the park was hurt by a lack of anchor stores to bring in local repeat shoppers, and a competing amusement park in the same general region pushed Old Chicago to the verge of bankruptcy. In 1978, the mall started closing early on Mondays and Tuesdays. Unfortunately, business did not improve, and the park finally closed on March 17, 1980, just five years after it opened. Despite heroic efforts to save the building, it was demolished in 1986. Arena Auto Auction, now called Manheim Arena Illinois, occupies the space.

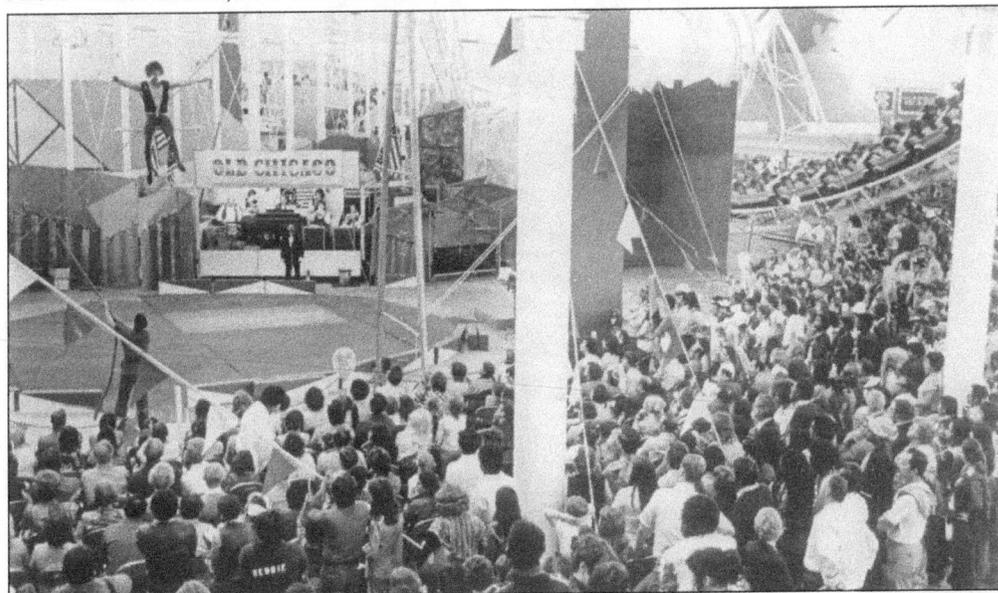

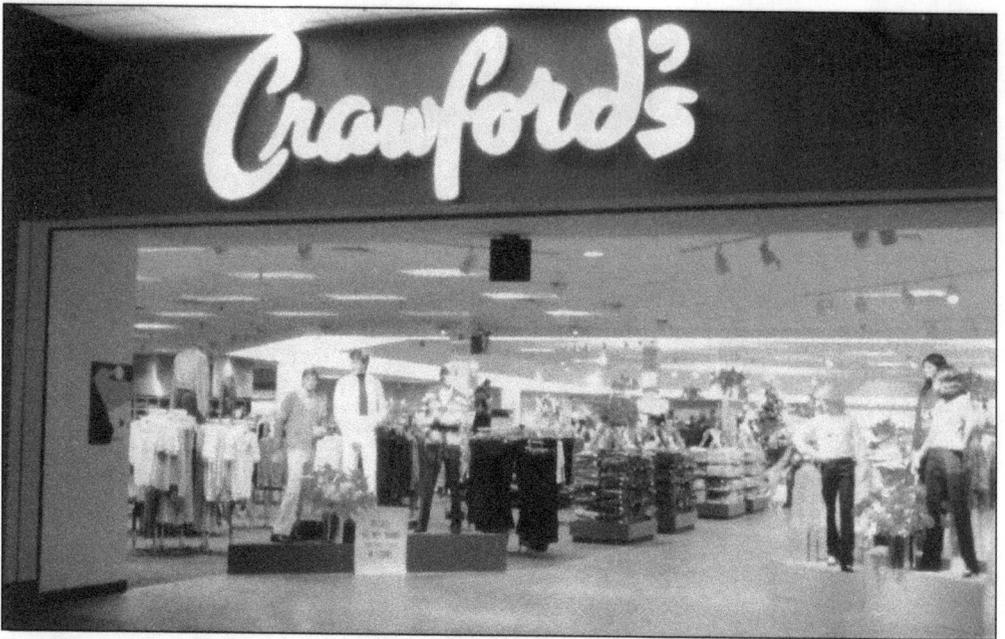

South Commons Mall was located south of I-55 on Route 53. Developed by E.N. Maisel & Associates, stores began opening in 1976, just one year after the opening of Old Chicago across the street. The first anchor store was Kmart, which opened on the north end of the mall. By 1980, Crawfords, an upscale clothing store, opened on the south end. South Commons Mall had over 40 storefronts, including shoe, jewelry, and furniture stores, Aladdin's Castle, Pearl Vision, and Walden Bookstore. Outbuildings included Aurelio's Pizza, Perkins Restaurant, and Bolingbrook's first movie theater. Originally built to draw visitors from Old Chicago, the last stores were opening as Old Chicago was beginning to shut down. Unfortunately, the mall did not remain open long after Old Chicago closed. Kmart did relocate to the western edge of Bolingbrook, in Maple Park Place just west of Weber Road.

PRAIRIE MOUNTAIN™

KING PETER

I-55 and Route 53 Bolingbrook, Illinois

Prairie Mountain Amusement Park, developed by Gurrie Rhoads, was located on Frontage Road just west of Route 53 and north of I-55. It offered village residents a variety of fun activities, including water slides, bumper boats, and a miniature golf course. It was one of the first water amusement parks in the southwest suburbs and provided many hours of entertainment for Bolingbrook residents. The bumper boats were particularly entertaining for the younger children, while the water slides offered fun for older children and adults. Food and refreshments were also part of the Prairie Mountain experience. Prairie Mountain could be seen from miles around with its location close to I-55, which attracted many visitors out of curiosity to check out the mountain in the middle of nowhere. Another side benefit of Prairie Mountain was that it provided many local teenagers with employment for the summer months.

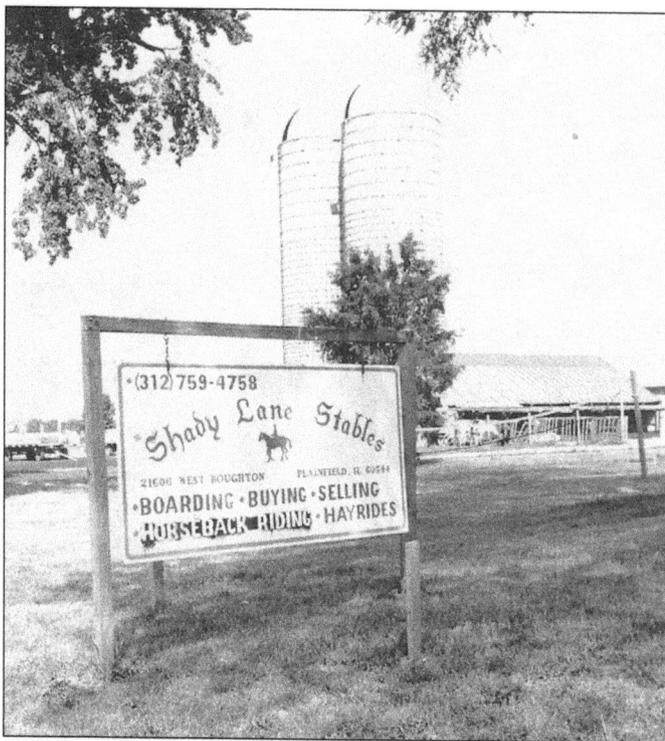

In the early farmland years, Bolingbrook had a place called Shady Lane Stables. It was located on the north side of Boughton Road, near what is present-day Kings Road. Shady Lane Stables offered residents the opportunity to board horses and take lessons in dressage and jumping. By the 1990s, it made way for yet another subdivision in Bolingbrook.

The Brehm house was located along Boughton Road west of Schmidt Road. In a *Bolingbrook Metropolitan* newspaper article on February 13, 1975, it was described as the only remaining brick farmhouse in DuPage Township. With the coming of Dover Construction Company in 1960, the farm face of the area was forever changed. The Brehm house was one of the last farmhouses to disappear.

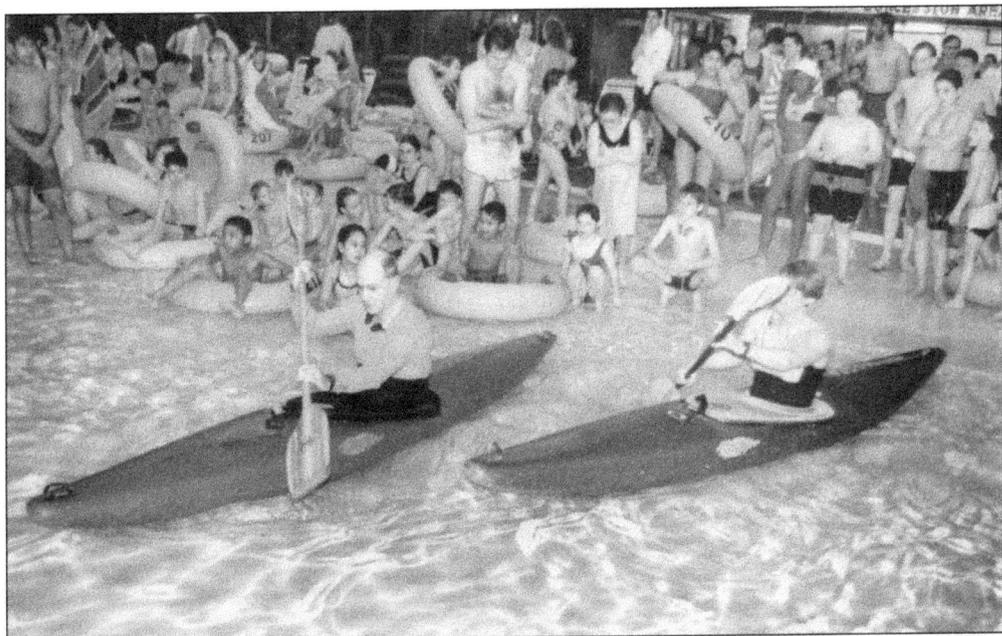

The Chicago Whitewater Association kayakers held training sessions at the wave pool. Bolingbrook's wave pool opened on November 6, 1982, and was the first indoor wave pool in the Western Hemisphere. As a zero-depth pool, patrons could walk into the pool just as if it were an ocean, and the wave machinery could generate waves as high as four feet. The pool closed because of deterioration from chlorine exposure, and today it is the home of Rocket Ice Arena, with two rinks to accommodate both figure skaters and hockey players. Below, at the wave pool, is Ursula Pahlow, a swim instructor in Bolingbrook for over 30 years. From the wave pool to the Bolingbrook Recreation Aquatic Center, she has taught swimming and water aerobics to multiple generations of Bolingbrook residents.

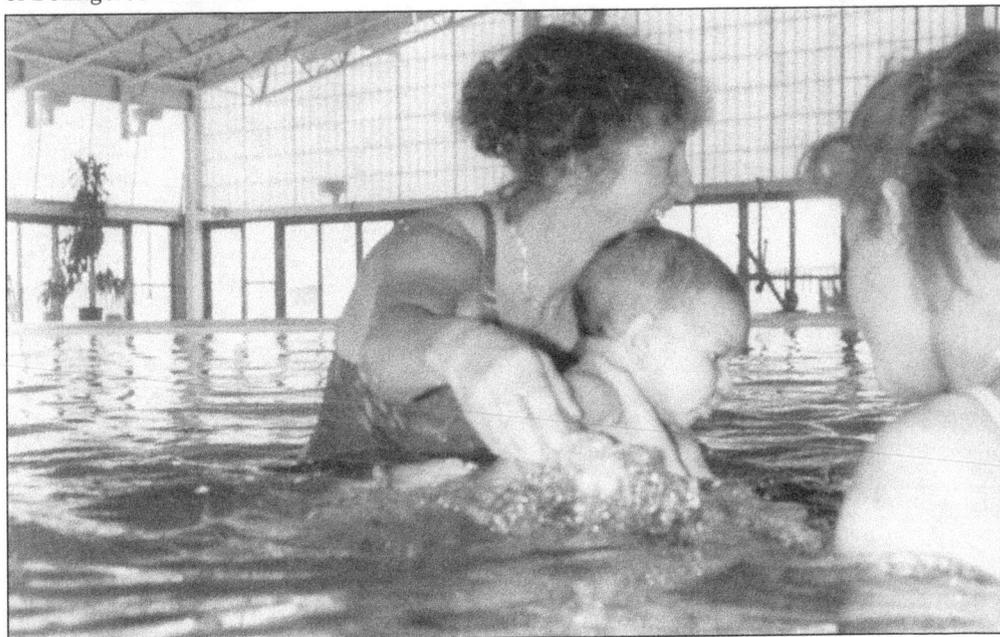

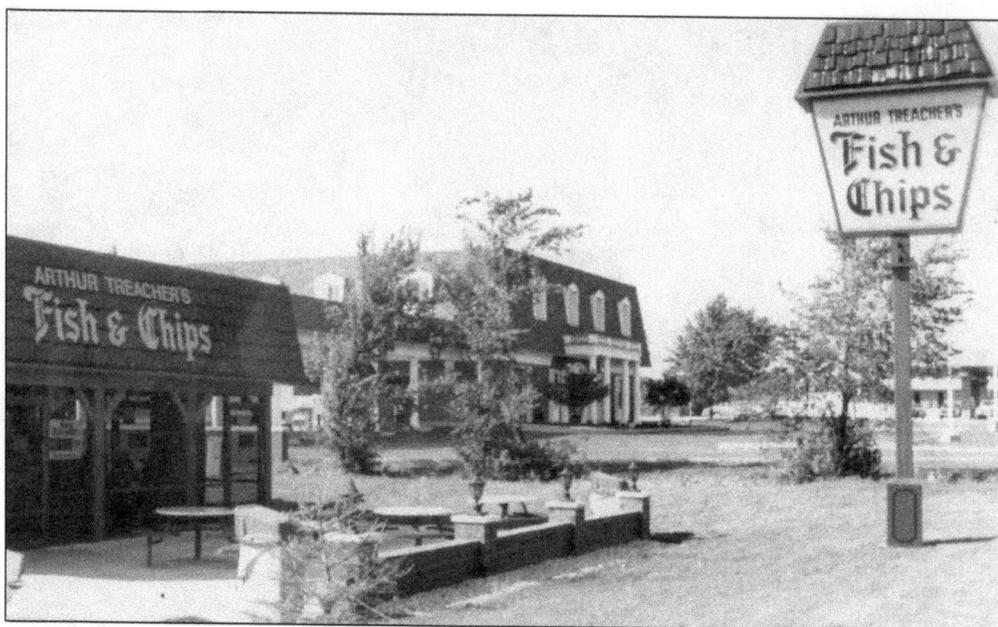

Arthur Treacher's Fish and Chips came to Bolingbrook in 1976, and prospered initially, as it was the only fish and chips restaurant in town. The firm was named after an English character actor who lived from 1894 to 1975; he served as the company spokesman in the early years. The franchise was started in 1969 and had 45 stores in eight states as of 2008.

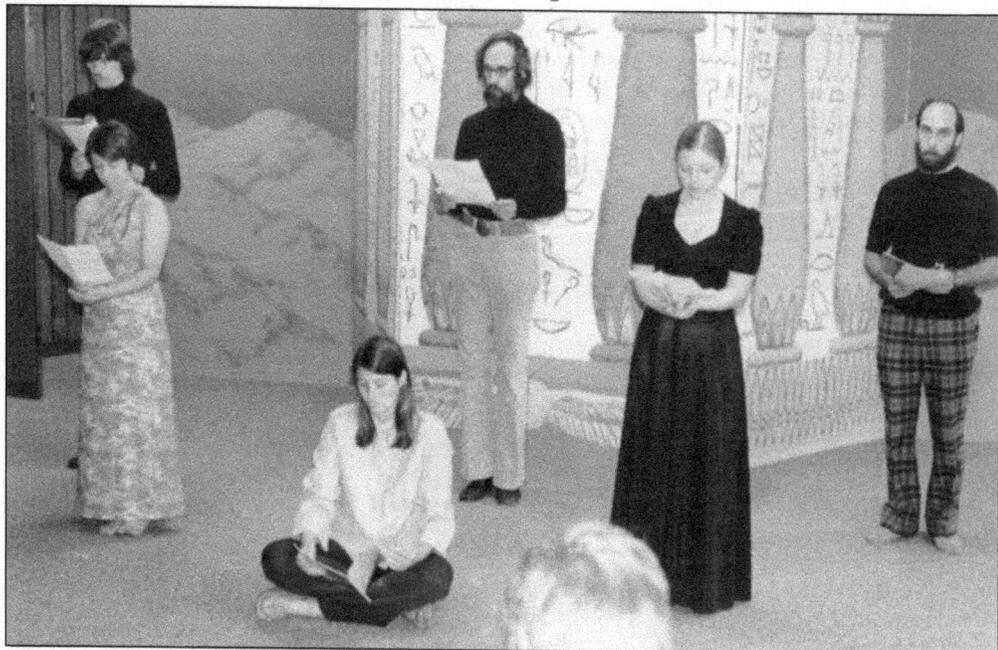

Started in 1975, the Fountaindale Community Theatre project was a division of the new community arts council. *Opus One*, a collection of short plays and scenes, was its first production. Pictured here are, from left to right, Jim Stenhouse, Mary Ann Galgano, Jean Stenhouse, Bob Dunlap, Corrine Galgano, and Martin Wallach, director and group founder. The group would later become the Valley View Theatre Guild, which performed into the late 1990s. (Courtesy of Jim Stenhouse.)

Nine

LEADERSHIP LEGACY

Residents who followed village politics from incorporation through today find themes running through the various platforms presented by the candidates. Progressive Economy Party, Pride in Bolingbrook, Priorities for People, Work Slate, and First Party candidates all had different philosophies about a vision for Bolingbrook. However, there were a number of questions commonly asked. Where will the boundaries of the village end? Who will own the sewer and water company? How can there be balanced commercial and industrial development helping the tax base for the village as well as the school district? Campaigns stated Weber Road would be the western boundary, and ownership of Citizen's Utilities (now Illinois American Water) would control the growth. The quality of life in Bolingbrook would include buying local and enjoying recreation without leaving town. Mayors and village trustees were elected and these themes were debated; however, Bolingbrook did not have a consecutively reelected mayor until Roger Claar. Expanding and improving on the work of his predecessors and with the cooperation of the board of trustees, many of these election themes have become a reality. The Bolingbrook Medical Center on Schmidt Road served residents for 25 years until the Bolingbrook Adventist Hospital was approved and built. Establishing Bolingbrook village boundary lines took time as well, since Woodridge, Plainfield, and Romeoville were all interested in expanding their boundaries. In the late 1980s, a state grant was received to upgrade the aging Royce Road Water Reclamation Plant, allowing for the closure of the East Briarcliff Plant. Annexing the land along I-355 gave Bolingbrook space for the Promenade Mall. Bolingbrook was listed as the 32nd Best Place to Live in 2008 and 38th Best Place to Live in 2014 by *Money* magazine.

1965 to 1968

The Progressive Economy Party, under the leadership of Jack Leonard for village president (mayor), swept the first election for village officers. Leonard was 32 years old; a graduate of Northwestern University with a degree in business administration, he was a good fit for establishing a village government. Elected with him were Nona Thompson (village clerk), Bob Schanks, Bill Plimmer, Bill Wipfler, Bob Jackson, Bob Reeves, and Lou Giacone (trustees). Leonard resigned in 1968, fearing that a referendum to create a fire department might fail due to conflicts he had with several board members. The referendum passed, and Leonard and his family lived in Bolingbrook until 1973. He died in Peoria, Illinois, in 2001. Pictured below at Fire Station No. 2 are two new fire trucks owned by the Village of Bolingbrook.

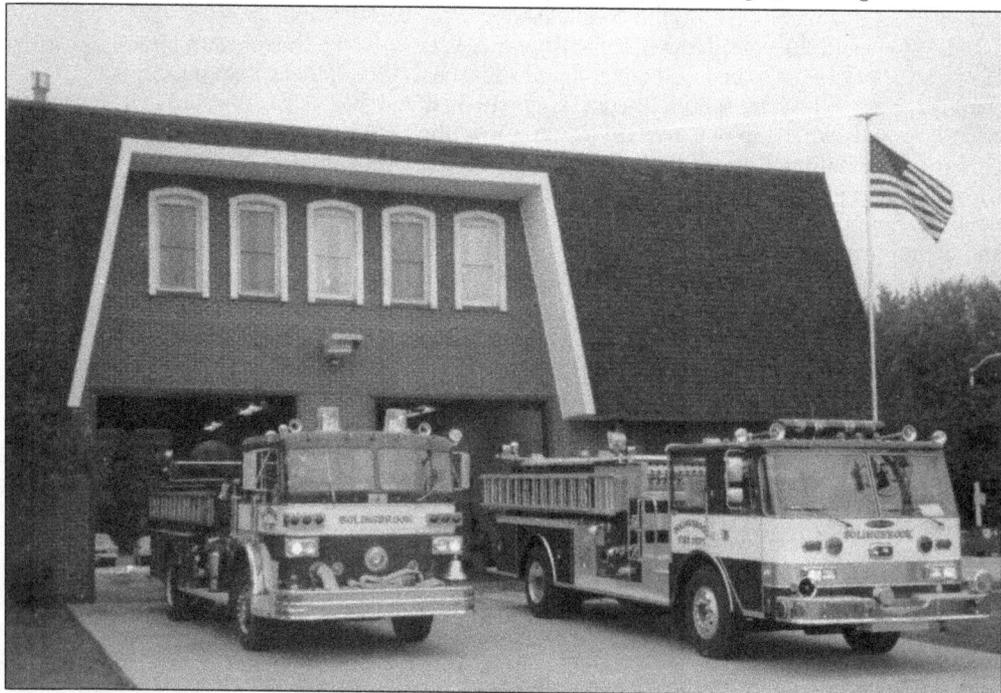

When Jack Leonard resigned in 1968, Robert B. Schanks, 33, was selected by the board to fill the mayoral position. Schanks was employed by Commonwealth Edison as a foreman. Reelected with the PACE Party in 1969, Schanks was confronted by numerous developers. Negotiations with Centex-Winston and Surety Builders put the fledgling village in the sewer and water business with the building of the Royce Road plant. Schanks remained in Bolingbrook, serving two terms as DuPage Township supervisor (1997–2004). He died in 2013.

1968 to 1973

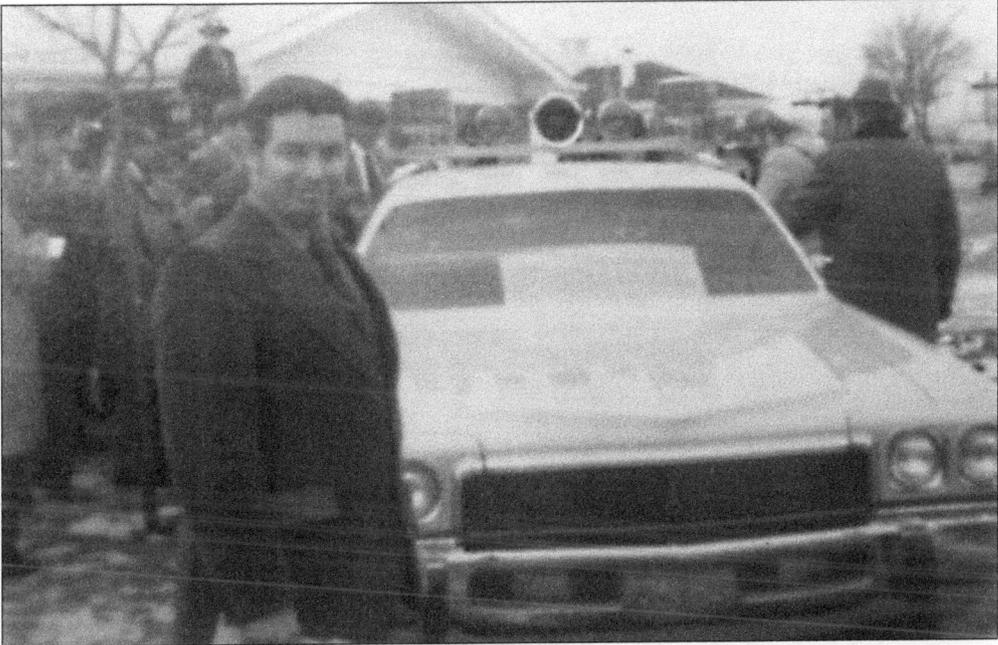

Freddy the Talking Squad Car was a 1973 Plymouth police car donated by the Chrysler Corporation. It made its debut in February 1973, and Gov. Dan Walker joined with local dignitaries to watch the first demonstrations. A policeman, using a radio, answered questions from the children, who thought that Freddie was speaking. The squad car was used for community education events.

1973 to 1974

Thomas Groseth and his slate won the election of April 1973. Based out of the Beaconridge Improvement Association, they were the first officials who were not involved in the incorporation of Bolingbrook. The new mayor wanted more businesses to locate in Bolingbrook. When Bob Brindel approached with the idea of Old Chicago, he received a warm welcome from the board. In 1974, Mayor Groseth ran into financial problems within his workplace and by May he had to resign. A revolving door of mayors and trustees began for the next two years. Mayor Groseth is pictured below congratulating the Pitch in for Pathways poster contest winners. Judy Bredeweg chaired the project for the Federated Women's Club. Tom Groseth died in 1998.

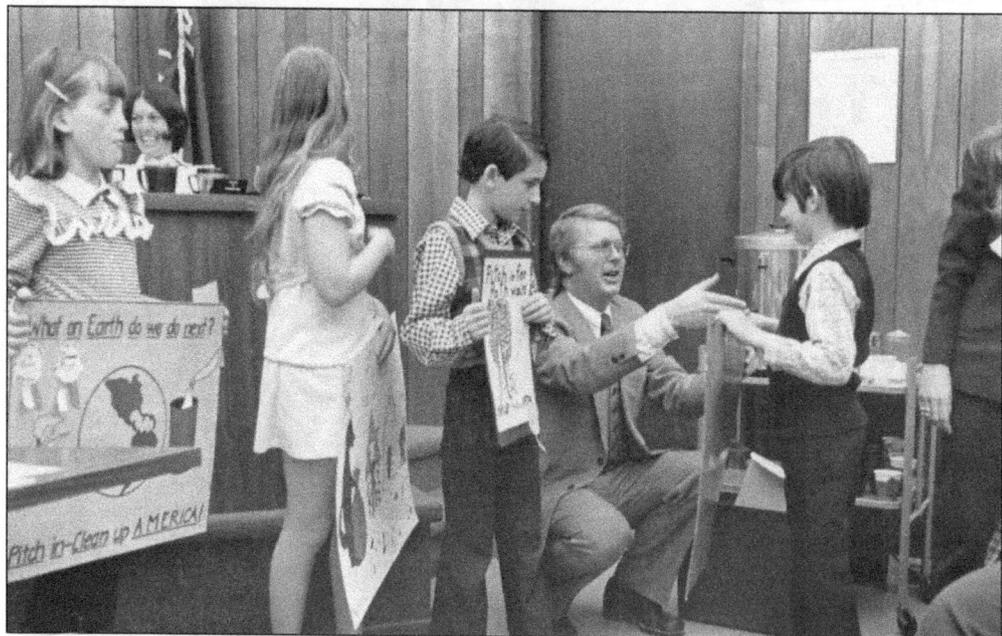

After Mayor Groseth resigned, Patricia "Pat" McDowell was appointed our first female mayor. She served for six months and then resigned due to her husband's transfer to Denver, Colorado.

May, 1974 to October, 1974

October, 1974 to April, 1975

Appointed to replace McDowell, James Johnston finished the term of office until April 1975. During the period from the 1973 election to the 1975 election, Bolingbrook had three mayors and numerous trustees; the entire board was up for election in 1975.

101

Eleanor "Nora" Wipfler and her husband, Bill, moved into Bolingbrook in 1962. Bill served as a village trustee on the first board, and Nora served as chair of the planning commission and a year on Groseth's board as a replacement trustee. Looking for stability and planning, the Bolingbrook Pride Party put forth a slate with Nora Wipfler as the mayoral candidate. She won, but two independent trustees, Chris Giannopulos and Judy Bredeweg, joined the board.

1975 to 1977

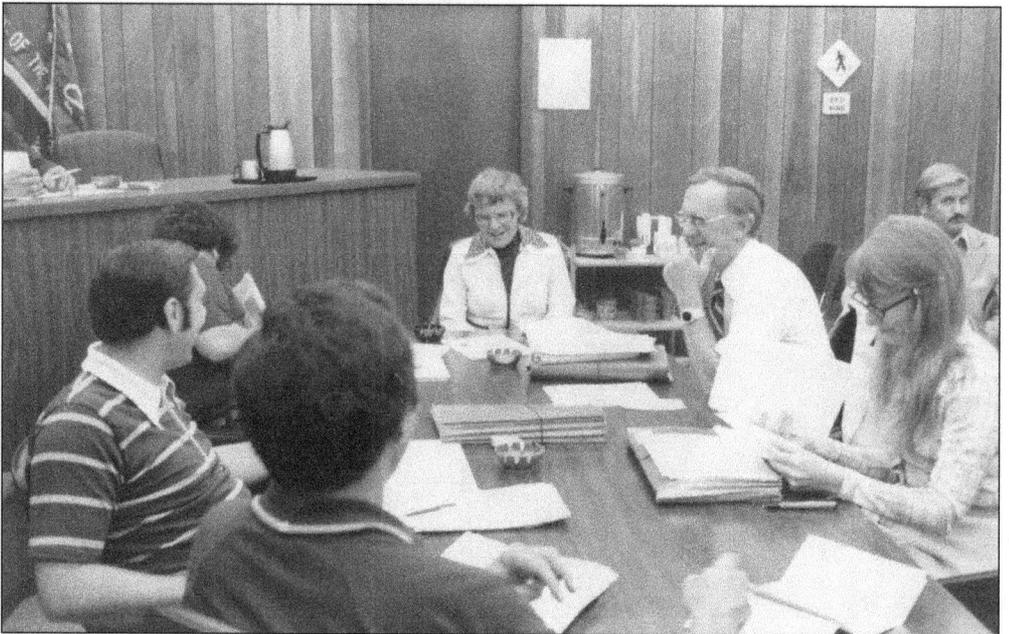

Many projects were discussed by the village board, including the town center. Pictured from left to right are village trustees Larry Barnes, Chris Giannopulos, and Ed Rosenthal; Mayor Nora Wipfler; village manager Reed Carlson; trustee Judy Bredeweg; and police chief Ron Johnson. After losing the 1977 election, Wipfler and Bredeweg were elected to the Will County Board. Nora Wipfler passed away in 1993.

Robert L. "Bob" Bailey and his Work Slate swept the 1977 election. Bailey moved to Bolingbrook in 1963, and volunteered for the Bolingbrook Homeowner's Association and Park District. He served as a trustee and two-time non-consecutively elected mayor. Bailey pushed for the widening of Route 53 to four lanes and built Remington Road to Schmidt Road in anticipation of industrial growth. A year into his second term, he resigned and moved to Missouri. Bailey cut the ribbon opening the town center and the third village hall in 1981. Just before Bob Bailey passed away in 1994, Mayor Roger Claar named the entire town center complex after him.

1977 to 1981 and 1985 to 1986

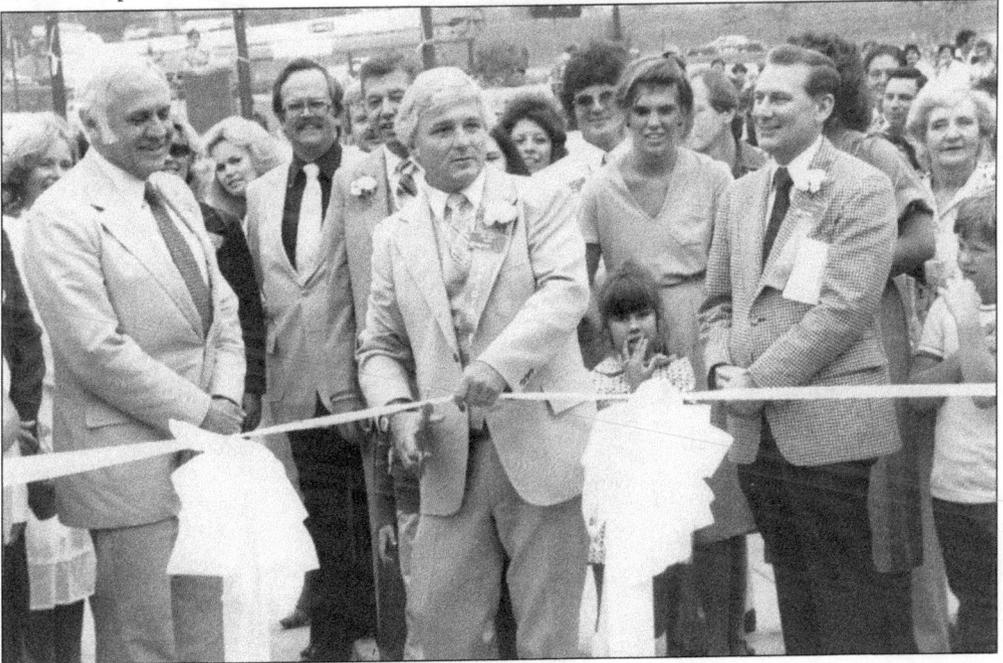

1981 to 1985

Edward Rosenthal and his family moved into Winston Village in 1970. Rosenthal was an earth science teacher who graduated from the University of Illinois and did his graduate work at Northern Illinois. Rosenthal went from president of the Winston Village Board to the plan commission, trustee, and mayor, in 1982. Seeing the effects of the Lemont tornado in 1976, Rosenthal made a village-wide tornado warning system part of his legacy. He also encouraged the Jaycees' sponsorship of Student Government Day. He is pictured below with Bolingbrook High School senior Michelle Dwonch, who was village president for the day. He did not seek reelection in 1985 and remains in the village today with his wife, Hilary.

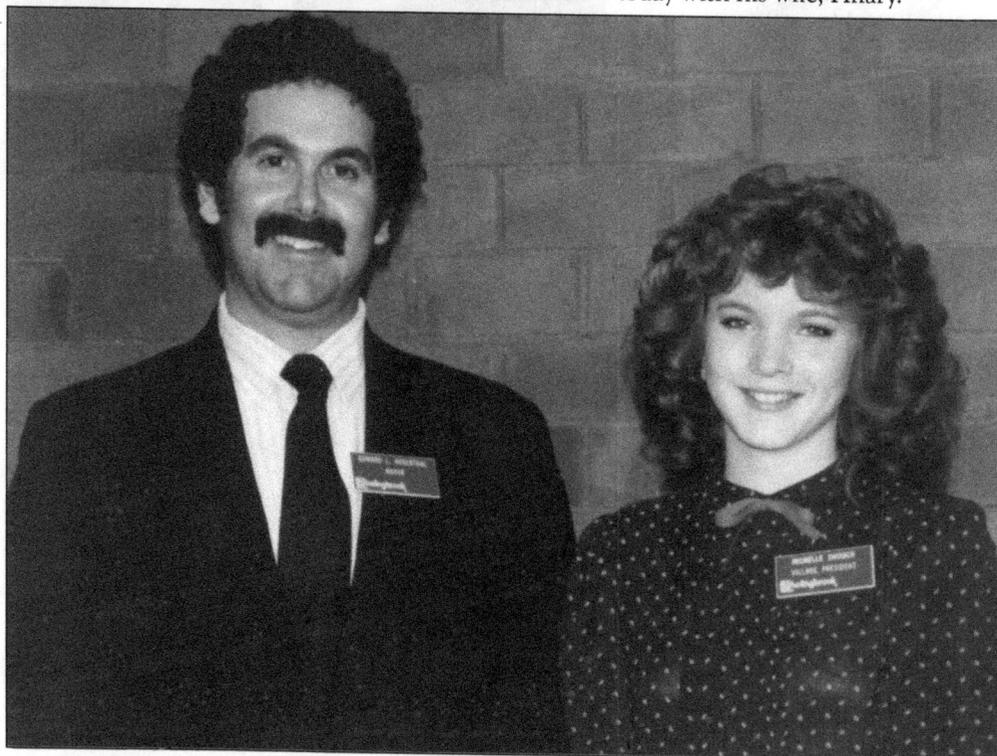

Roger C. Claar and his family moved to Bolingbrook in 1977, when he accepted the position of executive director of WILCO. His undergraduate work was at Eastern Illinois University, and he received his doctorate from Kansas State University. Claar was appointed to the police and fire pension board for one year before becoming a five-year village trustee. When Bob Bailey resigned in 1986, Claar was appointed mayor and has continued to be reelected up to the time of this writing. His Bolingbrook First Party retains full control of the village board. While serving as trustee, Claar learned how to pursue the best interests for Bolingbrook. Pictured below are, from left to right, (seated) Randy Bunker (WJOL), village manager Bob Kolodziej, economic director Barb Kattermann, and unidentified; (on the dias) trustees Jim Hobin, John Armstrong, Peggy Danhof, village clerk Carol Penning, Mayor Bob Bailey, attorney Barry Moss, trustees Roger Claar, Bob Lang, Leanne Johnson (hidden) and public works director Bill Moore.

1986 to

From May 12 to May 23, 2005, a delegation led by Mayor Roger C. Claar from Bolingbrook went to China to learn more about the Chinese people and explore economic opportunities between local businesses and the Asian nation. Traveling to Beijing, Xuchang, Shanghai, Tiananmen Square, and the Great Wall were highlights of the trip. The delegation also had an opportunity to visit several schools and enjoy a theatrical performance. (Courtesy of Sandie Calcagno.)

The Village of Bolingbrook Trade Delegation to the Republic of India was from February 16 to February 25, 2007. The delegation was formed to promote international trade relations with foreign countries. India was a likely choice to visit, based on the thriving Indian community in Bolingbrook. The delegation had an opportunity to visit the city of Delhi, the Taj Mahal, and Mumbai.

With urging from Bolingbrook residents, Mayor Roger C. Claar headed a 16-person trade and tourism delegation to the Republic of the Philippines from April 14 to April 21, 2008. Mayor Nick Churnovic from Crest Hill and Mayor Joe Cook from Channahon joined business and civic members from the southwest suburbs who traveled to Laguna Province, San Pablo City, Metro Manila, and Cebu, participating in business roundtable discussions and exploratory talks on business potentials. While visiting the city of San Pablo, a street was named after Bolingbrook, and San Pablo, the "City of Seven Lakes," became a sister city to Bolingbrook. One can view the sign at Boughton Road and Lindsey Lane. These trade trips to China, India, and the Philippines were led by local businessmen to showcase their countries' economic opportunities. (Above, courtesy of Sandie Calcagno.)

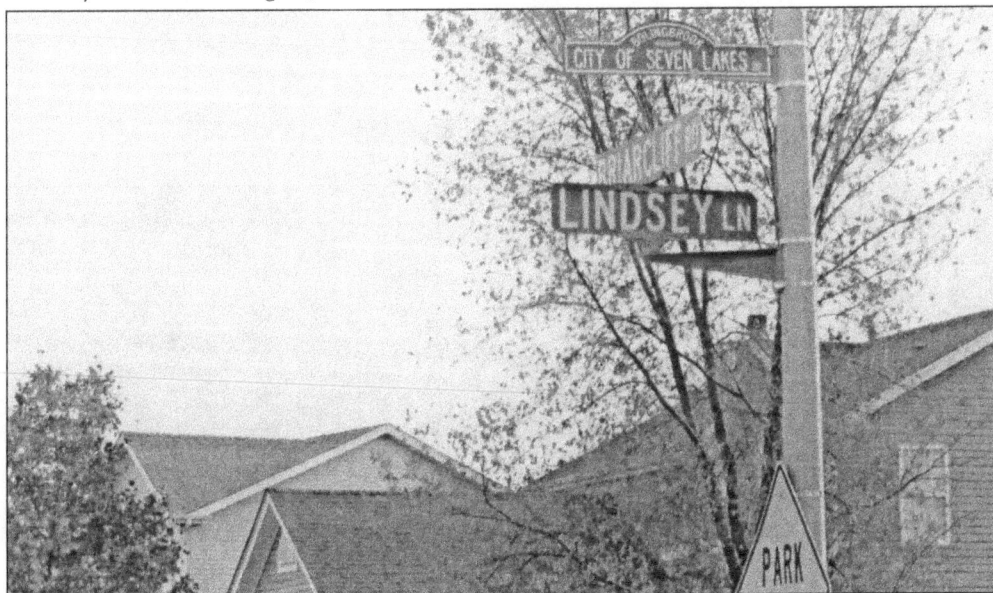

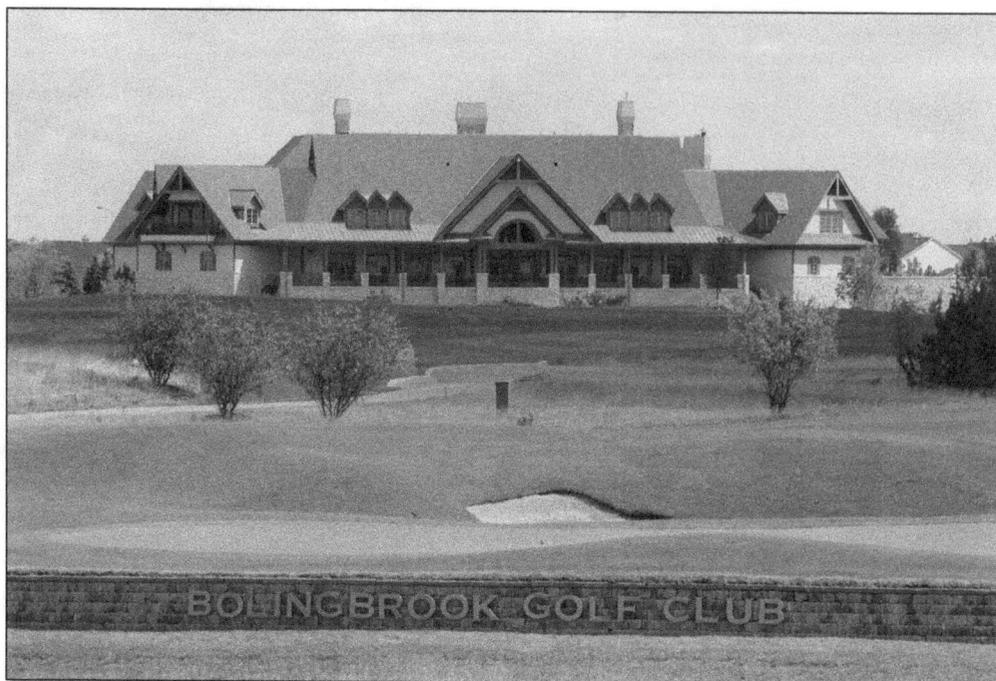

The Bolingbrook Golf Club opened in 2002. Located west of Weber Road on Rodeo Drive, one cannot miss the glorious three-story brick clubhouse, a symbol of community pride. The second floor contains the grand ballroom, accommodating up to 750 guests for a sit-down function. Highlights of the 18-hole championship golf course include an island green par-3 and 600-yard par-5 that should be played with the prevailing wind.

Since opening on January 14, 2008, as the state's first new hospital in 25 years, Adventist Bolingbrook Hospital with its Level II trauma center has been recognized as a state-of-the-art healthcare facility. It has the latest technology and a highly skilled, patient-oriented clinical team. The 138-bed, 310,000-square-foot hospital was designed with patients in mind, with private, family-friendly patient rooms designed for comfort and ease. (Courtesy of Bolingbrook Adventist Hospital.)

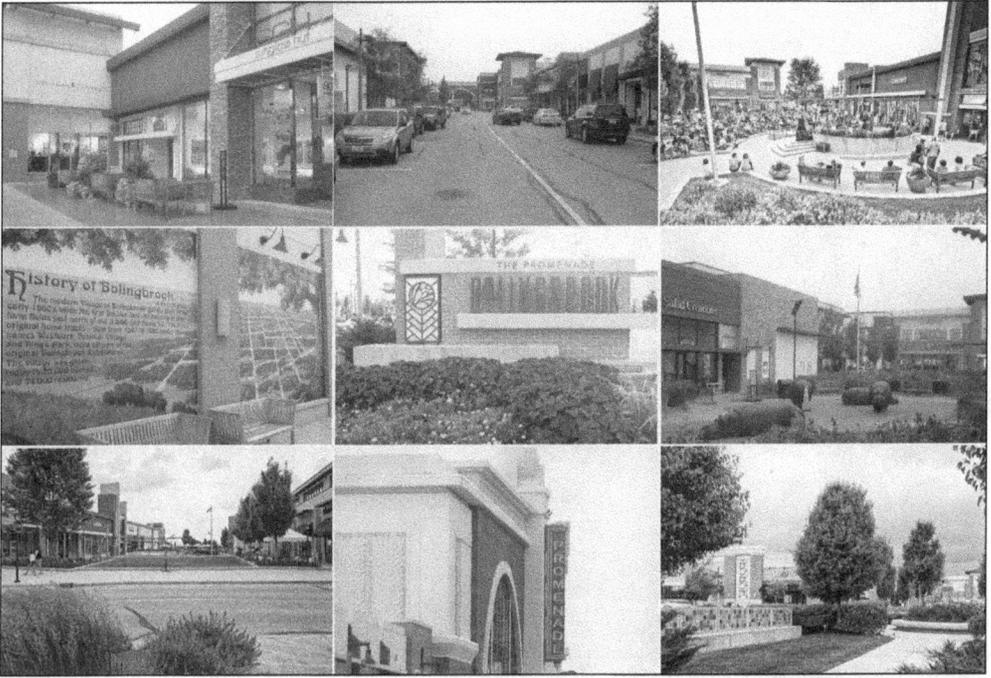

The Promenade Bolingbrook is the first lifestyle shopping mall built in the Chicagoland area in almost 25 years. Encompassing 121 acres on either side of Boughton Road near I-355, Promenade Bolingbrook opened in two phases. Phase I, on the north side of Boughton Road, is anchored by IKEA and other retail stores. Phase II, on the south side of Boughton Road, with anchors Macy's, Barnes & Noble, and Bass Pro, opened on April 26, 2007. To coincide with the opening, the promenade developers introduced Prints of Pride, a tile imprinting event to benefit the children's emergency room at Adventist Bolingbrook Hospital. For a donation, children could place their handprints into a clay tile. Andy and Nancy Witt of Circaceramics colored and fired the tiles. The tile wall below is located near Bass Pro.

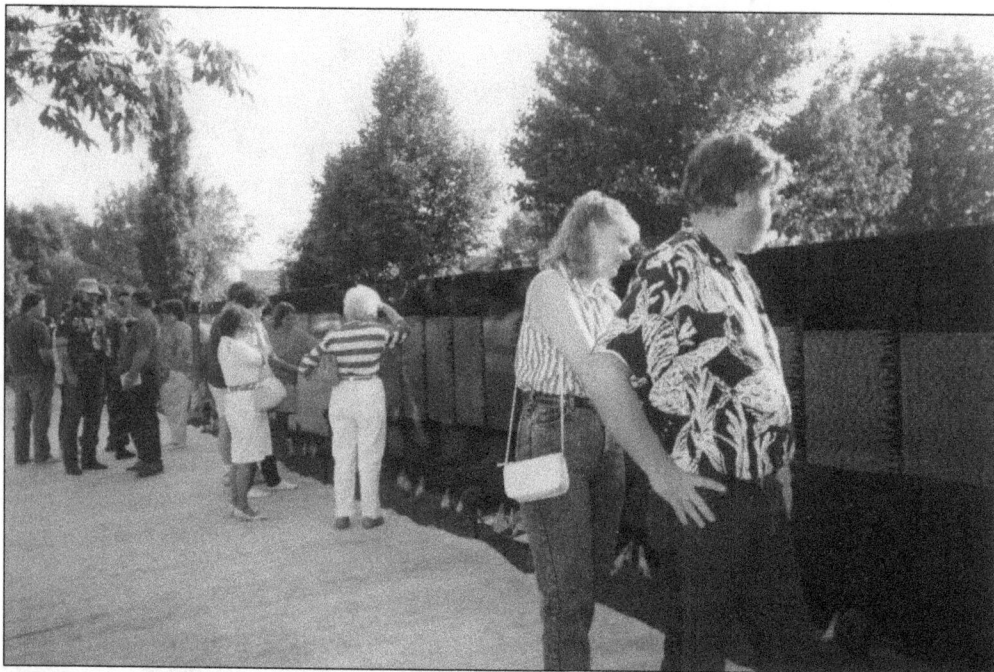

The Moving Wall came to Bolingbrook in 1990; this half-size replica of the Vietnam Veterans Memorial Wall in Washington, DC, has been touring the country since 1984. Among those responsible for bringing the memorial to Bolingbrook are John Davin, Peggy McMillan, and Bob Fagust. Many Vietnam veterans have supported the return of prisoners of war and those missing in action while serving their country. Many POWs have been released and returned home and MIAs identified and returned for a proper military burial. The POW flag flies at Bolingbrook Town Center out of respect for these servicemen. Vietnam veteran Dennis Meehan was instrumental in naming Veteran's Parkway, located off of Weber Road at 107th Street. (Above, courtesy of Jeanette Ginocchio.)

The village has always looked after residents with disabilities. Sidewalks have curb cuts, making it easier for wheelchair travel. Edward Bannister, who served as president on the Illinois Coalition for Disabilities, advocates regularly with Mayor Claar. In 2003, the village board added a Visitability Code to the village ordinances, providing criteria for step-free entrances, width of hallways, bathroom designs, and electrical switch placement in single-family homes.

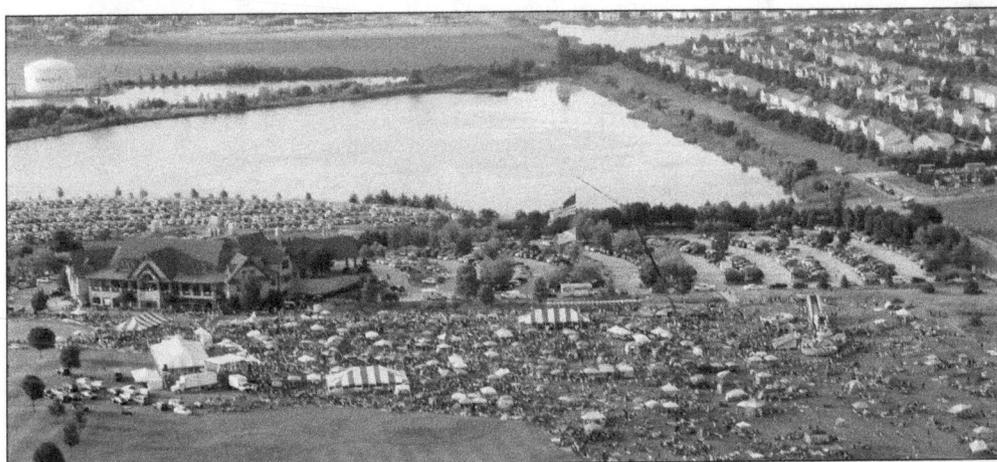

In 1990, Bolingbrook devised a master plan to handle storm and wastewater. In October 1992, the village board annexed 2,673 acres west of Weber Road, creating Americana Estates, Bolingbrook Golf Club and Course, and a new reclamation plant. There are 10 large storm water lakes doubling as water hazards at Bolingbrook Golf Club.

Pathway to Eagle annual encampment at the town center invites boys to focus on becoming Eagle Scouts, the highest rank a Scout can achieve; pictured here is Eagle Scout Jacob McVey. More than 200 Bolingbrook men have become Eagle Scouts, and the first from Bolingbrook was Paul Spittel from Troop No. 32. One can view the list of Eagle Scouts at the village hall.

The highest Girl Scout award is the Gold Award. In 1995, Bolingbrook's first Gold Award went to Nichole Payne (left) pictured here with Gold Award recipient Jennifer Randall. In August, one can find scouts enjoying a jamboree at the town center. (Courtesy of Nancy Hackett.)

Ten

A PLACE TO GROW

What a ride these last 50 years have given the residents of Bolingbrook. The pioneers from the 1830s would not recognize their homesteads. From incorporation in 1965 to 2015, Bolingbrook went from three small subdivisions with only a few amenities to a multi-subdivision, self-contained, thriving community. Now 25.6 square miles, Bolingbrook went from zero to 5,062 streetlights, zero to 581 miles of sidewalks, zero to 58 traffic signals, and zero to around 40 churches. Bolingbrook now has many shopping complexes and a manufacturing-industrial growth center that increase the tax base.

While the village of Bolingbrook encompasses two counties, several townships, and multiple school districts, the residents retain a strong sense of community. It is not just the mayor and board of trustees that moved Bolingbrook, but the countless clubs, organizations, and volunteers. The numerous people involved with community interest groups made the difference in developing the strong sense of civic pride in Bolingbrook. Second- and third-generation residents are proud to be called Bolingbrook natives. Some successful residents include Susana Mendoza, a Chicago city clerk; Fahad Babar, world-famous cricket player; Steve Jaros, professional bowler; and Schin Kerr, actor in the Walt Disney movie *Glory Road.*

Bolingbrook has grown and remains a place to continue growing. The diverse population of about 75,000 residents has plenty of opportunities to participate in the multiple programs offered by the village, park district, library, churches, schools, townships, and senior center. Shopping and quick access to interstate highways provide variety and mobility. Bolingbrook is a great place to grow.

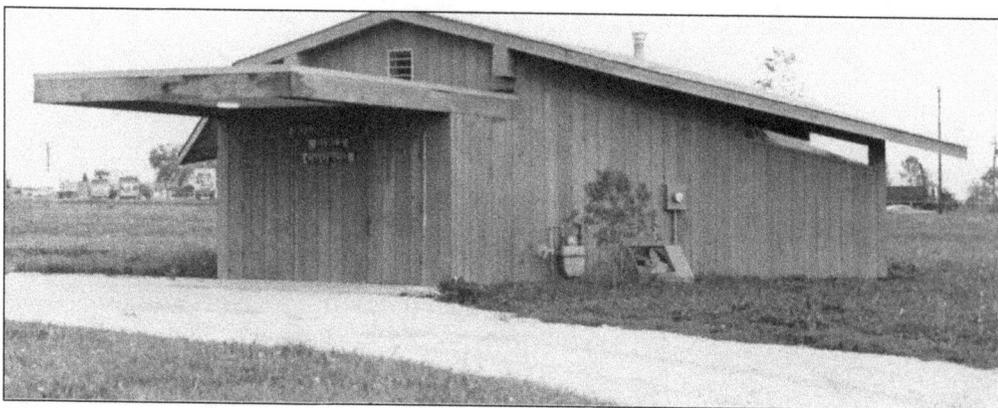

The Bolingbrook Community Bible Church was the first organized religious group in the Colonial Village subdivision. A nondenominational group started by Rev. Jack Strickland in 1962, the congregation first met in homes and later rented a home in the Westbury subdivision. As the church membership grew, a house was purchased on Pinecrest Drive in the Colonial Village subdivision in 1963. The church was built on East Briarcliff Road in 1968.

Since the first worship service on October 12, 1969, New Life Lutheran Church has been an integral part of the community. In 1972, New Life sponsored Boy Scout Troop No. 34, which still meets there today. The once-small church has built additions to include a larger sanctuary, basement, and gymnasium, all open to the youth of the community. The name New Life was chosen because of all the growth and new life springing up in the cornfields of Bolingbrook. (Courtesy of Rev. Orlyn Huwe.)

Begun as a mission in 1973, Friendship United Methodist Church was officially sanctioned on October 20, 1974. It first met in North View School and then the high school; the first service in the new church was on November 19, 1978. Friendship was added to the church's name in 1975. Known as the "Church with the Sign" offering advice to drivers on Boughton Road, the congregation touted advice such as "When looking for faults, use mirrors, not telescopes."

St. Benedict Episcopal Church held its first service in a member's home on June 11, 1972. Conducting services at various sites, the church was finally able to dedicate a new building on September 13, 1981. Two geodesic domes would rise out of the cornfields to become the new church. As the congregation grew, so did the mold in the domes, and the church had to be demolished in 2001. Today, a Prairie-style building replaces the old domes.

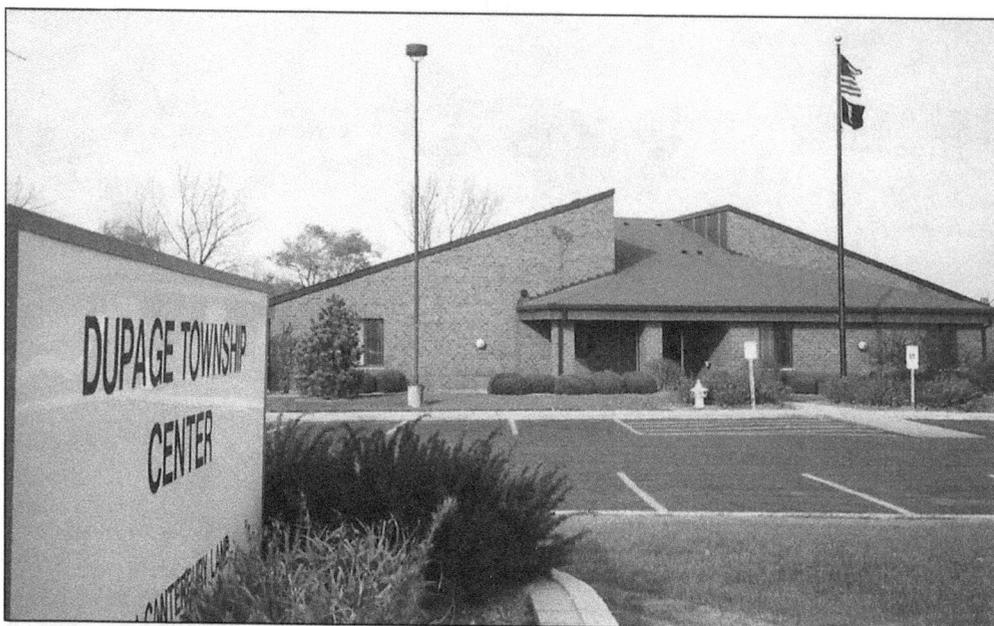

In 1987, DuPage Township opened its administrative building at town center. Located at 201 Canterbury Lane, the building is home to the township assessor, general assistance administrator, the youth department, and town supervisor and board. The township has won many awards from the Township Organization of Illinois for providing programs geared toward an urbanized township.

The snowstorm of 1979 brought together the town highway department and the Village of Bolingbrook to provide plowed roads. Highway commissioner Lloyd Eipers took this photograph at Schmidt Road. Before incorporation, all roads in the area were maintained by the township. Today, the highway commissioner's job no longer exists, as all roads are maintained under municipal agreement.

In 1991, Joseph Levy, a local car dealer, matched DuPage Township funds to build the Joseph and Sarah Levy Senior Center on Canterbury Lane, next to the township administration building. With a meeting room for 250 people and several smaller activity rooms, "The Poor Man's Country Club" is a local hangout for seniors.

Pictured here are, from left to right, state representative Jim Meyer, Joseph Levy, Bolingbrook Senior Club president Lottie Snopek, and supervisor Bob Schanks showing off a check to buy a van for senior trips.

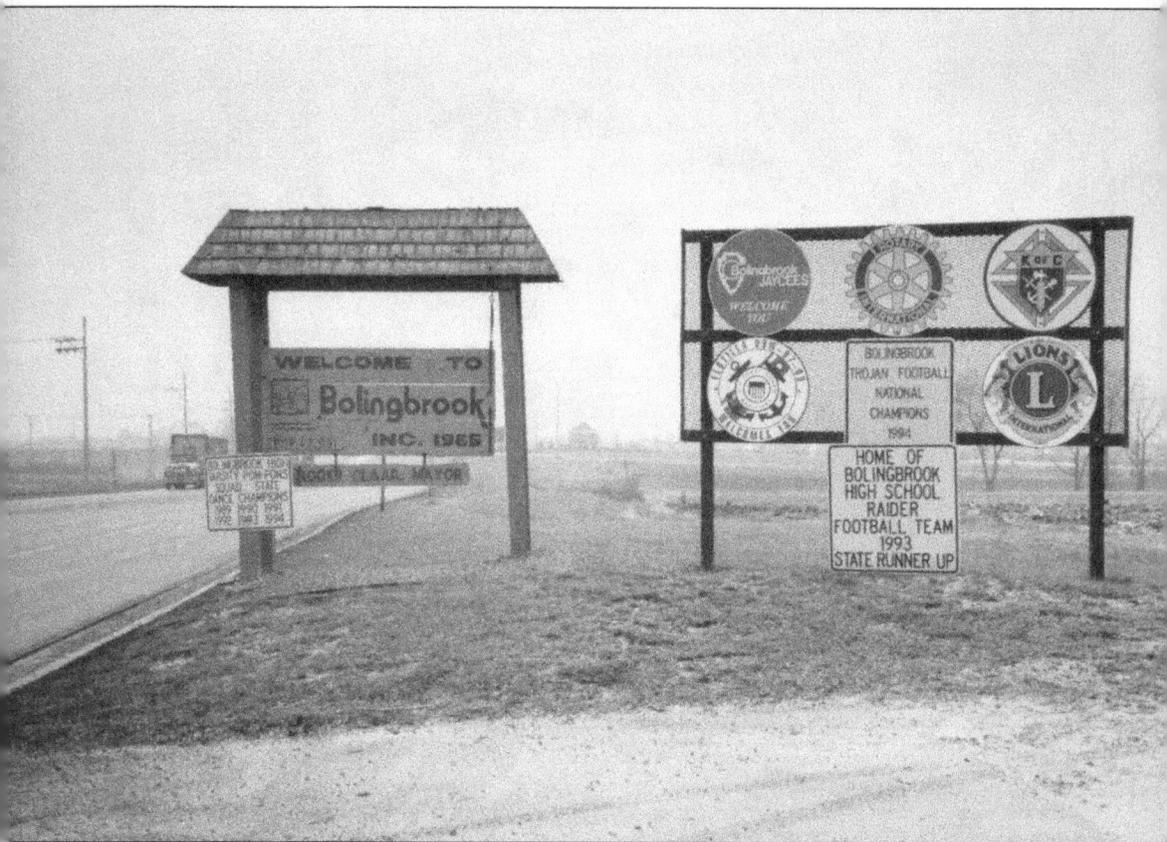

Once incorporation passed in 1965, residents soon realized more services were needed. A group of men organized the Bolingbrook Lions Club, and shortly afterward, the Bolingbrook Jaycees were formed. The Lions Club provides eyeglasses and hearing aids for residents, and the Jaycees sponsor the carnival at the Jubilee. In the late 1960s, the Bolingbrook Federated Women's Club was formed, followed by the Bolingbrook Business and Professional Women's Organization, supporting women in the workforce. As the community grew, so have the number of service organizations: the American Legion, Rotary Club, Exchange Club, Kiwanis Club, Veterans of Foreign Wars, Knights of Columbus, Alpha Kappa Alpha sorority, Greycore, and Bolingbrook Women's Club to name a few.

Pictured here is the annual Beep Baseball Tournament sponsored by the Lions Club, which provides services for the visual and hearing impaired. The needs of the community can be challenging with a population of nearly 75,000. Helping to improve health and welfare is the faith-based P.O.W.E.R. Connection, which provides training, food, and clothing for individuals. The Community Service Council serves northern Will County residents with housing and clinical counseling. HEART Organization has an intervention program assisting youth aged 12 to 18 who are in need of community service. Heart Haven Outreach provides programs and activities for high school students. The Valley View Educational Enrichment Foundation funds grant programs to local schools. These organizations are just a small sample of services available to Bolingbrook residents. Without the 50-year commitment of residents, the face of Bolingbrook would surely look very different than it does today. (Courtesy of the Bolingbrook Lions Club.)

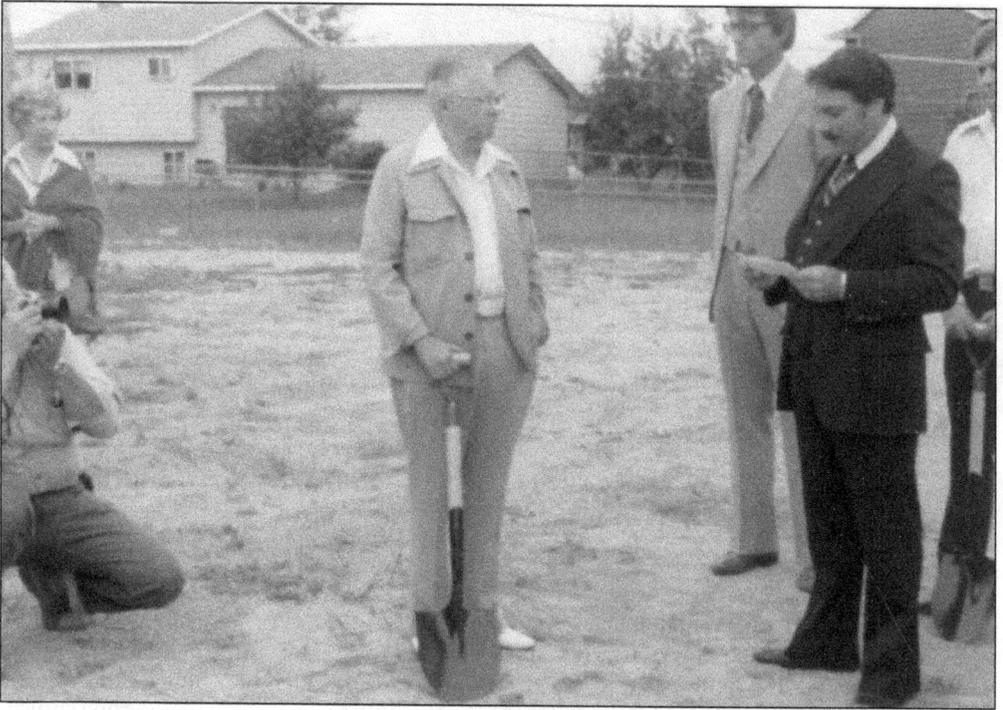

Alan and Flo Deatherage retired to Bolingbrook to be involved in a young community. President of the Bolingbrook Senior Club, vice president for Heritage Bank, member of the Region 9 Health Agency trying to get a hospital for Bolingbrook, and a member of the Businessman's Association are just a few of Alan's activities and accolades. Alan, who also has a street named for him, is pictured here breaking ground for the senior center with park president John Annerino.

The Local Development Corporation offered interested developers economic information about Bolingbrook, focusing on the positive reasons to locate within the village. An annual breakfast to discuss business events occurring in the village evolved into the state of the village address, sponsored by the chamber of commerce. Pictured here is a billboard promoting Hartford Insurance and 3M coming to Bolingbrook.

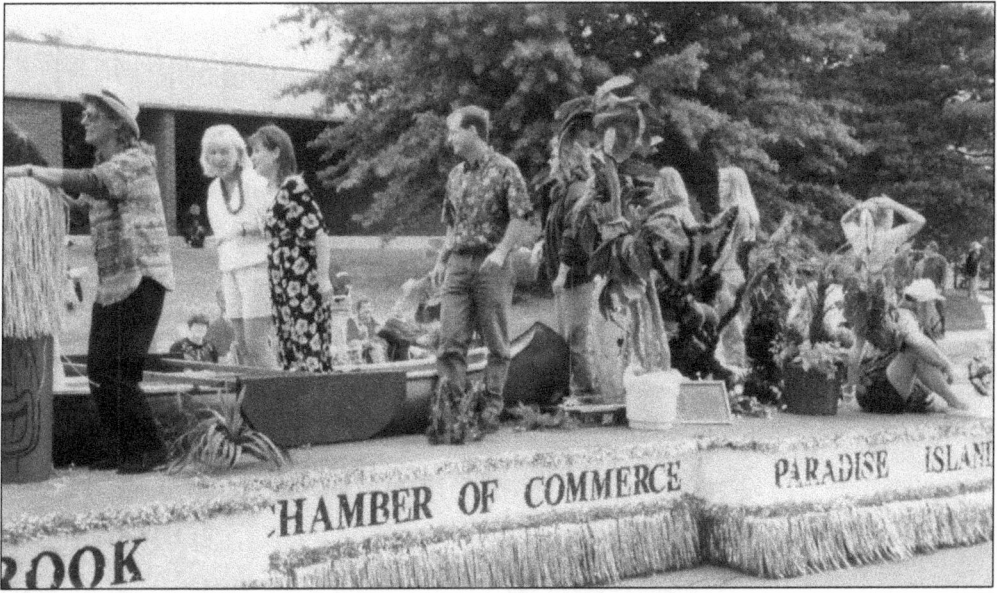

The Bolingbrook Area Chamber of Commerce's primary purpose is to promote, support, and develop the local business community. The chamber's 700 members comprise a mix of commercial, retail, industrial, and home-based businesses, medical, governmental, and educational entities, churches, and other non-for-profit service and social organizations. They participate in the annual Pathways Parade (above). Events sponsored by the chamber include ribbon cuttings for the new businesses, expositions, Chamber After Hours, golf outings, and Best of Business Awards Dinner. The annual Taste of Bolingbrook (below) held at the Promenade is a standing-room event. (Below, courtesy of Bolingbrook Area Chamber of Commerce.)

In 1986, the village of Bolingbrook had 115,000 square feet of industrial business. This changed dramatically in 1988, when the village passed a bond referendum to build new roads. The first road built was Crossroads Parkway, paving the way for tremendous industrial development in Bolingbrook. Once boundary lines between Bolingbrook and Romeoville were set, Trammell Crow Company announced plans in July 1988 for a 243-acre industrial park in Bolingbrook. The park was called Crossroads Business Park, and it is located southwest of the intersection of Route 53 and I-55. Some of the first businesses occupying the park were Ezon, Sanyo, Mention, Feltzer Bros., and Pearce Packaging. The 1990s would see the development of Crossroads Business Park Phase II, Corporate Crossing, Naper Crossing, and Carlow Crossing.

William Gahlberg also saw the potential in Bolingbrook and developed five phases of Remington Lakes Business Park. An avid fan of Southwestern art, he named the park after artist Frederic Remington. The extension of Remington Boulevard west from Schmidt Road would bring additional access to develop the western part of Bolingbrook. Besides numerous businesses, Bolingbrook is corporate headquarters to Weathertech, Ulta, ATI, and G&W Electric. The new century continues to see additional industrial growth in Bolingbrook. International Centre West, Bolingbrook Point, Crossroads Lakes, and Windham Lakes are just a few of the business parks that were being built. More and more companies were investing in Bolingbrook, with its ideal location to I-55 and the North-South Toll Road. In 2014, *Money* magazine named Bolingbrook the 38th Best Place to Live, noting how Mayor Roger C. Claar had increased the industrial, office, and manufacturing space to 32 million square feet.

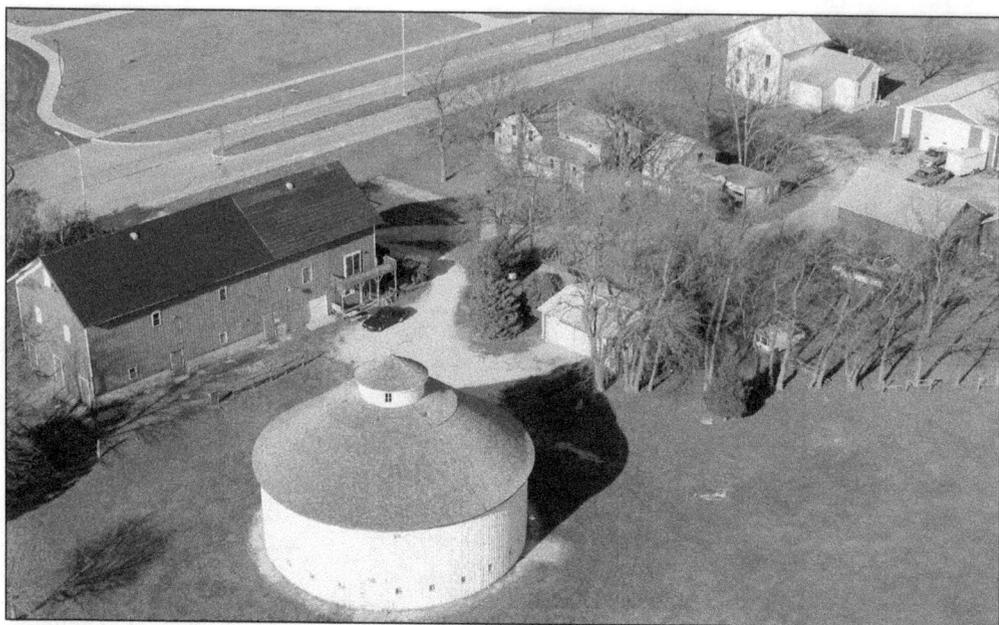

This round barn was built around 1912 by Frank Eaton of the University of Illinois Extension Program. It was originally located at 119th and Ferguson Roads. The barn was innovative in its time, designed to be more efficient than the ubiquitous rectangular barn. The barn was dismantled in 1998, moved, and reassembled at its present location on Essington Road as part of a future living farm.

Johansen Farms originated in 1925, when Hans Johansen came to America from Copenhagen, Denmark, and settled in Lisle, Illinois. His son Cort followed in his father's footsteps, continued to grow the business, and opened the location on Boughton Road in Bolingbrook in 1979. This location sells flowers and vegetables. In the fall, they have corn mazes, hayrides, pumpkins, a petting zoo, and more. In 2000, the Johansens opened a greenhouse and garden center on Route 53 in Bolingbrook. (Courtesy of Johansen Farms.)

In 2012, an aerial view of Barber's Corners shows Boughton Road running east to west and Route 53 running from north to south. Gone is the schoolhouse and implement store for two gas stations. The second village hall is opposite First Midwest Bank. The intersection is signalized to handle double left-hand turns—quite different from the stop sign and single lane of 50 years ago.

Along the north and west boundaries of Bolingbrook are active quarries providing stone, gravel, and asphalt for area roads. As the quarries are mined out, the pits generally become a lake or a clean landfill. The DuPage River Greenway, made up of several agencies, including the Will County Forest Preserve and Bolingbrook Park District, is prepared to accept a new recreational facility. Whalon Lake is one of the first.

The new village flag was adopted by the village board on June 17, 1980. The flag's colors dramatically emphasize Bolingbrooks' roots and a vision for the future that has no boundaries. The flag is designed to seem in constant motion even when it is not flying. Finally, the village motto, a "Place to Grow," has proven to be very prophetic in the ensuing years.

In 2002, the state of the village speech moved to the Bolingbrook Golf Club, where it is a sold-out event of 600 movers and shakers interested in Bolingbrook's future. In his address, Mayor Claar covers the village accomplishments, housing and business developments, and future prospects for Bolingbrook.

Happy 50th birthday, Bolingbrook! Bridging the past, present, and future from 1965 to 2015, check out the village website at www.bolingbrook.com.

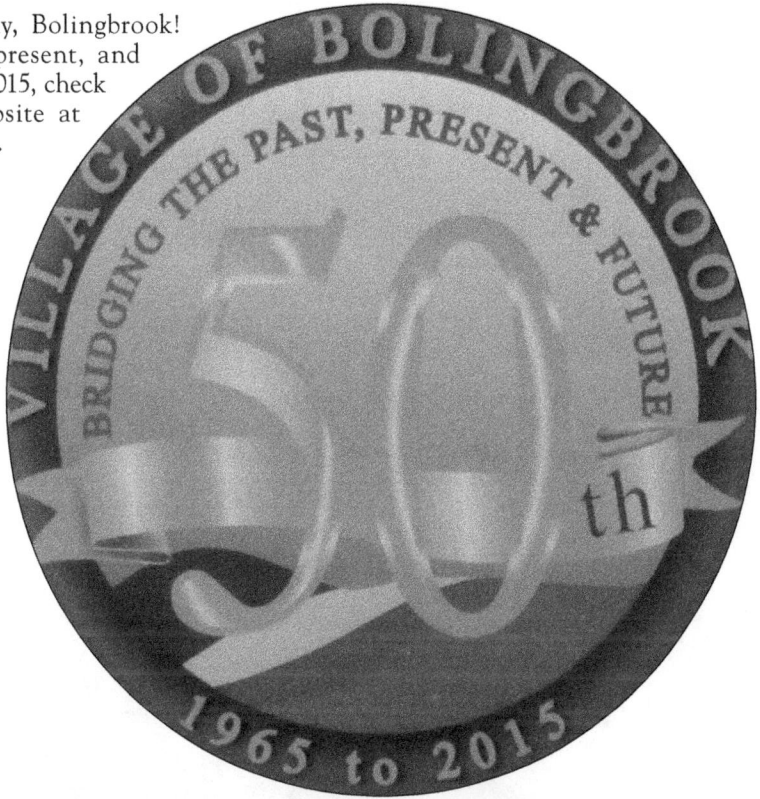

The future of Bolingbrook will be in their hands.

Visit us at
arcadiapublishing.com

www.ingramcontent.com/pod-product-compliance
Lightning Source LLC
Chambersburg PA
CBHW080600110426
42813CB00006B/1364